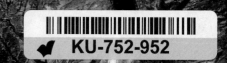
BRUEGEL *to* RUBENS

Masters of Flemish Painting

Desmond Shawe-Taylor

Jennifer Scott

Royal Collection Publications

This publication has been generously supported
by Mr Felix Robyns from 12 Advisors Ltd

Published by Royal Collection Enterprises Ltd
St James's Palace, London SW1A 1BQ

For a complete catalogue of current publications, please write to the address above,
or visit our website at www.royalcollection.org.uk

ISBN 978 1 905686 00 1

British Library Cataloguing in Publication Data:
A catalogue record for this book is available from the British Library.

Design: Price Watkins
Editorial project management: Johanna Stephenson
Production: Debbie Wayment
Printed and bound by Studio Fasoli, Verona
Typeset in Plantin and Scala Sans

Jacket: Pieter Bruegel the Elder, *Massacre of the Innocents* (no. 14, detail)
Spine: Peter Paul Rubens, *Self Portrait* (no. 30, detail)
Back jacket flap: Anonymous, *Boy at a Window* (no. 9)

CONTENTS

FOREWORD 7
INTRODUCTION 9

I THE INHERITANCE OF CHARLES V 45
1500~1555

II REVOLT 73
1555~1568

III WAR 93
1568~1598

IV THE ARCHDUKES 101
1598~1633

V THE LATER GOVERNORS 161
1633~1665

TIMELINE 194
FURTHER READING 196
PICTURE CREDITS 197
INDEX 198

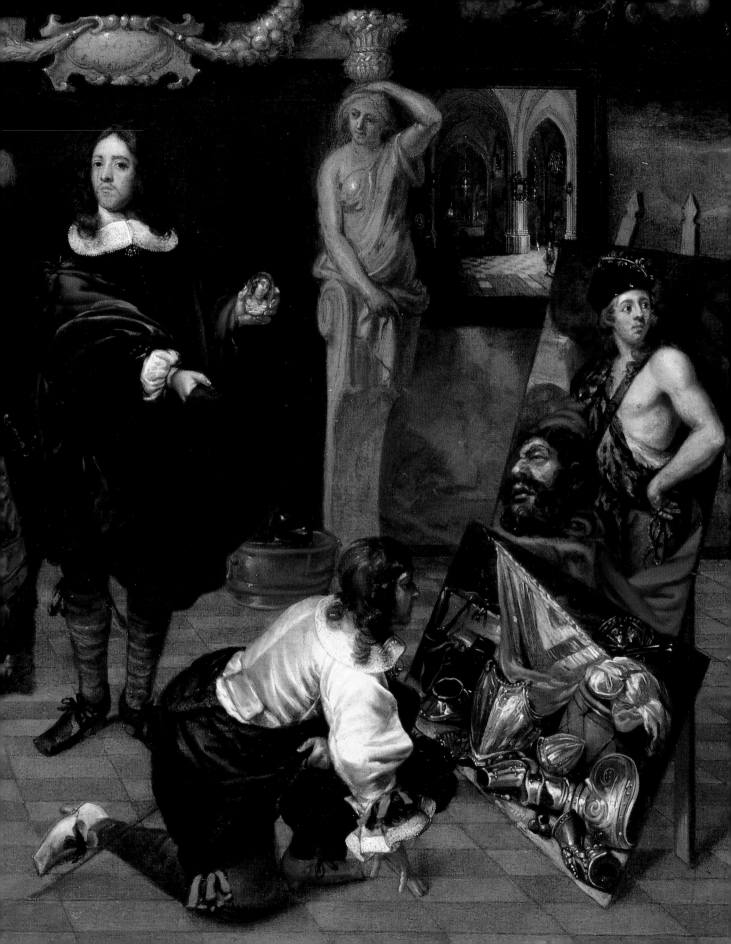

FOREWORD

Bruegel to Rubens: Masters of Flemish Painting is designed to coincide with the publication of Sir Christopher White's scholarly catalogue *The Later Flemish Pictures in the Collection of Her Majesty The Queen* (September 2007). These two projects celebrate the conclusion of an extraordinary campaign dedicated to cataloguing all the Netherlandish old master paintings in the Royal Collection, which has seen the publication (in order of appearance) of Oliver Millar's *The Tudor, Stuart and Early Georgian Pictures in the Collection of Her Majesty the Queen*, 1963; Christopher White's *The Dutch Pictures in the Collection of Her Majesty the Queen*, 1982; and Lorne Campbell's *The Early Flemish Pictures in the Collection of Her Majesty the Queen*, 1985. These three publications have provided the basis and most of the material for the entries in this present catalogue. All scholars, and in particular those interested in paintings within the Royal Collection, owe a quite exceptional debt to Oliver Millar for his scrupulous scholarship and for his commitment to the publication of colleagues' work. This is a debt of which we all became especially aware when, in May 2007, we heard the sad news of Oliver's death and realised that we could no longer rely upon his encyclopaedic knowledge, unfailing encouragement and astounding memory. This exhibition is but one of innumerable projects which would not have been possible without him.

The authors are extremely grateful to Christopher White, Lorne Campbell and Hugh Roberts for reading the manuscript and making many helpful suggestions. Janice Sacher provided invaluable assistance by tracking down images and obtaining copyright. Expert advice has also been freely shared by Rupert Featherstone and his colleagues in the Royal Collection Paintings Conservation Studio.

We have been very fortunate in this exhibition project in having the opportunity to work with the Royal Museum of Fine Arts in Brussels; we are most grateful to Michel Draguet and his colleagues for proving such professional and collaborative partners.

We are also grateful for the enthusiasm and dedication of the catalogue's editorial project manager, Johanna Stephenson, the creative flair of the designer, Ray Watkins, and the diligence of the production team, headed by Debbie Wayment, working under the supervision of Jacky Colliss Harvey.

The future of the programme of Royal Collection scholarly and exhibition catalogues depends upon the continuing support of sponsors. Few benefactors can have taken up a project with as much gusto and generosity as Felix Robyns, who agreed to bear the entire cost of the production of the catalogue upon first hearing of the proposal and who has followed the progress of the exhibition with infectious enthusiasm ever since. We are most grateful to Mr Robyns for his commitment and encouragement.

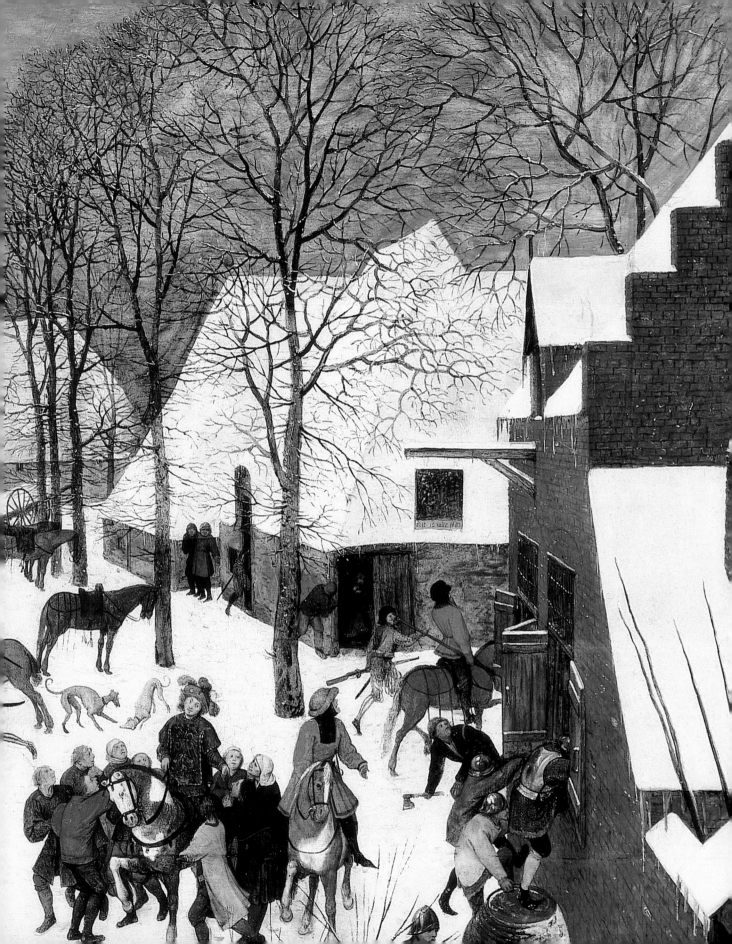

INTRODUCTION

About suffering they were never wrong,
The Old Masters; how well they understood
Its human position . . .
They never forgot
That even the dreadful martyrdom must run its course
Anyhow in a corner, some untidy spot
Where the dogs go on with their doggy life and the torturer's horse
Scratches its innocent behind on a tree.
(W.H. Auden, *Musée des Beaux Arts*)

Auden's famous lines were inspired by the Royal Museum of Fine Arts in Brussels and especially by Pieter Bruegel the Elder's *Fall of Icarus*. His description also fits Bruegel's *Massacre of the Innocents* (no. 14, detail opposite) down to the last detail of doggy life (two innocent greyhounds play in the snow in the right middle ground). But does Auden really mean the old masters or just Pieter Bruegel? For it must be said that in general the old masters do not paint like this.

The subject of Bruegel's *Massacre* is the order given by King Herod to slay every male child in his kingdom under the age of 2, in order to eliminate the one said by the Magi to be destined to rule. The scene has been transposed from first-century Palestine to an untidy modern spot – a small Flemish country town under thawing snow. The innocents and their families are Flemish townspeople; the perpetrators are imperial troops serving their Habsburg overlords. The German mercenaries (Lansquenets) can be recognised by their coloured hose and slashed leggings; the imperial herald, mounted to the right, by his tabard, which once bore the Habsburg eagle (subsequently painted over). The men in red coats superintending the operation and the knights in armour have not been securely identified, but could be native Netherlandish agents of authority. This mix of local enforcers and foreign overlords matches the biblical story in which Herod, a Jewish king, perpetrates a crime unbeknownst to (or condoned by) the Roman governor.

It is difficult to be certain of the exact contemporary reference intended here: the Herod of the Low Countries, the Duke of Alva (1507–82), did not arrive as governor until August 1567 (see figs. 1 and 36 and p. 76 below), while Bruegel's painting is usually dated to between 1565 and 1567. It is either a quick reaction to the brutality of the new regime or a prophetic painting, based on similar experiences of the oppression of foreign overlords, of which many are on record. Either way the image became known through many copies executed by Bruegel's son, Pieter the Younger (*c.*1564–1638), during the next fifty years,

FIG. 1
Simon van Gijn, *Alva as Chronos*, c.1567;
engraving (Dordrechts Museum, Dordrecht)

all of which show the distinctive features of the Duke of Alva on the mounted officer commanding the cavalry in the centre background (figs. 36 and 39). This image is a biting political satire, either one that began as a general comment and 'became' specific or one that was specific all along.

Bruegel's masterpiece stands apart from the Flemish tradition of painting, yet at the same time sums up many of its characteristics. Painted satires are not uncommon in this period: Bruegel himself made drawings with inscriptions, which, according to Karel van Mander (1548–1606), 'were too biting and too sharp, and which he had burned by his wife during his last illness, because of remorse, or fear that most disagreeable consequences might grow out of them'. An anonymous satirical print produced at approximately the time of Bruegel's last illness in 1568–9 (fig. 1; see pp. 74–7 below for the history of these years) is a parody of the triumphal statue Alva erected of himself in Antwerp in 1568, where he was shown trampling on allegorical representations of the rebellious nobility and commoners. Here he triumphs over the decapitated bodies of Horn and Egmont, mourned by Burghers and labourers alike (seen in the background). Alva is not here massacring an innocent, but rather, like Chronos, eating one. In his other hand he holds money bags for, according to the inscription, he 'takes wealth by force and spills innocent blood by stealth'. Behind, a three-headed French Hydra roams the land with the faces of Cardinal Granvelle (advisor to Alva's predecessor as governor of the Netherlands, who is also gnawing innocent flesh) and the leaders of the Catholic faction at the French court: Charles de Guise, Cardinal of Lorraine (1524–74) and Henri of Lorraine, 3rd Duke of Guise (1550–88), both later involved in the St Bartholomew's Day massacre and here supporting the Franco-Spanish pact to extirpate heresy in the Netherlands (which is why one licks the labourer's shoulder in anticipation of carrion). A winged evil genius (half-monk, half-devil) blows air into Alva's ear with a bellows, as if fanning the flames of his religious fanaticism.

Bruegel's *Massacre* is a 'modern dress production'; there are other examples in this exhibition of ancient stories similarly modernised. The ruins of ancient Rome as they appeared in the sixteenth century (admittedly veiled in mist) serve Marten van Heemskerck as a cipher for ancient Nineveh (no. 11). Hendrick van Steenwyck sets the story of St Peter's escape in a modern vault (nos. 23 and 24). Hans Vredeman de Vries imagines Mary and Martha in a modern Antwerp merchant's house (no. 13), the splendour of which suggests that Martha is 'house proud' and must be unfavourably compared with the humble Mary, seated at Christ's feet. If familiar stories may be recast as scenes

of modern life, then scenes of modern life may contain echoes of familiar stories. Rubens set the story of the prodigal son (fig. 53) in a modern Flemish barn; all three of his landscapes in this exhibition may be interpreted as containing veiled elements of narrative and personification (nos. 27–9). A contemporary audience could probably have read as many mini-narratives in Jan Brueghel the Elder's *Village Festival* (no. 18) as they could in his father's *Massacre*.

THE LOW COUNTRIES

This exhibition concerns itself with art produced in the region called the Netherlands or Low Countries (for maps see figs. 33 and 59). It was sometimes poetically given its Latin name, Belgica, after Gallia Belgica, one of the three parts into which Caesar divided Gaul. Its area was that of present-day Belgium, Luxemburg and The Netherlands, with a substantial slice of north-eastern France (Dunkirk, Arras and Cambrai were all some way within the borders). In the sixteenth century the Low Countries was made up of seventeen provinces, though sometimes other smaller units are included as independent entities. They included the duchies of Brabant, Limburg, Luxemburg and Gelderland; the counties of Flanders, Artois, Hainault, Holland, Zeeland, Namur and Zutphen; the lordships of Friesland, Groningen and Overijssel; and the bishopric of Utrecht.

Each of these provinces had a separate ruling dynasty and history that became merged by intermarriage, until the Emperor Charles V (1500–1558), heir to almost all of them and most of Europe beside, decided in 1549 to merge them into a single entity (fig. 33). In 1648, one hundred years later (eighty of which had been spent at war), the division of this entity into two halves (roughly modern Belgium and The Netherlands) was formally acknowledged in the Treaty of Münster (fig. 59). The provinces of Brabant, Flanders, Limburg, Artois, Hainault, Namur and Luxemburg ended up in the southern or Spanish Netherlands. The Dutch Republic to the north was made up of the Seventeen Provinces represented at the States-General (Gelderland, Holland, Zeeland, Utrecht, Friesland, Overijssel and Groningen), territories that were not (Drenthe and Zutphen) and the occupied parts of Flanders and Brabant (called the Lands of the Generality). The Treaty of Münster acknowledged something that had been a fact of life since the beginning of the century. This exhibition therefore deals with the art of a country at a time when it was splitting in two. The selection of works draws from all seventeen provinces for as long as this entity of a United Netherlands could be said to exist (roughly until 1585) and thereafter from the southern or Spanish Netherlands, though Flemish-born artists working in the north, like Roelandt Savery (nos. 20–21), are included.

In practice, however, the significant region is much narrower than this long list of provinces might suggest. The history of Dutch and Flemish art during

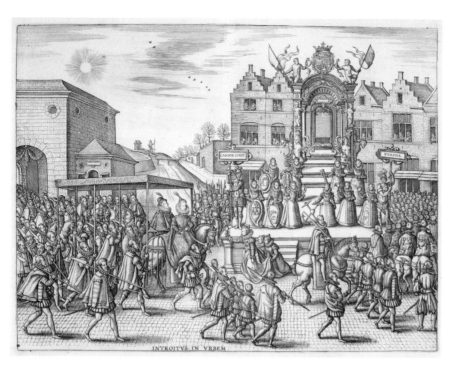

FIG. 2
Pieter van der Borcht, *Triumphal Entry of Archdukes Albert and Isabella into Antwerp in 1599*, 1602; engraving (Museum Plantin-Moretus/ Prentenkabinet, Antwerp)

this period (1500–1700) takes place within the provinces of Flanders and Brabant in the south and Holland and Utrecht to the north. Distances between the artistic centres of the region are tiny: Antwerp is 85 miles from Amsterdam; Brussels is 25 miles from Antwerp; while the cities of Haarlem, Leiden, Delft, The Hague, Rotterdam, Dordrecht and Utrecht all lie within 40 miles of Amsterdam (fig. 33). This exhibition begins in the sixteenth century, after the great medieval cities of Bruges and Ghent had begun to decline as artistic centres; in the seventeenth century it follows the fortunes of the southern Netherlands before the Dutch artistic centres (listed above) started to flourish. This means that it is dominated by one city – Antwerp (fig. 4). All but a handful of artists had some connection with Antwerp; most worked there for substantial parts of their career. The most important city for the history of sixteenth- and seventeenth-century Flemish art after Antwerp is not Bruges, Ghent or even Brussels, but Rome.

How were the seventeen provinces of the Low Countries ruled in the sixteenth century? Theoretically (and in the minds of their inhabitants), they should have been ruled in at least seventeen different ways. Each province and, in many cases, each city had a different contract between local people, governors and their feudal overlord. Typically the cities were ruled by an oligarchy of burghers: middle-class elders representing a series of bodies and institutions – guilds, courts, chapters, and so on. Their importance is expressed in the great municipal buildings of the era: town halls, where the aldermen met, where the public scale (the arbiter of weights and measures) was kept and where justice was administered; the cloth halls, headquarters of the hugely important cloth-makers' guild, and so on. These burghers owed allegiance to the local prince – the Count of Flanders, the Duke of Brabant and others – who, upon inheriting the title, took possession of the city in question with a grand ceremonial procession (fig. 2). He was welcomed with triumphal arches and flattering tributes, but was also presented with a list of the cities' privileges – rights, areas of executive power, and so on – to which he duly signed up. An insight into the governance of the region (as well as its geography) is provided by the Florentine Lodovico Guicciardini (1521–89), whose 'Description of the Low Countries' (*Descrittione di tutti i Paesi Bassi*) first appeared in 1567 (the English translation

of 1593 is quoted below). Guicciardini lists the restrictions imposed by the people of Brabant upon their prince: that he cannot pursue a subject without due course of law, or levy taxes without the consent of the local estates (parliaments), or put a stranger in office unless he can speak Flemish, and so on. The people on the other hand have leave to hunt and to buy and sell their own land. If the prince breaks any restriction the Brabanters' oath is null and they can choose another prince. Respect for privileges became therefore a fundamental way to distinguish between a good prince and a tyrant. 'Whoever touches the privileges', wrote the pro-Spanish Maximilian Morillon, 'cuts to the quick'.

This was understood to be (in the ideal) a 'social contract': the great Renaissance humanist Desiderius Erasmus (1466–1536) of Rotterdam (in the province of Holland), observed:

> In return for his [a King's] good behaviour let the people pay him just so much reverence, and yield him just so many privileges and prerogatives as are for the public good, and no more. A good king will require no more; and as to the unreasonable desires of a bad king, the people should unite to check and repel them.
> (Erasmus, *The Complaint of Peace*, 1517)

This is exactly what the northern provinces did in 1581 when they pronounced their hereditary king, Philip II (1527–98; fig. 34), a tyrant and thus no longer entitled to their allegiance. In theory the social contract should have left the cities free to create wealth, while the prince offered them the protection of an army. But, again according to Erasmus, the reality was rather different:

> The people, the ignoble vulgar, despised as they are, are the very persons who originally raise great and fair cities to their proud eminence; who conduct the commercial business of them entirely; and, by their excellent management, fill them with opulence. Into these cities, after they are raised and enriched by plebeians, creep the satraps and grandees, like so many drones into a hive; pilfer what was earned by others' industry; and thus what was accumulated by the labour of the many is dissipated by the profligacy of the few: what was built by plebeians on upright foundations is levelled to the ground by cruelty and royal patrician injustice.
> (Erasmus, *The Complaint of Peace*, 1517)

The relationship between plebeians and satraps became more complex as the seventeen provinces merged through intermarriage and conquest and became the possession (and only part of the possessions) of a single foreign overlord, as happened when the Low Countries became part of the Burgundian Empire

and passed into the possession of the Emperor Charles V (see no. 3 and pp. 46–9). Even then a complex governmental infrastructure was preserved: each province had a parliament, or estate, where every decision was ratified, and the estates sent representatives to the Estates General, usually meeting in Brussels. Each province had a governor, or stadtholder – an aristocrat appointed by the sovereign – whose personal estates usually lay in another province, to guarantee impartiality. The sovereign (or regent acting on their behalf) ruled in Brussels in consultation with a small council of state comprising Netherlandish noblemen who were usually knights of the Golden Fleece, the chapters of which encouraged frank criticism between members. This balance of local and feudal governance worked well with Charles V, who was born and bred in Flanders. His son and heir, King Philip II, on the other hand, was a Spaniard by birth, upbringing and world-view: he may theoretically have ruled Amsterdam in his capacity as Count of Holland, and Brussels in his capacity as Duke of Brabant, according to different contracts set up in the Middle Ages, but he preferred to rule both in his capacity as King of Spain, through a governor with a large Spanish army at his back. His governor from 1559 to 1567 was his half-sister, Margaret of Parma (1522–86), who, according to the French ambassador, was 'surrounded by Spanish minds, which are hated here to the death . . . nothing here is well said, well done or well considered unless it comes in Spanish and from a Spaniard'. To the rulers the Flemish were constitutionally disloyal: Don Luis de Requesens, governor-general of the Low Countries 1573–6, noted that 'in the history books we read that there have been thirty-five revolts against the natural prince, and after each of them the people remained far more insolent than before'. To the ruled such overlords were merely conquistadors: even the loyal Rubens complained in 1631 that 'Spain is willing to give this country as booty to the first occupant, leaving it without money and without any order'.

The Low Countries represented rich booty. A glance at the paintings in this exhibition reveals a level of middle-class luxury not matched elsewhere in Europe for centuries. The interiors depicted by De Vries in the 1560s and Formentrou and Coques a century later (nos. 13, 50–51) are palatial, with huge glazed windows, marble floors, fine furniture and carved architectural decoration. These are imaginary, but evoke with reasonable accuracy the town houses of Antwerp merchants, which struck visitors like John Evelyn as 'furnish'd like a Prince's'. Even artists lived in such splendour, as may be deduced from the description of the Antwerp town house that Quinten Massys acquired in 1521, or from a visit to Rubens's house in Antwerp (fig. 3) – which survives to this

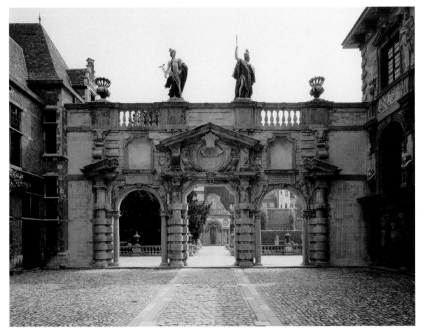

FIG. 3
View of the entrance to the gardens at the
Rubenshuis, Antwerp

day as a museum and which may once have
displayed the three landscapes in this exhib-
ition (nos. 27–9). Farmers, innkeepers and
poor townspeople lived in darker spaces with
dirt floors and small, shuttered (rather than
glazed) windows. Well-tended examples of
such modest houses are shown inside and
out in the works of Bruegel, Rubens and
Teniers (nos. 14, 28, 44, 45 and 47). Even
in such surroundings there seems to be a
plentiful supply of food. When Rudolph II
(1552–1612) had Bruegel's *Massacre of the
Innocents* (no. 14) painted over as a scene
of plunder he re-created a familiar scene: a
small Flemish town disgorging a month's
ration of livestock. The interiors of Teniers
and the landscapes of Rubens (especially
no. 27) are similarly filled with generous
piles of produce. The only activity depicted in such a way as to suggest an
unfavourable ratio of effort to reward is fishing (see no. 43), which at this time
yielded cheap fare at great risk. Yet even here the fishermen and boys are all
shod; the only bare feet in this exhibition belong to idealised figures and (in
one case, no. 28) to a lame beggar. The land was exceptionally fertile, but it
was the cities that struck contemporaries. According to Guicciardini, 'the
Spaniards at their first coming into the countrey, seeing such a multitude of
townes, villages, monasteries and buildings, said that all *Flanders* was but one
Cittie'. It has recently been estimated that 30 per cent of the populations of
Flanders, Brabant, Holland and Artois were city dwellers in the sixteenth cen-
tury; the other provinces within the Low Countries were no different from the
rest of northern Europe, with an almost overwhelming rural population. The
two cities that produced almost everything in this exhibition, Antwerp and
Brussels, were evidently incomparably fine (see fig. 4). Guicciardini described
the 'fair, large, even and straight' streets of Brussels and concluded that no town
in the world was better for pleasure and profit. He records that Antwerp prof-
ited from trade with seven different nations: 'It is marvelouslie wel furnished
both out of their owne countrey and out of forren countreyes, of all kinde of
victuals and dainties, both for the necessary use of man, and also for wanton-
nesse.' Antwerp, he concluded, was a 'truly leading city in almost all things, but
in commerce it headed all the cities of the world'. From a Florentine this is
praise indeed. More prosaically, recent estimates show the population of Antwerp
doubling in the first half of the sixteenth century, reaching 100,000 in 1550
and making it the second most populous northern European city after Paris.

FIG. 4
(Overleaf) Georg Braun and Franz Hogenberg,
Anverpia from *Civitates Orbis Terrarum*, 1572;
engraving (The British Library, London)

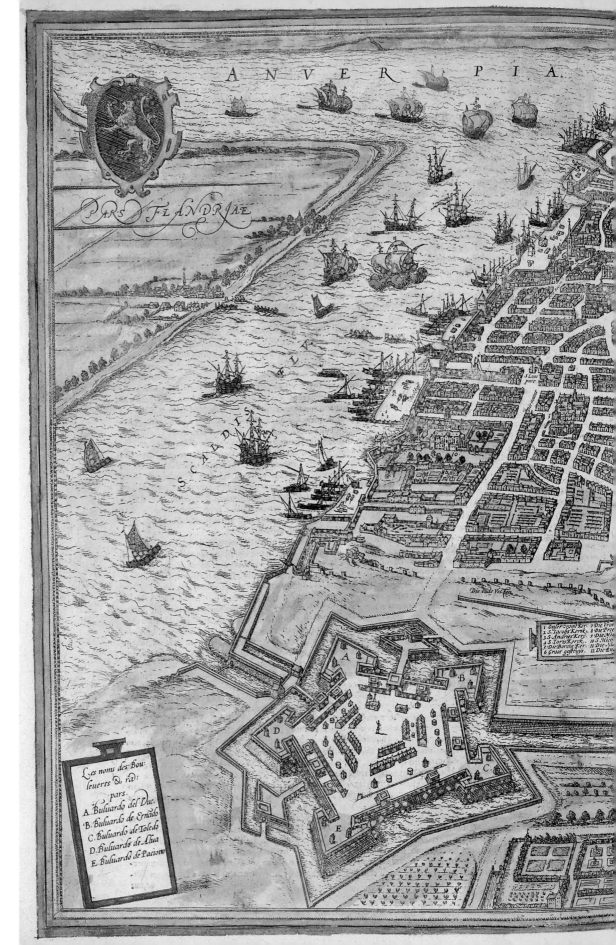

ANVERPIA.

PARS FLANDRIAE

SCALDIS FLV.

Die dule Vesten

S Lnis
pore

1 Onser vrouw. Ker. 7 Die Vro
2 S. Iacobs Kerck. 8 Die Pro
3 S. Andries Kers. 9 Die Min
4 S. Iorus Kerck. 10 S Mich
5 Die Boreon Ker. 11 Die Vn
6 Groot gasthuys. 12 Die B

Les noms des Bou:
leuerts & ra:
pars.
A. Buluardo del Duc.
B. Buluardo de Ernado
C. Buluardo de Toledo
D. Buluardo de Alua
E. Buluardo de Paciotto

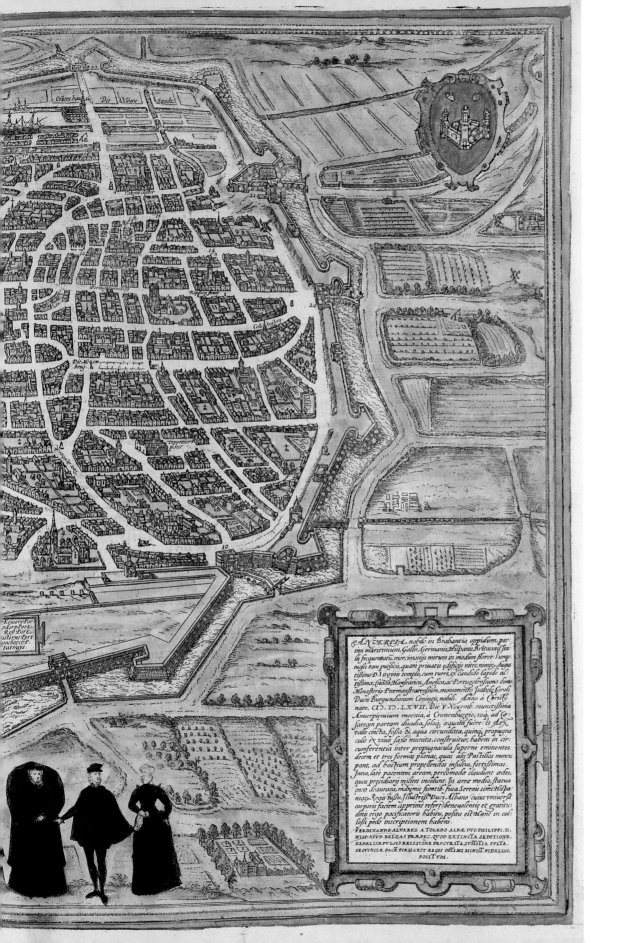

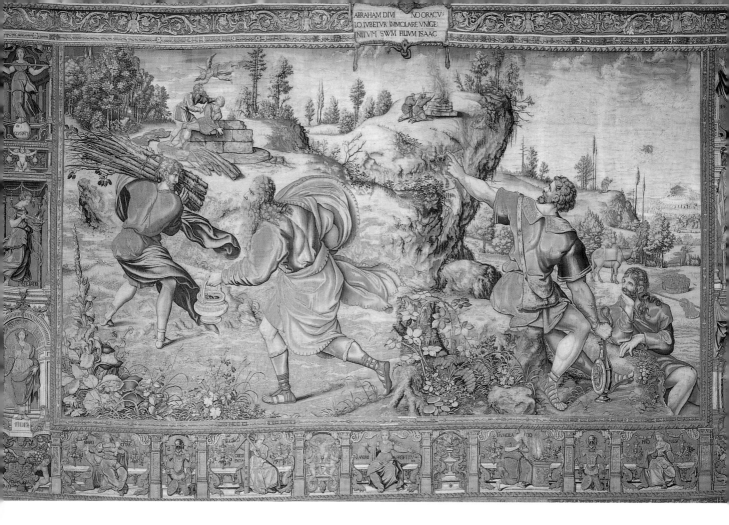

ABRAHAM DIVI NO ORACV
LO IVBETVR IMMOLARE VNIGE
NITVM SVM FILIVM ISAAC

FIG. 5
The Sacrifice of Isaac from *The History of Abraham,*
*c.*1545; tapestry (Royal Collection, RCIN 1046)

According to van Mander, 'art is drawn to wealth'. At the time that Guicciardini was writing (1567) there were two super-zones in the European economy – certain cities in Italy and a small group of Netherlandish provinces: Flanders, Artois, Holland and to a lesser extent Brabant. These were areas of high population density, high proportion of middle classes, excellent infrastructure, strong manufacturing base and thriving trade. The Flemish excelled in the manufacture of luxury goods (things made 'for wantonnesse'). The Low Countries was the main centre for tapestry-weaving, which is why the old English word for tapestry is the name of the town of Arras in the province of Artois. Henry VIII (1491–1547) acquired one of the best collections of such tapestries in Europe (now mostly on display at Hampton Court, fig. 5), which must have completely overshadowed his collection of paintings. Every type of cloth was made in the Netherlands during the period. The sumptuous costumes seen in this exhibition could all have been of local manufacture, with their fine silk, velvets and fur trimming (seen in nos. 1–3 and 6), starched ruffs (no. 22), lace collars (nos. 31 and 51), and paraphernalia of cloaks, hats, stockings, rosettes and shoe-buckles (no. 50). Some of the finest furniture and musical instruments were also made in Antwerp during this period, and can be seen in

painted interiors such as nos. 13 and 50. There is almost no piece of carving, gilding or furnishing, no artefact or costume here painted, that could not have been made in the Netherlands to the same standard. The exceptions to this rule are the rare artefacts which were imported from Asia into Antwerp, the trading hub of Europe: the kris (asymmetrical dagger) seen in Francken's cabinet (no. 25); the Persian rug in Formentrou's interior (no. 50). Where there are specialist tradesmen – dyers, cloth-makers, tapestry-weavers, goldsmiths, joiners, lute-makers and so on – there are likely to be painters also. During the Renaissance the two zones mentioned above – Italy and the Netherlands – were the only two serious centres of painting. This exhibition picks up the story of Flemish art at the zenith of Antwerp's fortunes, after it had taken over the role of the North Sea Venice from Bruges in *c*.1516, and stays with it during years of relative decline. At the end of the period trading supremacy within the region had been surrendered to Amsterdam, largely as a result of the blockade of the Scheldt maintained by the Dutch throughout the war and after the peace of 1648 (see pp.162–5). The province of Holland became the northern European economic hot-house in the seventeenth century, but this does not mean that it was a backwater in the sixteenth century: Guicciardini wrote of Holland in 1567, 'their townes are well built, their houses wonderfully well furnished, & their furniture exceeding fine and neete above all Countries in the world'. Conversely, Antwerp's prosperity may have suffered in the seventeenth century, but it remained a magnificent art-producing metropolis and the character of its culture did not significantly change.

ARTIST AND PUBLIC

A city's artistic culture is affected by three elements: general intellectual climate, the market, and the artists' training and professional organisation. Antwerp was a centre of humanist learning – that is, the appreciation of the works of classical antiquity as a counterbalance to the dogma of medieval Christianity. The sceptical and enlightened style of its greatest exponent, Erasmus, has already been sampled. Massys's portrait of Erasmus (no. 5) was painted as a pair to one of his friend, the Antwerp town secretary Pieter Gillis (see fig. 29); both were to be sent to their mutual friend in London, Sir Thomas More (1478–1535). Meanwhile at the other end of the scale, Guicciardini reported that 'every husbandman can write and read' and that many who had never been out of the country could speak French, German, Italian, English and Spanish. Merchants, artists and other prosperous citizens with a literary bent joined 'Chambers of Rhetoric', societies which organised festivals called *Landjuwelen*, with processions, performances of plays (farces and morality plays) and rhetorical contests. The makeshift stage in Pieter Bruegel the Elder's 1560 print *Temperance* (fig. 6) may depict such a performance. The rhetoricians' plays (like English mystery

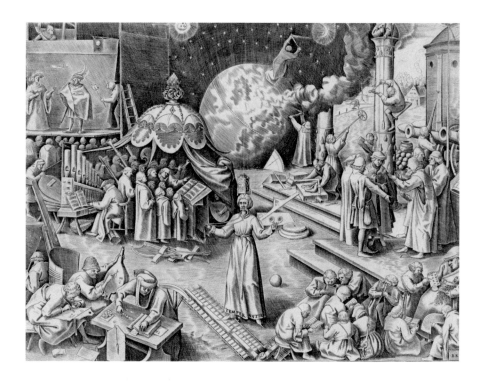

plays) grew out of religious festivals; it is possible that two actors in them appear in Jan Brueghel's *Village Festival* (no. 18, see detail on p.112). Two characters seem to be wearing biblical costume and Chinese-style hats that (viewed from the right angle) might look like haloes; are these Mary and Joseph off-duty? More generally it is possible to imagine how an audience familiar with this literary culture would appreciate the political satire and the multiple human narratives of Bruegel's *Massacre of the Innocents* (no. 14). Dramatic story-telling or at the least a strong element of human interest is a characteristic of a very high proportion of paintings in this selection from every date and within every genre. The strong market for prints within the period also suggests that visual and literary culture were closely allied.

Antwerp was the centre of the northern European publishing industry: the press founded in 1550 by Christopher Plantin (1520–89) had become by the 1570s the largest in Europe, with 16 presses, 80 employees, an average of 72 new editions a year, and a royal monopoly on the sale of religious texts in Spain and its empire. The Siege of Antwerp in 1584–5 caused Plantin to set up another press at a safe distance in Leiden, which laid the foundation of Dutch academic printing. The Antwerp arm of the business, which passed to the family of Plantin's son-in-law, Jan Moretus (1543–1610), did not close until 1876. As well as publishing theological and humanist texts, the Plantin Press also produced books devoted to geography, mathematics and the natural sciences.

Antwerp's scientific learning may explain the popularity of 'encyclopaedic' painting during the period. Jan Brueghel's *Allegory of Sight* (fig. 10) displays

an abundance of things made to delight this sense; it also includes scientific instruments designed to improve the power of observation and extend its use. Frans Francken's *Cabinet of a Collector* (no. 25) is an example of an attempt to celebrate all forms of learning and species of natural curiosity; a similar instinct for empirical classification is manifest in Brueghel's *Adam and Eve in the Garden of Eden* (no. 19), Savery's landscapes (nos. 20–21) and the 'specimen painting' of Jan van Kessel (1626–79) and others, examples of which may be seen in nos. 25 and 50. Artists clearly numbered themselves among these intellectuals: Van Dyck's series of portrait prints begun in *c.*1630 and published in Antwerp (by Gillis van Hendricx) in 1646, the 'Images of Foremost Men of Learning' (*Icones Principum Virorum Doctorum*), featured nineteen artists (Flemish, Dutch, Italian, French and English), including Rubens, Hendrick van Steenwyck, Frans Francken and Van Dyck (nos. 22–32).

The one difference between the Antwerp of 1550 and that of 1600 concerns the religious faith of its population. A significant proportion of the literate and sceptical humanists mentioned above became Protestants. An even more significant proportion of those who remained Catholic believed that Protestants should be free to practise their religion without fear of persecution – hence the common cause made by Roman Catholics and Protestants in their revolt against intolerant Spanish rule. This revolt is now called the 'Dutch Revolt' because of its eventual outcome (the formation of the Dutch Republic); at the time it was a Netherlandish revolt with Antwerp as its epicentre. By the seventeenth century a very large number of prosperous and intellectual citizens of Antwerp had fled north to escape Spanish persecution, naturally including all Protestants. The flight of businesses and business capital to the north left Antwerp permanently economically impoverished. The flight of Protestants left it wholly Roman Catholic. This is clearly an important factor when comparing the artistic production of Antwerp and Amsterdam during the seventeenth century, and in particular when considering the great public religious commissions which Rubens fulfilled so magnificently (see no. 26). It is more difficult to discern any fundamental difference between the type of domestic painting enjoyed in Antwerp and Amsterdam: Dutch equivalents could certainly be found for Teniers's genre scenes (nos. 43–7), while Gonzales Coques (1614–84) worked for the stadtholders of the northern Netherlands, Frederick Henry (1584–1647) and Amalia van Solms (1602–75), before becoming court painter to the Count of Monterrey, governor of the southern Netherlands, in 1671.

Almost any market will be a pyramid, with the richest and most assiduous buyer at the apex and the poorest and most casual at the base. The size and shape of this pyramid varies greatly; that of the Flemish art market was very

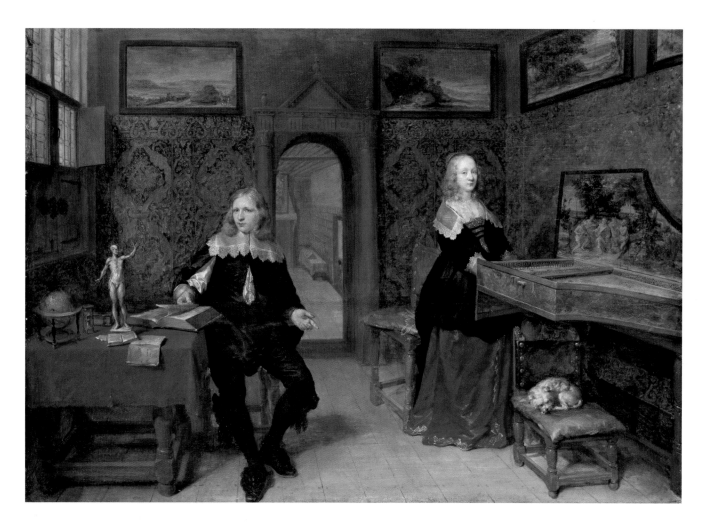

wide and shallow. Many people could afford to buy a painting, even down to those husbandmen who impressed Guicciardini with their ability to read and write. The large number of prosperous members of the middle class could afford to buy rooms full of paintings. Their middle-class town houses were luxurious but not huge, which encouraged the production of small to medium-sized paintings. This exhibition focuses on just such works; it has been selected to fit in the cabinet-sized rooms of The Queen's Galleries at Holyroodhouse and Buckingham Palace, which means that major altarpieces and full-length aristocratic portraits have been of necessity excluded. Formentrou's *Cabinet of Pictures* (no. 50), though presumably imaginary and overstocked, provides some idea of how such domestic paintings were displayed, especially if read in conjunction with more probable interiors, like that shown in Gonzales Coques's *Young Scholar and his Sister* of 1640 (fig. 7). The prime location is over the fireplace, where the largest painting hangs, a biblical subject in a gilded frame. It is possible to imagine either of Van Dyck's Antwerp religious paintings (nos. 34–5) in such a setting. The smaller paintings are hung from the ceiling

FIG. 8
Detail of no. 50

FIG. 9
Anthony Van Dyck, *Charles I with M. de St Antoine*, 1633; oil on canvas (Royal Collection, RCIN 405322)

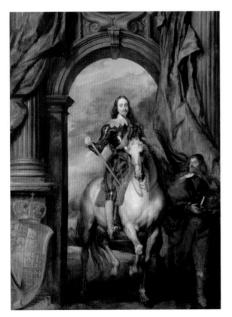

downwards; in a less crowded interior (as seen in fig. 7) there would probably be only a single row often sitting above high decorative panelling or other wall-covering. Other interiors of the period show individual paintings hung on such a covering as well as above it. In these rows subjects and types of painting appear to be mixed indiscriminately. This may seem rather high to hang paintings of such fine technique, but it is clear from many cabinet paintings (including nos. 25 and 50) that precious works were brought down from the walls and examined close to. The man kneeling on the floor of Formentrou's painting (no. 50 and fig. 8) is adopting exactly the correct viewing position for the majority of works in this exhibition.

This sort of painting collection could have been acquired without any direct contact with the artist: from dealers (who displayed works in their houses in a way similar to that seen in no. 50) or from stalls at fairs. A letter of 1663 from a Parisian to an Antwerp dealer even refers to small paintings by David Teniers being sold 'from door to door'. Do artists have to work in a special way for a mass market at one remove, as opposed to working for a handful of individual patrons, known to them personally? The question is best answered by imagining a dealer's shop looking something like Formentrou's interior (no. 50). The stock must sell itself 'on sight'; it will need to have a very strong technical quality and visual identity to compete with all the other paintings on display. The walls in Formentrou's paintings show one example of each artist's work, which creates an effect of great variety. But individual artists do not need to achieve much variety *within* their own oeuvre. The broad middle-class market for painting in Antwerp was demanding in the area of technical quality and immediate accessibility; it was forgiving in the matter of repetitiveness. These things encouraged artists to excel in one area, even if it meant repeating themselves. It made, in short, for specialists.

There is some discussion below (pp. 36ff.) of the impact in the north of Italian ideas about art. This body of artistic theory concerned itself with works executed for the apex of the market pyramid. In this model of patronage, a prince of unlimited resources and space (in his palaces and family chapels) commissions directly from an artist in his service (and therefore known to him) a relatively small number of highly important works. These will usually be executed on a large scale and will be varied in form and subject. They will probably be more concerned with delivering a grand idea than with minutiae of execution. Flemish artists certainly knew these opportunities: Van Dyck's work for Charles I (1600–1649) fits the model exactly (see fig. 9), as does Rubens's entire career. As we shall see, Italianate artistic theory despised the mechanical accomplishment of specialist painters. The reaction from Flemish theorists was subtly different. Karel van Mander wrote a theoretical tract, *The Foundations of the Liberal Art of Painting* (*Den Grondt der Edel vry Schilder-const*), and a collection of lives of Flemish painters in *The Book of Painters* (*Het Schilder-*

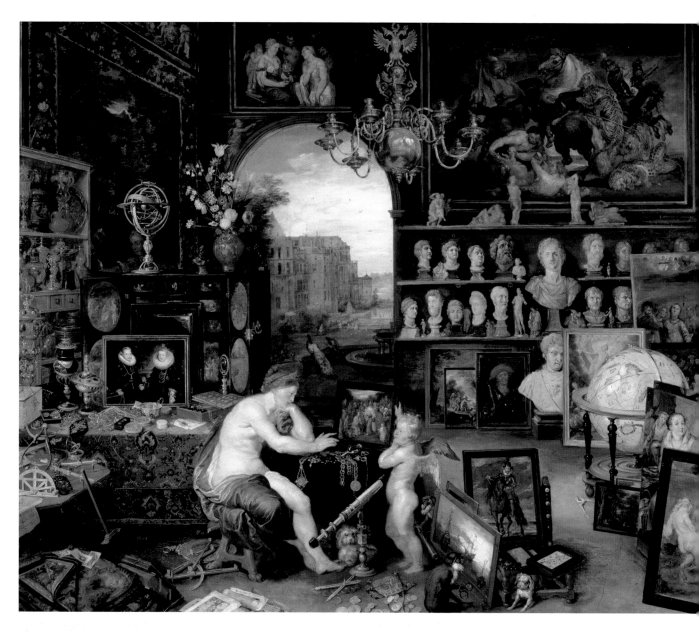

FIG. 10
Jan Brueghel the Elder, *Allegory of Sight*, c.1618;
oil on panel (Museo Nacional del Prado, Madrid)

Boeck) of 1604, very much in emulation of Giorgio Vasari's lives of Italian painters (*Le Vite de' più eccellenti pittori, scultori et architettori*) of 1568. More than anyone he represents the attempt to bring Flemish painting into the mainstream of Italianate artistic theory. He makes it clear that figure painting is the highest goal of art but nonetheless acknowledges the value of 'specialisms' (*Verscheydenheden*): 'if your perfection is not in figures or histories, so may it comprise animals, kitchens, fruit, flowers, landscape, masonry, views into rooms, grotesques, night-scenes, fires, portraits done from life, sea-scenes, ships, or the painting of other such things'. He even suggests that history painting, instead of being above all specialities, is a kind of *sum* of them all.

Most of the paintings in this exhibition are by specialists, working in the familiar areas of genre painting (the depiction of everyday life), landscape and portraiture, but also in smaller 'niche genres', like the 'cabinet of curiosities', a type invented by Frans Francken (see nos. 25 and 50); architectural painting (nos. 13 and 22–4) and flower painting (nos. 39–40). Artists became so specialised that they collaborated to ensure that they each played to their strengths. The two flower scenes by Daniel Seghers (nos. 39–40) have fictive carved architectural decorations designed to frame a figure by another hand, one of which was never executed. Seghers is documented as having collaborated in this way with Italian and French painters, Domenichino (1581–1641) and Nicolas Poussin (1594–1665), as well as Flemings. In 1618 the city fathers of Antwerp gave a pair of paintings to the Archdukes Albert and Isabella in which a group of twelve Antwerp artists (including Rubens and Frans Francken) had worked under the direction of Jan Brueghel the Elder (see nos. 18–19); the commission was organised by the collector and friend of Rubens, Cornelis van der Geest (1555–1638). The works, depicting the Five Senses and destroyed by fire in Brussels in 1731, are known through replicas, executed by Jan Brueghel alone (fig. 10). In a cabinet scene in Munich dated 1666, by Charles Emmanuel Biset, Wilhelm Schubert von Ehrenberg and other artists, the individual paintings-within-the-painting are executed by their real-life creators. It has been suggested that a similar collaboration of at least twelve painters resulted in Formentrou's *Cabinet of Pictures* (no. 50).

Whether or not the artists present in this painting were actually working together on the canvas, they were clearly collaborating on the project. Whoever this painting was intended for, whether a gift from the municipality (like the Brueghel project) or a work for sale to a private individual, it must have helped to promote the quality and range of a group of Antwerp artists. It is a marketing tool. Antwerp artists were clearly working in co-operation, and the name given to their co-operative was the Guild of St Luke. An artist became a member of this guild (or its equivalent in other cities) by studying as an apprentice (for four years in the case of a painter in oils) in the studio of one who was already a member and then submitting a work for assessment. Once accepted, the artist could take pupils of his own (up to a certain number) or continue to work in another's studio as a journeyman. A guild member could sell his works in the city (non-members could only sell in free fairs); he might even serve a term as dean of the guild. The guild would try to help him if he fell on hard times and to support his family after his death. 'His' here reflects the expectations of the period and is not to deny the achievement of the few women who made it as professional painters. The guild also had a ceremonial side, with a meeting hall, a chapel and a role assigned to it in public processions. A guild was an instrument of protectionism and quality control; it was a mutual benefit society; it was part trades union and part *appellation contrôlée*.

Even panel makers worked for a guild and stamped the back of their panels with the guild mark – a guarantee of quality acknowledged and appreciated to this day by conservators. Painters who worked for the court (who included Jan Brueghel the Elder, Rubens, Van Dyck and Teniers) were automatically exempt from all guild restrictions: they could take unlimited assistants, sell paintings where they liked, and, in Rubens's case, use inferior home-made panels. Again Italian artistic theory reflects the mind-set of the prince and his court painter and can find nothing good to say about guilds. Van Mander here adopts the orthodox view, considering it an outrage that Painting (*Pictura*), 'Mother of the decorative arts' and sister of the Liberal Arts, was forced into guilds, like those of the coarsest trades, 'by the pressure of inefficient daubers who made the most shameful laws and narrow rules'. The 'Liberal Arts' (grammar, logic and rhetoric, geometry, arithmetic, astronomy and music) were those considered suitable for a gentleman (and correspond to the sorts of subject taught until recently in universities). The campaign for painting to join their number (and therefore quit entirely the sphere of the artisan in his guild) had been waged for a century in Italy and led eventually to the formation of an academy in Antwerp in 1664, a project led by the court painter to the regents, David Teniers.

The members of the Antwerp guild were not 'inefficient daubers', but the arrangement implied something of a closed shop and perhaps a limited field of recruitment. It was not just that painters in the period came from a narrow artisan class and lived within a small area of the city in Antwerp; they were usually related to each other as well. Most artists studied with their father, or possibly a relation or family friend; many artists married the daughters or sisters of their colleagues. The catalogue entries below provide outline biographical information, which almost invariably reveals some connection with the extended artistic dynasties of the period. Even artists from outside this class, like Rubens, the son of a court secretary, encouraged the same communal spirit, buying up most of the square next to his house in Antwerp in order that he could lodge his pupils in a sort of painting ghetto. Rubens also clearly hoped that his children might keep the studio going: he gave orders that his drawings (a central and valuable piece of 'intellectual property' at this date) be held together until all his children reached majority and only sold if none became or married a painter. They were eventually sold in 1657, when it was evident that his children had no connection with painting.

The Bruegel family provides the most obvious example of an Antwerp dynasty. The studio remained in business for over a century, during which time the name changed from 'Bruegel' to 'Brueghel' presumably in order to dissuade Francophones from softening the 'g'. Pieter Bruegel I (*fl.*1551–69; no. 14) was apprenticed to Pieter Coeck, whose daughter he married in 1563. Pieter Bruegel I had two sons; the eldest, Pieter II (*c.*1564–1638), continued painting

'Bruegel delighted in observing the manners of the peasants in eating, drinking, dancing, jumping, making love, and engaging in various drolleries.'

(Karel van Mander, 1604)

accurate repetitions of his father's designs throughout his life (fig. 39) and trained Frans Snyders, Gonzales Coques (no. 51) and his son, Pieter III. Pieter I's younger son, Jan I (1568–1625; nos. 18–19), was said to have learned water-colour technique from his maternal grandmother; he was a friend and collaborator of Rubens, he worked on paintings with Hendrick van Steenwyck II (nos. 22–4), and he trained Daniel Seghers (nos. 39–40) as well as his son Jan II (1601–78). After Jan I's death, his daughter Anna was looked after by Rubens, who gave her away when, in 1637, she married David Teniers II (nos. 43–9). David II – who had of course studied with his father, David I (1582–1649) – took over guardianship of the other Brueghel children not yet of age and inherited the studio estate, including drawings by Pieter I and Jan I. In 1662 David Teniers acquired a country estate, Drij Toren, from the second husband of Rubens's widow, Helena Fourment.

The point of this tangled family tree is not just that members of the Bruegel dynasty were active at the heart of the Flemish art world throughout the seventeenth century, but that they were copying and creating works inspired by the example of the great Pieter the Elder. It is as if David Garrick (1717–79) had made his debut in the 1740s on a stage managed by someone called William Shakespeare III. The analogy is not entirely facetious: Pieter Bruegel, like Shakespeare, became a cult figure. The 'witty and gifted' Bruegel – who, according to van Mander, was born a peasant in an obscure village in Brabant and in later life liked to disguise himself as one in order to observe their ways – sounds rather like the stag-poaching Warwickshire lad whom Milton imagined 'warbling his native woodnotes wild'. There is another parallel: for hundreds of years dramas were composed throughout Europe, breaking every classical rule, merely by invoking the authority of Shakespeare. In the same way Bruegel's work came to define a genre of painting.

At one level a speciality is merely an area of limited and exceptional competence; at another it is a means by which artists may collectively invent and exploit new forms. Bruegel the Elder seems to be doing this with the *Massacre of the Innocents* (no. 14), a religious subject which grows out of his comic peasant crowd scenes, *Battle between Carnival and Lent* of 1559 and *Children's Games* of 1560 (both Kunsthistorisches Museum, Vienna), with a strong element of landscape painting thrown into the mix. Bruegel's distinctive hybrids were revered as a part of 'the lasting glory of the Netherlands' (van Mander's phrase) and thus became a breed of their own. There is a tradition of landscape and

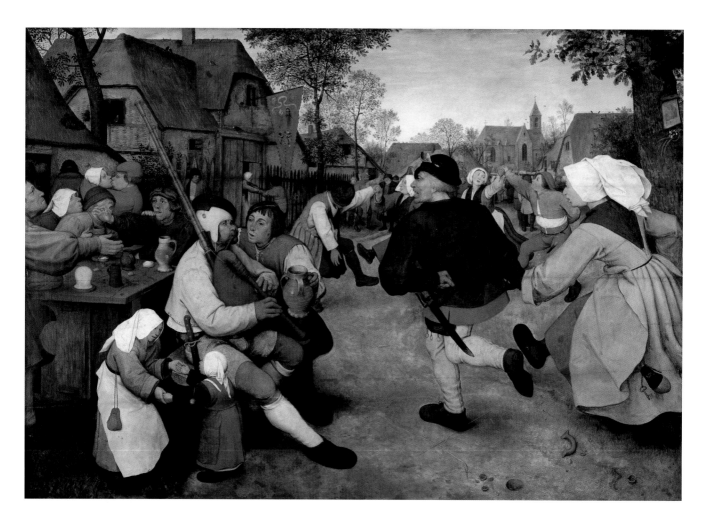

FIG. 11
Pieter Bruegel the Elder, *Peasant Dance, c.*1568;
oil on panel (Kunsthistorisches Museum, Vienna)

genre painting, surviving throughout the seventeenth century in the northern and southern Netherlands, which is consciously 'Bruegelian' – there are at least ten examples in this exhibition (nos. 18, 27–9 and 42–7). Bruegel's trademark is a figure type, a thick-limbed, heavy-booted peasant, looking as if made by stuffing coarse clothes with straw (see fig. 11). This cartoon character, as recognisable as the Michelin Man, inhabits the comic peasant scenes of Jan Brueghel (no. 18) and David Teniers (nos. 43–5, 47), as well as those of Adriaen Brouwer (1605/6–38) and Adriaen van Ostade (1610–85). The settings depicted in these works by Jan Brueghel and David Teniers also derive from particular Pieter I designs, even if straying far from the original source: the *Kermis* (fair) scene (nos. 18 and 47) originated in the *Peasant Dance* of *c.*1568 (fig. 11), while the subject of boorishness in a rustic interior (see nos. 44–5) seems to be a remote derivation of the *Peasant Wedding* also of 1568 (Kunsthistorisches Museum, Vienna). Rubens owned several paintings by Pieter Bruegel the Elder, including the Alpine *Flight into Egypt* (Courtauld Institute), and painted *Christ Giving the Keys to St Peter* for his tomb in the church of

Notre-Dame de la Chapelle in Brussels. His commissioned works (religious subjects, portraits, etc.) have little in common with Bruegel's, but when he turns to landscapes executed for his own pleasure, a Bruegelian flavour becomes almost 'part of the landscape', as if Rubens is depicting that 'obscure village in Brabant' where Nature 'selected the gifted and witty Pieter Brueghel to paint her and her peasants'. It is interesting that *Summer* (no. 29), which has the strongest echoes of a particular Bruegel design, the *Return of the Herd* (fig. 54) of 1565, takes an Alpine scene and brings it home to Flanders.

LANDSCAPE

Landscape was known as a Flemish speciality by the middle of the sixteenth century. Paolo Pino mentioned the northerners' gift for landscape in 1548, while van Mander remarked that 'the Italians always assume that we are as good in this [landscape] as they are in painting figures, though I hope that here, too, we shall steal a march on them'. As this passage implies, the Italians despised this branch of painting: Michelangelo's conversation with Vittoria Colonna is quoted in the *Dialogues* of Francisco de Hollanda (1548):

> they [Flemish artists] paint stuff and masonry, the green grass of
> the fields, the shadows of trees, and rivers and bridges, which they
> call 'landscapes', with many figures on this side and many figures
> on that. And all this, though it pleases some persons, is done without
> reason or art, without symmetry or proportion, without skilful
> choice or boldness and, finally, without substance or vigour.

For Michelangelo anything but the depiction of figures in art is vain employment, the painting of 'this and that'. Heemskerck's *Four Last Things* (no. 12) is a rare example of a Netherlandish artist trying to pare an image down to its essentials by reducing landscape to bare surfaces. It is probable that these attitudes softened during the sixteenth century: the way in which the intellectual collector Cardinal Federigo Borromeo (1564–1631) wrote of his friend Jan Brueghel suggests that landscape (along with genre and flower painting, Brueghel's other specialities) was more appreciated in 1590 than in 1540:

> even the most insignificant works of Jan Brueghel show how much
> grace and spirit there is in his art. One can admire at the same
> time its greatness and its delicacy. They have been executed with
> extreme strength and care, and these are special characteristics
> of an artist enjoying, as he does, a European reputation. So great
> will be the fame of this man one day, that my panegyric will
> prove to be less than he deserves.

Michelangelo held that landscape painting was inconsequential and unintellectual, 'without reason or art, without symmetry or proportion'; for Cardinal Borromeo it showed grace, spirit, strength and care. Borromeo might have found these qualities in Brueghel's brilliant touch, in his depiction of atmosphere and above all in his remarkably accurate observation of natural species. At the time that these lines were written other landscape painters were introducing symmetry and proportion by applying the laws of perspective to landscape. Giulio Mancini (1558–1639) wrote in 1617–21, 'With regard to that part of the landscape in which the story is set . . . there are rules of mathematics and perspective founded in the laws of vision for the mastery of this and for the regulation of lines and angles – rules to which the judgement ought to be referred and by which one's procedure should be guided.' The English writer Edward Norgate (1581–1650) repeats this advice: 'Let not your *Lanscape* rise high nor lift up in the aire, (a great fault in a great Master in Art *Albert Durer*) rather low, and under the command of the Eye, which is ever more gracefull and naturall.' Mancini felt that it was Annibale Carracci (1560–1609) who had invented this new type of landscape 'founded in the laws of vision'; he commended Paulus Bril (no. 17) for following his example and not making his 'horizon as high as the Flemish are accustomed to do', a habit which makes a typical landscape by a Flemish artist appear more like a 'scenic tabernacle' (*una maestà scenica*) – in other words an altarpiece with scenes one above another – than a 'perspectival view of the land' (*prospetto di paese*). A difference may be discerned between the work Bril executed before and after his exposure to the mature landscapes of Annibale in *c.*1604. His *Fantastic Landscape* of 1598 (fig. 12) is decorative in its design and 'piled up' against the frame; his late *Landscape with Goatherds* of *c.*1620 (no. 17) is soft, atmospheric and interested in spatial recession (though still following a similar compositional formula). Seen in the context of seventeenth-century Roman landscape, no. 17 is a stage on the way towards much more comprehensively perspectival landscapes by Cornelis van Poelenburgh in the 1620s (fig. 13); and yet it is as perspectival as any of the later Flemish landscapes in this exhibition.

The landscapes of Jan Brueghel

FIG. 12
Paulus Bril, *Fantastic Landscape*, 1598; oil on copper (National Gallery of Scotland, Edinburgh)

FIG. 12
Paulus Bril, *Fantastic Landscape*, 1598; oil on copper (National Gallery of Scotland, Edinburgh)

(nos. 18–19) and Rubens (nos. 27–9), and to a lesser extent those of Savery, Teniers and Wouters (nos. 20–21 and 42–3), are cast in a traditional unsystematic Flemish mould, which has not changed since the landscape by a follower of Cornelis Massys of *c.*1550 (no. 10). This is especially remarkable for an artist like Rubens who was so aware of the work of his contemporaries and had such an intellectual understanding of painting. Rubens wrote to his scholarly friend Peiresc in March 1636 about some engravings made after ancient Roman landscapes in the collection of the Barberini family; according to him the handling was admirable, 'but as far as optics are concerned, certain rules are not too accurately observed, for the lines of the buildings do not intersect at a point on a level with the horizon . . . in a word, the entire perspective is faulty'. This was written in the same year that Rubens was painting his *Château de Steen* (National Gallery, London), which has exactly the same old-fashioned perspectival system as the *Summer* (no. 29), though squeezed under a slightly lower horizon line.

How does the 'old Flemish' system of perspective work and what explains its survival? In a small way it can be seen in operation in Bruegel's *Massacre of the Innocents* (no. 14). The architecture throughout is entirely consistent with a viewpoint the height of the pub sign to the right; it is as if we are looking down from an upper window. The figures, on the other hand, are arranged as if seen from a much greater distance and height: we can see *over* the groups in the middle distance, while we seem to be looking down at roughly the same angle on the near and the distant groups. Karel van Mander twice refers to the effect in Bruegel's work that 'one can look into it from above'. Many of Bruegel's most extensive landscapes depict Alpine distances, so precipitous as to overwhelm any reasoned assessment of angles and viewpoints (see no. 18 for a survival of the same formula). However, most are consistent with this same principle: every feature, near or far, is looked down upon at the same angle, as if seen by a bird flying over the terrain, an effect tempered by painting distant objects much smaller than the near ones. The 'Flemish compromise' – same angle, different sizes – creates images of almost vertiginous excitement, a power that is all the more effective for being subliminal. In Bruegel's *Massacre* each group is seen from an ideal point of view,

neither subordinated to nor interrupted by any other group. It is like the battle-scenes of Shakespeare in which fighting pairs take the stage one after the other, allowing us to understand their particular interaction within the context of the overall *melée*. The same thing in landscape is less episodic – a farm or copse is not the same as a duel – but creates a similar effect of God-like powers to explore and interpret. Rubens's *Summer* (no. 29) is his first major essay in the so-called *Weltlandschaft* of Pieter Bruegel the Elder, in which he pays conscious tribute to this special compromise. According to Edward Norgate, a landscape (possibly no. 29) was 'indeed a rare peece, and done by the Life as him selfe [Rubens] told me *un poco aiutato* [a little helped]'. We apprehend the scene as an encyclopaedic catalogue of the life of an entire geographical region; we feel that we have a special, bird's-eye insight into every detail. All this supports Rubens's use of landscape as a celebration of peace, plenty and the fruits of a well-ordered and pious society. This is deliberately *una maestà scenica* – a huge, multi-episode landscape altarpiece – rather than *un prospetto di paese*. In 1625 Cardinal Federigo Borromeo wrote of his friend Jan Brueghel (nos. 18–19): 'It also appears that he even wished with his brush to travel over all of nature, because he painted … seas, mountains, grottoes, subterranean caves, and all these things, which are separated by immense distances, he confined to a small space.'

PORTRAITURE

The *Tribuna of the Uffizi* (fig. 14) of 1772 by Johann Zoffany (1733–1810) is a brilliant reworking of a familiar Flemish form, the 'Collector's Cabinet', and must have been inspired by Formentrou's *Cabinet of Pictures* (no. 50), a painting acquired by George III, as well as by Teniers's similar celebrations of the collection of the Archduke Leopold William (1614–62) in Brussels (fig. 65). Unlike Formentrou, Teniers and Zoffany depict princely collections including only the best examples of the most exalted type of painting. There are no landscapes and only a few portraits, in Zoffany's case entirely executed by northern artists – except for a glimpse of the portrait by Raphael (1483–1520) of Leo X with his nephews at the extreme right. The portrait of Galileo by Justus Sustermans (1597–1681), originally from Antwerp, hangs on the left wall; Holbein's *Sir Richard Southwell* low down on the centre wall; and Rubens's *Pupils of Justus Lipsius* high on the right wall. According to the assumptions of artistic theory, which would have been shared by Vasari, van Mander and Zoffany, portraiture is the only speciality fit to keep company with religious and mythological painting and it earns its place by depicting a great man, like Galileo, or by involving some expressive interaction, like the groups of Rubens and Raphael. Portraiture was regarded as a Flemish speciality, from which Rubens was anxious to disassociate himself when making his name in Italy: he complained in a letter of November 1603 that his employer, Vincenzo

Gonzaga, Duke of Mantua, was commissioning 'wretched portraits' (*vili de' ritratti*), a task unworthy of his talents. According to van Mander:

> Most artists are attracted by a sweet profit, and, as they have to support themselves, they take this by-path in art – the painting of portraits from life. Artists travel along this road without delight, in time to seek the main road – the painting of compositions with human figures, the road that leads towards the highest in art.

He goes on to justify and qualify this view: 'something very good can be made of a portrait; the face, the most lively part of the human body, has a great variety of interesting expressions, and an artist by translating one of these expressions may reveal the virtues and the expressive power of art'.

FIG. 14
Johann Zoffany, *The Tribuna of the Uffizi*, 1772; oil on canvas (Royal Collection, RCIN 406983)

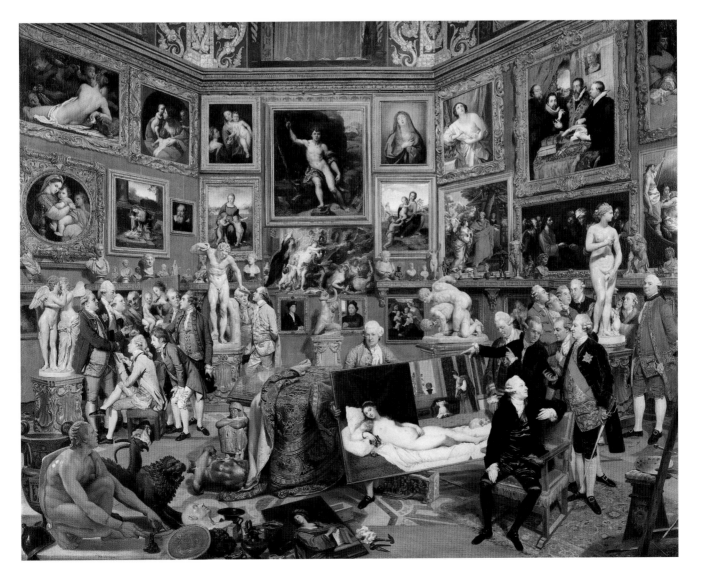

FIG. 15
Detail of no. 6

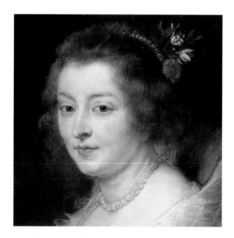

FIG. 16
Detail of no. 31

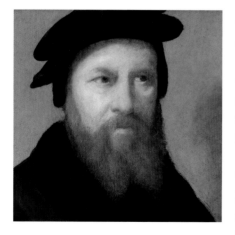

FIG. 17
Detail of no. 7

Turning to the selection of portraits in this exhibition, the first thing that strikes one is the presence of an element that does not seem to 'lead towards the highest in art', namely illusionism. The *Boy at a Window* (no. 9) was probably painted as a *trompe-l'oeil*, a work hung in such a way as to convince the unwary for a moment that it depicted reality. Half the skill in achieving this lies in the hanging, about which in this case we know nothing. But if, for example, this wooden panel were incorporated into a window shutter (like those seen to the left of no. 13) showing this image in the closed position, it is easy to see how convincingly the painted window would at the same time conceal and represent the real window. Roger de Piles (1635–1709) describes a similar trick using a window shutter, executed by no less an artist than Rembrandt (1606–69); the *Man at a Window* by Rembrandt's pupil Samuel van Hoogstraten (1627–78; fig. 32) gives some idea of what this lost work looked like. There are other accounts of such illusions painted *in situ*, like the 'optical illusion' of a 'view into a court' executed by Hans Vredeman de Vries and described by Karel van Mander.

This servant boy or jester (no. 9) must be considered as a most 'wretched portrait', but surprisingly similar tricks occur in images of scholars and princes. Quinten Massys runs a consistent space across his pair of portraits (no. 5 and fig. 29), as if the frames of the two pictures were window frames opening onto a single inner room. An abbreviated version of the same device occurs in Joos van Cleve's pair of portraits (nos. 7–8), where again the frames are granted a reality within the image and the power to cast a shadow. Gossaert's *Three Children of Christian II* (no. 6) plays the game of 'false assumptions': because the painted frame in the upper half of the image aligns with the real frame, we assume that it must be touching, something the lower half of the painting tells us cannot be. Elsewhere there are fictive ledges (no. 3), labels apparently stuck onto the picture surface (no. 11 and fig. 20), false inner frames (no. 10), and objects seeming to project from the front of the painting (no. 25). These games occur much less frequently in the seventeenth century; they are found in Dutch art of the period, but almost never in Flemish.

The 'expressive power' which for van Mander was the redeeming quality of portraiture is certainly in evidence in the sixteenth-century examples in this selection. Portraits throughout the entire history of Flemish art participated in religious paintings, as donors (often accompanied by their name saints) prayed from the wings of altarpieces towards the scene depicted in the central panel (see figs. 18, 27). The most significant painting of the Northern Renaissance in the Royal Collection is the altarpiece showing, in its closed position, Edward Bonkil, Provost of Holy Trinity Church in Edinburgh (fig. 18), kneeling to face an image of the Trinity. In its open position portraits of James III of Scotland and his Queen, Margaret of Denmark, are accompanied by Saints Andrew and George respectively. They probably faced a central panel (now lost) depicting

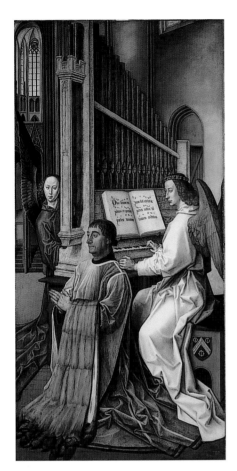

Hugo van der Goes, *The Trinity Panels: Edward Bonkil with Two Angels*, *c.*1478–9; oil on panel (Royal Collection, on loan to the National Gallery of Scotland, RCIN 403260)

the Virgin and Child. The interaction of Pieter Gillis and Desiderius Erasmus (no. 5) is an informal, and secular, derivation of this type of 'praying portrait'. Joos van Cleve and his wife (nos. 7–8) similarly participate in a scene of family worship, though no saint is present; he explains some matter of faith, she listens patiently while holding her rosary. Gestures in several other portraits of the period (nos. 2, 3, 4, 6 and 9) seem to imply interaction with the viewer or to reveal the sitter's state of mind or heart.

It is clear that Rubens and Van Dyck are capable of using a similar language of gestures: an expressive portrait symposium by Rubens occurs on the walls of Zoffany's *Tribuna* (fig. 14), Zeger van Hontsum in Van Dyck's portrait (no. 36) holds his prayer book in such a way as to keep his place, Margaret Lemon (no. 37) greets her lover with her hand on her heart. Both these artists however are following van Mander's advice in using the face, 'the most lively part of the human body', as the principal means of demonstrating the 'expressive power of art'. One of the distinctive features of Flemish fifteenth- and sixteenth-century portraiture is the way in which the features tend to be exaggerated at the expense of the overall structure of the cranium and the way in which, when the head turns, we see more of the far eye than we would in reality. Gossaert's *Three Children of Christian II* (no. 6 and fig. 15) illustrates both these effects to an exaggerated degree, as the artist seems deliberately to be suggesting that these children will 'grow into their features'. One might have expected this oddity to be eliminated from the work of artists, like Rubens and Van Dyck, who have made an exhaustive study of antique busts. Yet Rubens's *Portrait of a Woman* (no. 31 and fig. 16) is as flagrant an example of Flemish compromised perspective as his *Summer* (no. 29). The image seems to combine a range of points of view lying between profile and frontal, as if the artist is recording the experience of walking up to the sitter, who turns to greet him. Something similar occurs in Rubens's other two portraits and possibly even in Van Dyck's. Very occasionally these optical inconsistencies disturb, as in Rubens's profile portrait of Van Dyck (no. 32). When they are carried off with Rubens's characteristic serpentine drawing of the features, as in nos. 30 and 31, they merely contribute to the effect of animation and engagement.

Portraiture also provides the best opportunity to appreciate the continuity within the technique of Flemish painting. Flemish painters were acknowledged to be consummate technicians (and colourists) by the Italians in the Renaissance and by subsequent generations of artists throughout Europe. Typically a Flemish painting is executed on wood panel, sealed and prepared with a layer of rabbit-skin glue mixed with chalk, creating a smooth, white surface like super-fine plaster. This is then covered with a thin 'priming' layer of paint, usually a light buff colour. The same smooth surface can be applied so as to soften the weave of a canvas, especially if it is a fine one. Karel van Mander writes of the technique employed by Hieronymus Bosch (*c.*1450–1516): 'he made his

drawing of subjects on the white ground of his panel, over which he painted a transparent layer in a colour, or in a shade, more or less like flesh. Frequently he used the ground for part of the final effect of the painting.' This priming can be seen reflected in the predominantly light tone of many Flemish paintings – including works by Heemskerck, De Vries, Pieter Bruegel and Jan Brueghel, Steenwyck, Frans Francken, Rubens and Teniers (nos. 12–14, 18, 23, 25, 26 and 43).

The priming colour is often patterned – streaked on with a coarse brush or seemingly dabbed with a sponge – as if to re-create the effect of the grain of the wood which the gesso concealed. It is often possible to see this priming through the subsequent layers (as van Mander mentioned). Damage to the paint surface has made the mottled brown pattern in the priming more visible in the shadows of Joos van Cleve's *Self Portrait* (no. 7 and fig. 17) than the artist intended, but it must always have played an important part in the image. Rubens's grounds, with their distinctive streaky brown pattern, can best be seen in the sketchiest of his oil sketches (fig. 56). However, similar passages can be seen in the shadows of Rubens's finished paintings (see especially nos. 31–2). The paint layers applied over this priming are often thin and oiled down, using transparent colours. These transparent layers (called glazes) reinforce or modify (rather than conceal) the colour underneath; many may be required to create the image, obviously to some extent in combination with more thickly applied, viscous and opaque passages. The Italian theorist Giovanni Paolo Lomazzo wrote in 1584 of Flemish artists' use of transparent colours, like stained glass, creating a 'shining of pictures . . . so much esteemed in this age that no picture will please the vulgar eye without it'.

The opposite extreme technically can be seen in two Italianate works: Crispin van den Broeck's *Christ Healing the Sick* (no. 15 and detail p. 92) and Karl Spierincks's *Venus with Satyrs and Cupids* (no. 41 and fig. 19). Both of these are painted on a coarse weave of canvas covered with a dark red-brown priming, with a single layer of dry paint applied very thickly. Softness is achieved by the 'furry' contours, which occur when dry paint is dragged over coarse cloth (imagine drawing on sacking with chalk).

Rubens and Van Dyck both admired Titian, who pioneered the technique described above. Both artists employ Titian's thick impasto, with its tactile and sensuous texture; both also preserve the trace of the loaded brush as part of the descriptive and expressive pattern of the surface. Gian Pietro Bellori (1615–90) especially admired Rubens's 'quickness and fury of the brush' (*prontezza e furia dell pennello*). Rubens's *Winter* (no. 28) is painted on coarse canvas with a dark red-brown priming, which shows through in many places, and light touches added in thick 'porous' dry strokes. Elsewhere Rubens grafts these painterly flourishes onto the smooth, glossy, luminous and multi-layered transparency of Flemish technique. His *Assumption* (no. 26), like all

FIG. 19
Detail of no. 41

FIG. 20
Marten van Heemskerck, *Portrait of the Artist with the Colosseum in the Background*, 1553; oil on panel (Fitzwilliam Museum, Cambridge)

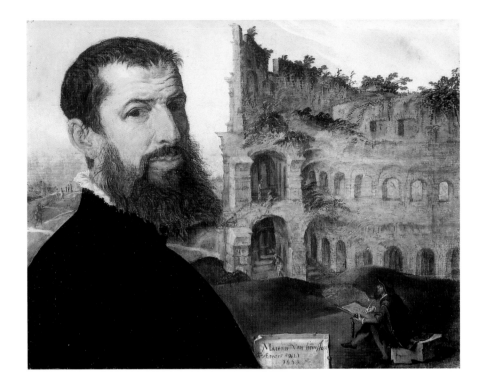

his oil sketches, provides an excellent example of the underpaint showing through, while layers of paint reinforcing each other produce the extraordinary luminosity in the blues. Rubens was later much admired for not overmixing or 'tormenting' his colours: Roger de Piles remarks that his colours are so strong and so separate that they seem like 'blotches' (*taches*) and that his use of strong reflected light in the shadows (seen on the necks and under the chins of his portraits here, nos. 30–32) makes his forms seem diaphanous and transparent, almost like glass.

UNA BUONA MANIERA ITALIANA

Zoffany's *Tribuna* (fig. 14) expresses the commonly held view that the great tradition of art passed from Greek and Roman statues to the religious and mythological paintings of the Italian Renaissance. The dominance of Italian art here is not surprising in a Florentine collection, except that a similar selection of Italian masters is celebrated in the collection of the Archduke Leopold William in Brussels, as depicted by David Teniers (fig. 65). It is all the more impressive therefore that Rubens's allegorical painting *The Effects of War* (Pitti Palace, Florence) is given pride of place in this imaginary hang of the Tribuna, in addition to his group portrait, the *Pupils of Justus Lipsius* (mentioned above). Rubens went to Italy in 1600, studied the antique and the Italian Renaissance, struggled to make his name as a figure painter (not just a portraitist), and on

29 July 1607 was able to boast that he had won the commission to paint the high altar of the mother church of the order founded by St Philip Neri, the Chiesa Nuova, 'against the pretensions of all the leading painters of Rome'. The Oratorians, Philip Neri's followers, chose Rubens in part because they believed him to be a 'Fleming but from childhood a pupil in Rome'. In the 1640s Rubens's first biographer, Giovanni Baglione, commented that he had 'a good Italian manner' (*una buona maniera Italiana*).

Rubens was not the first Flemish artist to visit Rome: an astonishing proportion of those represented here made the journey. Gossaert (no. 6) was there from 1508 to 1509; Marten van Heemskerck from 1532 to 1536, a visit which inspired his remarkable self portrait set against the background of the Colosseum (fig. 20); Pieter Bruegel went to Italy in 1552–4, even visiting Sicily, though he seems to have been more struck by the Alps (which, according to van Mander, he 'swallowed whole') than the artistic heritage. Dionys Calvaert and Paulus Bril (nos. 16–17) made their careers in Italy; Jan Brueghel (nos. 18–19) spent the years from 1592 to 1595 there, working for Cardinal Federigo Borromeo; Rubens and Van Dyck both spent crucial years studying in Italy and building an Italian reputation, Rubens from 1600 to 1607 and Van Dyck from 1621 to 1627. Karl Spierincks spent his brief career in Rome from 1624 to 1639, as part of the important artistic circle of Poussin and Duquesnoy. Daniel Seghers (nos. 39–40) studied as a Jesuit in Rome during the years 1625 to 1627, while also working as a painter. A survey of all Flemish painters of the period would reveal the same proportion of 'Romanists', as artists who had visited Rome called themselves when, after they returned, they formed into societies in all the major artistic centres of the Netherlands. In van Mander's words, Rome was 'the capital of Pictura's schools'.

The artistic 'gap year' was not necessarily spent in high-minded study; Rome was also a place of idleness and dissipation for young artists. In the years around 1620 Netherlandish artists in Rome formed themselves into an informal society called the 'Bentvueghels' or 'Birds of a Feather'. This group devised pagan initiation rites at which new members were baptised with a 'Bentvueghel' nick-name. An anonymous drawing, possibly for a book of members (fig. 21), shows a group of them (annotated with names and aliases) approaching with due reverence a figure of the wine god Bacchus seated on a barrel. They met in taverns and refused to

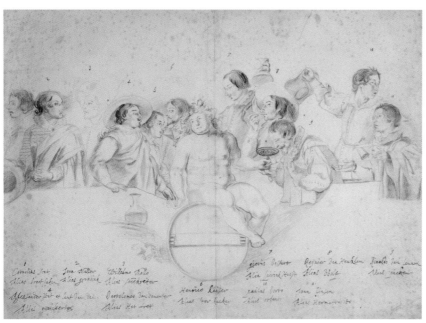

FIG. 21
Anonymous (Netherlandish), *The Bentvueghels around Bacchus*, seventeenth century (Museum Boijmans van Beuningen, Rotterdam)

'Rome has always attracted painters. It is a city that seems to exist for artists.'

(Karel van Mander, 1604)

pay their dues to the Roman academy of St Luke, but also presumably found a market for their work amongst Italians and visitors to the city. Generally, members of the 'Band of Painters' (*Schildersbent*), as it was also called, executed landscapes and scenes of Roman low-life. Paulus Bril seems to have been too old to join, but paintings like his *Landscape with Goatherds* (no. 17) certainly influenced the works of those who did, like 'Satyr' (*Satir*) and 'The Ferret' (*Het Fret*), otherwise known as Cornelis van Poelenburgh (1594–1667; fig. 13), and Bartholomeus Breenbergh (1598–1657) both Dutch artists. It is perhaps not surprising that the Italians execrated the scenes of squalor produced by these artists, who according to one theorist had dragged Painting – a queen – to live in taverns, brothels and pigsties.

It seems that Rome had always encouraged dissipation among groups of young northern artists gathered there. On the other hand there were always artists who kept themselves aloof. According to van Mander, Marten van Heemskerck used his time there well and did not 'go to banquets with the Netherlanders'; Van Dyck shunned the Bentvueghels, thereby earning himself the nick-name 'the Painter Knight' (*il pittore cavalieresco*).

It is not surprising that the three diligent Roman students so far mentioned – Heemskerck, Rubens and Van Dyck – were not there to paint the picturesque ambience of Rome (ruin-filled landscapes or sunny street scenes) but to study figure painting. There had been an exchange of influence between the Low Countries and Italy from the earliest Renaissance period, with many examples of Flemish types inspiring Italian artists, rather than vice versa; Memling's portraits, for example, were especially admired (no. 4). The achievement of the High Renaissance in Rome – the work of Michelangelo and Raphael, not to mention the discovery of masterpieces of classical sculpture, like the Laocoön – seems to have tipped the balance for a generation of Flemish artists. They visited Rome as if to consult an oracle. We know a great deal about the lives and the views of this group of artists because Karel van Mander, our principal source for Flemish art of the period, visited Rome from 1573 to 1577 and was completely absorbed in the Italian theoretical mind-set. He exhorts young artists studying in Rome: 'Be alert, my young friends, take courage, even though there will be many disappointments, apply yourself, so that we can achieve our goal – namely, that they can no more say (as is their custom): The Flemings cannot paint figures.' He also cites several artists who have done this, like Jan van Calcker and Frans Floris; or Jan van Scorel who brought back from Italy 'the new, extraordinary method of painting'; or Francesco Badens, 'the

first artist in Amsterdam to introduce the beautiful modern method of painting', for which reason younger artists called him 'the Italian Painter'.

What van Mander means by the new, extraordinary, beautiful, modern method of painting is illustrated by Heemskerck's *Four Last Things* (no. 12), a work stripped of everything except sculptural essentials: anatomy, drapery and those symbolic attributes needed to expound the meaning. There is a reason for this selectivity: man is created in God's image and therefore the human body contains the only beauty that matters. This beauty can be disfigured by Death and Sin; it can be transfigured by Redemption; either way the study of the artist – to achieve ideal human forms – is part of the spiritual message. Heemskerck's painting therefore does not just resemble that of Michelangelo; it also follows the exalted tenets of his artistic theory. Sir Joshua Reynolds (1723–92) remarked that Bruegel's *Massacre of the Innocents* contained a great deal of 'thinking', but for Bruegel's contemporaries a 'thinking' painting looked like the *Four Last Things*. The view is expressed most clearly in the commentary to Dominicus Lampsonius's series of prints after portraits of artists (*Pictorum Aliquot Celebrium Germaniae Inferioris Effigies*) of 1572: 'The Italian has his intelligence in his head. It is not an idle statement to say that the Netherlander has his wit in his hand.' Similarly for van Mander, the 'art of painting is born first of the spirit, of the mind, and of the imagination, before its new life can be expressed by the hand'. If your 'wit is in your hand' you will paint accurate (but unselective and copious) imitations of nature; if your art is 'born of the spirit' you will seek the only divine species of beauty – the idealised human form. This latter task is accomplished by studying classical antiquity, by creating uncluttered, sculptural, anatomical drawings (like the ones visible in Francken's intellectual still life, no. 25) and by preserving their grave and graceful character in the appearance of the finished painting. Van Dyck's *Christ Healing the Paralytic* (no. 34), a painting executed in Rubens's studio, possibly following his designs, is the best example from the seventeenth century of what this should look like in practice. An artist who can do this is achieving something more than the imitation of a national style; as well as referring to his 'good Italian manner', Giovanni Baglione called Rubens a 'universal painter' (*Pittore universale*).

The fortunes of those Flemings dedicated to 'universal painting' changed considerably during the course of the sixteenth century. With more artists driven from the Low Countries by wars (after 1568) and the relative decline of Italian art at the same time, we find a generation of Flemings competing with Italians on their own ground. Giovanni Bologna (Jean de Boulogne, 1529–1608) is the most important Italian sculptor of his generation; Jacopo Stadanus was one of the most successful painters working for the Medici in Florence; Dionys Calvaert (no. 16) taught a generation of Italian artists in his studio in Bologna. A century later, after the revival of Italian painting by the Carracci, Flemish artists were still an acknowledged part of the great tradition. Giovanni Pietro

FIG. 22
Interior of Inigo Jones's Banqueting House, Whitehall, with ceiling painted by Peter Paul Rubens showing *The Apotheosis of James I*, 1635

Bellori published his 'Lives of Modern Painters, Sculptors and Architects' (*Le Vite de' pittori, scultori et architetti moderni*) in 1672 not to assemble anecdotes but to demonstrate the highest principles of art through the example of an elite of twelve artists, one might almost say 'apostles of art'. Eight Italians were joined by a Frenchman, Nicolas Poussin (friend of Spierincks), and three Flemings: Rubens, Van Dyck and the sculptor François Duquesnoy (1597–1643; also a member of the Poussin circle).

This account of Italian artistic theory serves to introduce the reasoning behind the handful of works in the exhibition executed in this universal manner: Heemskerck's *Four Last Things* (no. 12), Crispin van den Broeck's *Christ Healing the Sick* (no. 15), the Assumptions of Dionys Calvaert and Rubens (nos. 16 and 26), the three religious paintings of Van Dyck (nos. 34–5 and 38), and Karl Spierincks's *Venus with Satyrs and Cupids* (no. 41). It also acts as a reminder that, for practical reasons, the selection here is vastly untypical of Rubens's career in general as it neglects his altarpieces and decorative schemes, including the Whitehall ceiling for Charles I (fig. 22), executed in his universal manner. Similarly the selection of portraits by Van Dyck under-represents his large-scale public images of monarchy (see fig. 9), where he demonstrates that 'nobility of head and grace of action' (*alle teste una certa nobiltà, e gratia nell' atto*) admired by Bellori, qualities that bring portraiture closest to universal painting.

There is another twist in the story of artistic theory. During the years 1500–1750, art became more academic: Italian artistic theory was translated into every European language, the power of the guilds declined and academies were formed, like the one David Teniers founded in Antwerp in 1664. But these academies could not be as selective in their membership as Bellori's lives. The two founder members of the Antwerp academy represented in this exhibition – David Teniers and Gonzales Coques – are excellent specialists, not 'universal painters'. Artists like these and their admirers might have welcomed the status and training conferred by an academy, but this did not mean that they were able or wanted to paint like Raphael. It is perhaps for this reason that around 1700 there arose a vein of counteracademic theory, the most famous proponents of which were the 'Rubenists', who did battle with the 'Poussinists' at the French Academy. As this name suggests, the hero of these academic

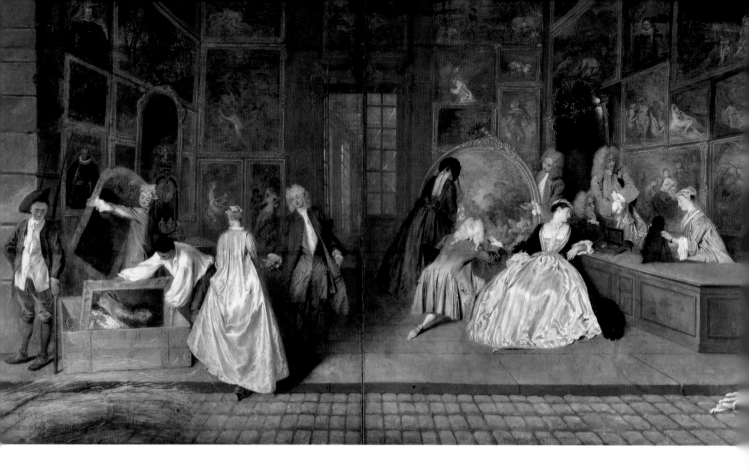

FIG. 23
Jean-Antoine Watteau, *L'enseigne de Gersaint*,
1720; oil on canvas (Schloss Charlottenburg,
Berlin)

liberators was Rubens, whose work (even his heroic figure paintings) demonstrated a vividness of reality, a painterly sensuality and a richness of colour absent from the works of Nicolas Poussin. Roger de Piles in his famous painters' score-card (*Balances des peintres*) of 1708 sets Rubens head to head with Raphael through four rounds, each worth twenty points: in *Composition* Rubens scores 18 to Raphael's 17, scores which are reversed in *Expression* – Raphael 18 and Rubens 17; in *Drawing* Raphael is the clear leader with 18, against Rubens's 13; but in *Colour* Raphael scores a disastrous 12, which means that Rubens's 17 brings the points level. It may be the absurdity of the contest that strikes us; contemporaries would have gasped at the thought that any artist could match Raphael.

Rubens appealed to the academics of the eighteenth century because of the variety of genres in which he excels – portraiture and landscape, as well as history painting. This made him a 'universal painter' in a different way. The French Romantic painter Eugène Delacroix (1798–1863) called him 'that Homer of painting, the father of warmth and enthusiasm in art, where he puts all others in the shade, not perhaps because of his perfection in any one direction, but because of that hidden force – that life and spirit – which he put into everything he did'. Eighteenth-century taste had decided views about the other painters in this exhibition. The artists of the sixteenth century were generally despised: Reynolds found that Pieter Bruegel the Elder was 'totally ignorant of

all the mechanical art of making a picture' and in his final *Discourse* of 1790 dismissed the 'Romanist' generation of Marten van Heemskerck:

> Many of the Flemish painters, who studied at Rome, in that great era of our art, such as Francis Floris, Hemskerk, Michael Coxis, Jerom Cock, and others, returned to their own country, with as much of this grandeur as they could carry. But like seeds falling on a soil not prepared or adapted to their nature, the manner of Michael Angelo thrived but little with them; perhaps, however, they contributed to prepare the way for that free, unconstrained, and liberal outline, which was afterwards introduced by Rubens, through the medium of the Venetian Painters.

It is not surprising that almost all of the sixteenth-century paintings in this exhibition reached England either at the time that they were painted – as presumably in the case of the portraits in Henry VIII's collection (nos. 1–3 and 6) – or were acquired during the seventeenth century by generations of Stuarts: Henry, Prince of Wales (no. 9), Charles I (nos. 5, 7–8 and 10), Charles II (nos. 11–12 and 14–15) and Queen Anne (no. 4). A full account of the formation of the Flemish works in the Royal Collection may be found in Campbell (1985) and White (forthcoming). It was not just Rubens that appealed to Reynolds; it was Rubens's contemporaries as well. A generation of Flemish painters, working during the seventeenth century, including every kind of specialist, began to be appreciated around 1700 by artists, theorists and collectors. This attitude profoundly affected the formation of the Royal Collection: a very high proportion of seventeenth-century specialist paintings were acquired during the eighteenth and early nineteenth centuries, by Frederick, Prince of Wales (as in the case of nos. 18–19, 24, 28–9, 45 and 48–9), George III (nos. 25, 36 and 50) and, above all, that great collector of Dutch painting, George IV (who acquired nos. 26–7, 31, 34–5, 43–4, 46–7 and 51).

In 1717 the Franco-Flemish painter Antoine Watteau (1684–1721) submitted a reception piece to the French Academy, the *L'Embarquement de Cythère* (Louvre), which was accepted not as a history painting but as a *fête galante*, an altogether new species of subject. Watteau's painting is a homage to Rubens and Flemish landscape, and the decision of the French Academy an acknowledgement that such works defy categorisation. The huge shop sign Watteau painted for his friend Gersaint in 1720–21 (fig. 23) is a conscious tribute to and brilliant reinvention of the cabinet scene (see no. 50 and figs. 10 and 65), that most distinctive Flemish speciality. Fifty years later a German member of the English Academy, Johann Zoffany, created in the *Tribuna* (fig. 14) another variation on the same theme; the quality and contrasting character of these two seminal works (figs. 14 and 23) is a testament to the vitality of the Flemish tradition within eighteenth-century painting throughout Europe.

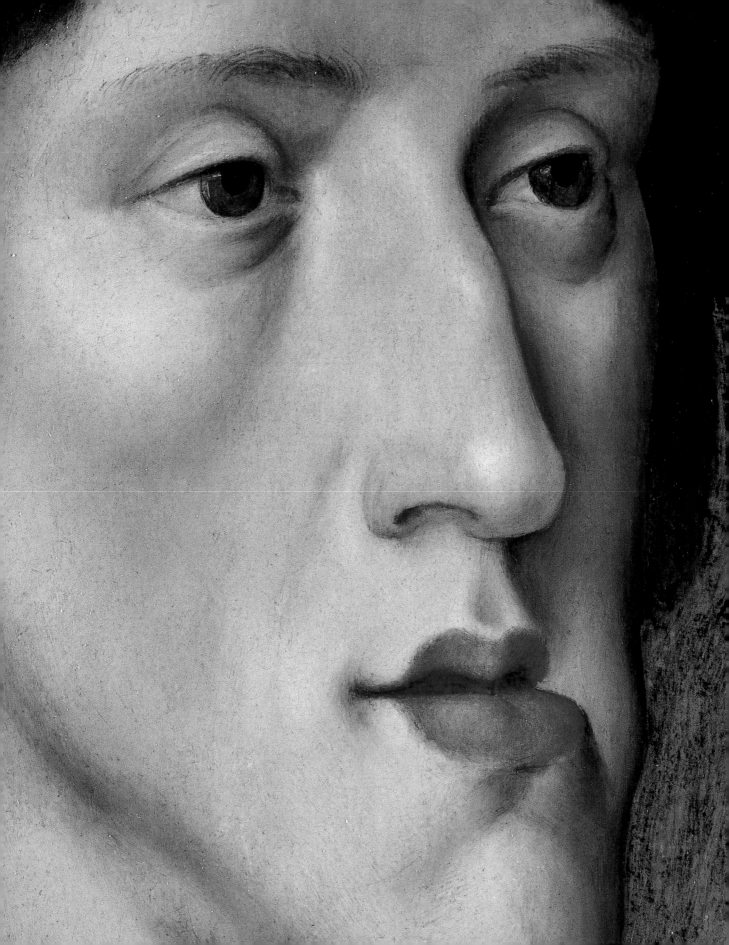

I

THE INHERITANCE OF CHARLES V

1500~1555

I THE INHERITANCE OF CHARLES V
1500~1555

A convenient starting point for the story of the Low Countries during the Renaissance is 1384, when Philip the Bold, Duke of Burgundy, inherited, through his wife Margaret, the counties of Flanders and Artois and the cities of Antwerp and Mechelen (see fig. 24). In 1390 Philip acquired the duchies of Brabant and Limburg. Philip the Bold's grandson, Philip the Good (no. 1), Duke of Burgundy from 1419 to 1467, consolidated his power in the Low Countries by buying the county of Namur in 1421 and the duchy of Luxemburg in 1443; in 1433 he annexed the counties of Hainault, Holland and Zeeland. Philip prohibited the import of English cloth and founded the Order of the Golden Fleece in Bruges in 1430 (see fig. 25). His son, Charles the Bold, married Margaret of York, Edward IV's sister, in 1468. His attempt to expand the southern part of his empire by occupying Lorraine ended in catastrophe; he was defeated and killed in 1477 in Nancy, which allowed the French King to seize the duchy of Burgundy. The northern possessions of Charles the Bold were inherited by his daughter, Mary of Burgundy (1457–82), who was instantly compelled on 10 February 1477 to sign the

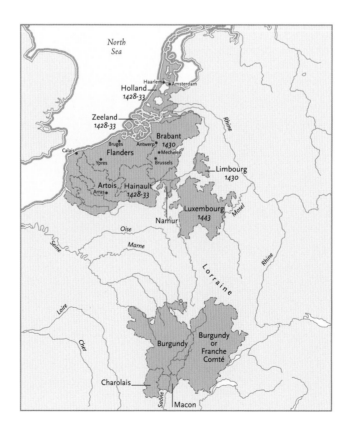

FIG. 24
The Burgundian Empire in 1477 with the dates
of acquisition of the Netherlandish Provinces

Manuscript illumination in Martin Le Franc's *Champion des Dames* (ms. Fr. 12476, f° 1v°), 1451 (Bibliothèque Nationale de France, Paris)

The author is shown presenting the book to Philip the Good. The Duke is surrounded by the arms of his Burgundian and Netherlandish possessions, while two scenes allude to the biblical and mythological origins of the idea of the Golden Fleece: on the left the story of Gideon's Fleece (Judges 6: 36–40) and on the right the story of Jason and Medea

'Great Privilege', restoring to the provinces of Flanders, Brabant, Hainault and Holland the ancient rights which Charles had sought to rescind. In the same year Mary married Maximilian of Austria, thus initiating three hundred years of Habsburg rule. When Maximilian succeeded his father as Holy Roman Emperor in 1493, he ceded his Flemish lands to his son, Philip the Handsome (no. 2). In 1496 Philip married Joanna of Castile, daughter of Ferdinand of Aragon and Isabella of Castile and elder sister of Catherine of Aragon (known

PIVS·VLTRA

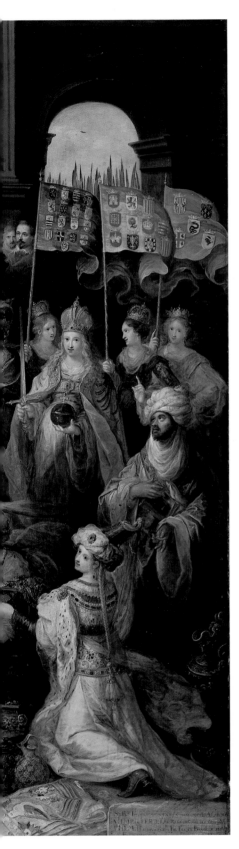

as Joanna the Mad for her erratic and violent behaviour; see fig. 27), and became King Philip I of Castile from 1504 until his death in 1506 (at this stage his father-in-law Ferdinand was still King of Aragon).

Charles V (1500–1558; no. 3) was the son of Philip the Handsome and Joanna the Mad. He inherited most of Europe. The Low Countries came to him when he was 6 upon his father's death, though his aunt, Margaret of Austria (fig. 28), ruled as regent until he was declared of age by the Estates General in 1515. It was at this ceremony that he stood in the great hall of the ducal palace in Brussels and said: 'Be good and loyal subjects and I shall be a good prince to you.' In 1516 Charles's maternal grandfather, Ferdinand of Aragon, died, leaving him the Spanish crown (Castile and Aragon having been united by the marriage of Ferdinand and Isabella); in 1519 Charles's paternal grandfather, Maximilian I, died, leaving him the title of Holy Roman Emperor.

In 1548 Charles persuaded the Diet of the Holy Roman Empire at Augsburg to recognise his domains in the Low Countries as a unit only loosely contained within the empire, a decision which was ratified in the following year by each of the seventeen provinces. This so-called 'Pragmatic Sanction' created the United Provinces of the Netherlands as a single, distinct entity.

On 25 October 1555, in the ducal palace in Brussels, in the presence of the Estates General, representing each of the seventeen provinces, Charles V abdicated. He relinquished the title of emperor to his brother, Ferdinand I, and bequeathed Spain and the United Provinces to his son, Philip II. An allegorical representation of this moment (fig. 26) shows Charles enthroned with the insignia of office laid out on a cushion at his feet and his two heirs approaching, Ferdinand from the left and Philip from the right. A group of crowned women to the right represent the principalities in his gift: behind the Empire come, from left to right, the Netherlands (the arms of the seventeen provinces on her banner); Spain and Italy (both also with banners bearing provincial heraldic emblems). Across the foreground the continents and oceans of the world pay tribute to their universal ruler. The Pillars of Hercules with the words 'Plus Ultra' ('yet further') was a personal device of the Emperor's, here referring to his American colonies. A small coach in the background takes Charles to his retirement in a villa adjoining the remote Spanish monastery of San Jeronimo of Yuste, where he died three years later.

FIG. 26
Frans Francken II, *Allegory on the Abdication of Charles V*, c.1620; oil on panel (Rijksmuseum, Amsterdam)

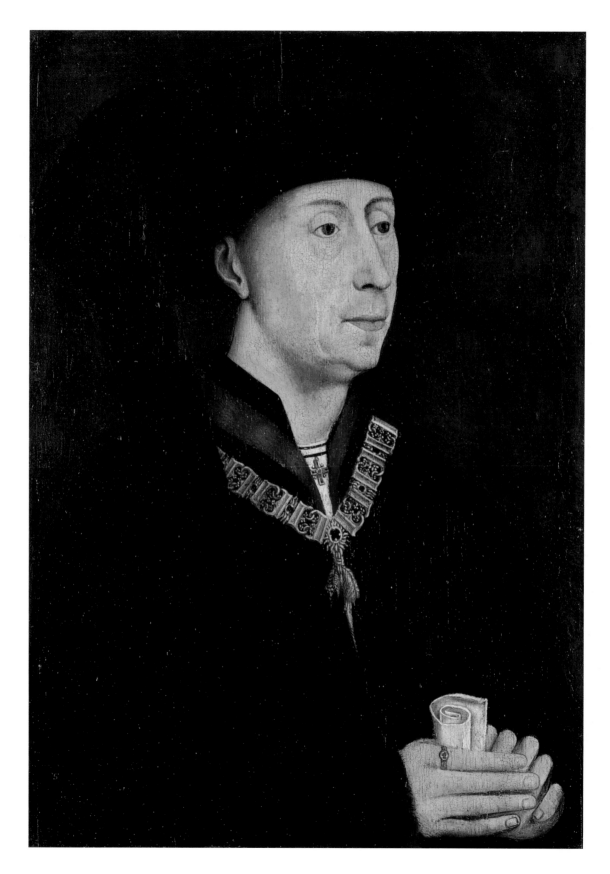

Philip the Good ruled the duchy of Burgundy from 1419 to 1467. An active patron of the arts, he had strong links with Henry VI's court in England though he preferred to concentrate on the expansion of his own land rather than becoming embroiled in the Hundred Years War.

He is shown here wearing the collar of the Order of the Golden Fleece, which he established on 10 January 1430 in emulation of the English Order of the Garter; he had been invited to become a Garter Knight but declined for fear of offending the French King Charles VII. The symbol of the Order refers to both the Old Testament account of Gideon's Fleece and the legend of Jason and the Golden Fleece from Greek mythology (see fig. 25). The chivalric overtones of the Jason story clearly appealed to the Duke, who had the legend illustrated for him numerous times.

This portrait conforms to a standard type of image of Philip the Good created by various artists to satisfy popular demand. There is no existing painted prototype and it is possible that one never existed. Instead, the numerous versions may derive from an original drawing or 'pattern' by Rogier van der Weyden, who is known to have worked for the Burgundian court.

No. 1, therefore, was probably painted by a member of Rogier van der Weyden's large workshop and is an idealised image of the ruler. Comparisons with other versions, such as that in Bruges Musée Communal, highlight the pattern-book nature of the image. Philip is depicted in three-quarter profile, wearing a black *chaperon* (a hood or hat), with a scroll prominently held in his hands. The gesture of his hands is striking: his right is outstretched as though in prayer, whereas his left is foreshortened, thereby demonstrating the artist's grasp of perspective. The age of the sitter – around 50 – combined with the style of his clothing indicates a date around the mid-1440s.

AFTER ROGIER VAN DER WEYDEN
(*c*.1399–1464)
Philip the Good, Duke of Burgundy (1396–1467)
Oil on panel
31.9 x 21.6 cm
c.1445
RCIN 403440
First recorded in the collection of Henry VIII at Whitehall in 1542
Campbell, no. 76

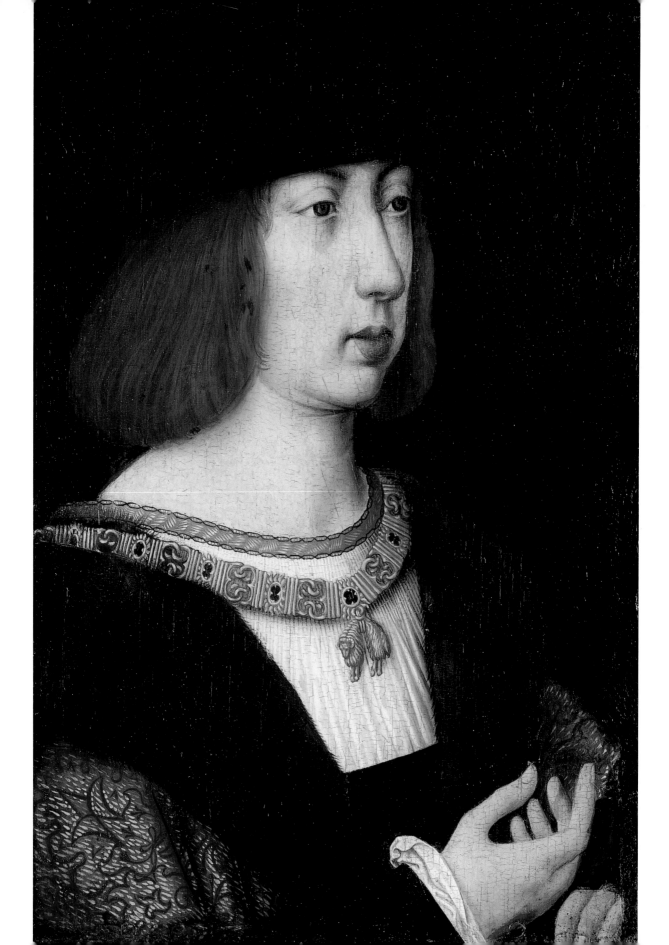

Philip the Handsome was so called because of his fair hair and attractive grey-blue eyes. He was the only surviving son of the Holy Roman Emperor Maximilian I and Mary of Burgundy (daughter of Charles the Bold of Burgundy and granddaughter of Philip the Good). On the death of his mother in 1482 he took over the inheritance of the Netherlands, with his father acting as regent until Philip came of age. In 1496 he married Joanna of Castile (known as Joanna the Mad; see pp. 47–9) and briefly enjoyed the title of King Philip I of Castile.

The painting is considered one of the best contemporary versions of the much-repeated design. The original may have been intended to face a companion portrait of Joanna. No. 2 lacks the immediacy of an image painted from life and is unlikely to be a faithful representation of the sitter's features. His black cap is worn low, pulled down over his forehead. In other versions, such as that attributed to the Master of the Legend of the Magdalene, the cap is adorned with a brooch depicting the Coronation of the Virgin. The Royal Collection version has no brooch. Philip is shown wearing a velvet cloth of gold lined with brown fur. Around his neck over a white tunic he wears the collar of the Order of the Golden Fleece.

This portrait may be dated to *c*.1500 by the age of the sitter (who would have been 22 at the time) and by comparison with other portraits, such as the two wings of the altarpiece showing Philip and Joanna in *c*.1505 in the Royal Museum of Fine Arts, Brussels (fig. 27).

ANONYMOUS
Philip the Handsome (1478–1506)
Oil on panel
32.1 x 20.3 cm
c.1500
RCIN 403438
First recorded in the collection of Henry VIII at Whitehall in 1542
Campbell, no. 80

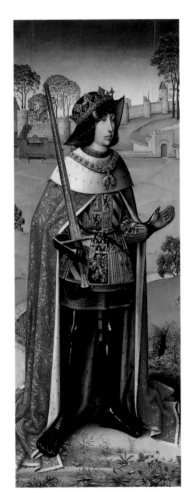 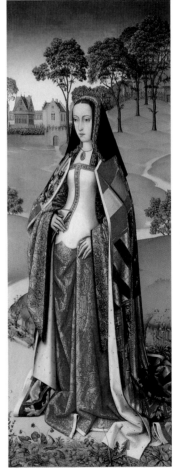

FIG. 27
South Netherlandish School, *Portrait of Philip the Handsome* and *Portrait of Joanna the Mad*, *c*.1505; oil on panel (Royal Museum of Fine Arts of Belgium, Brussels)

These are the outer wings of a triptych; the central panel (not shown here) depicts *The Last Judgement*

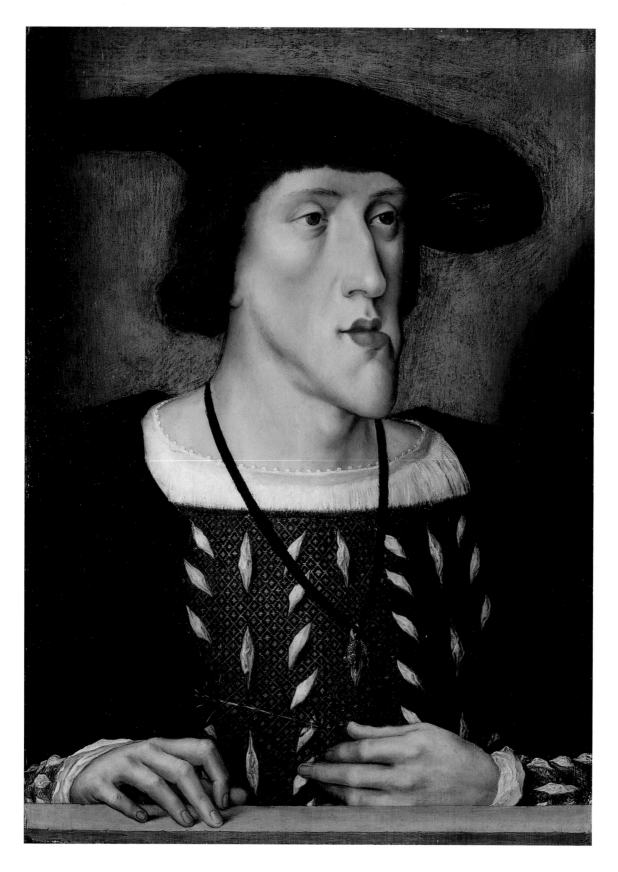

The son of Philip the Handsome (no. 2) and Joanna the Mad (fig. 27), Charles V was born in Ghent and raised in Mechelen (Malines) by his aunt, Margaret of Austria (fig. 28). At the age of 6 he succeeded his father as ruler of the Low Countries, although Margaret acted as regent until 1515. He succeeded his maternal grandfather in 1516 as King of Spain and in 1519 became Holy Roman Emperor on the death of his paternal grandfather, Maximilian I. He was identifiable by his dramatically undershot lower jaw, known as the 'Habsburg lip'. This unsightly quality serves only to make the physical impression of this ruler more powerful – the combination of the strong jaw and steady gaze of the Emperor render this a commanding image.

Like Philip the Good and Philip the Handsome, Charles V is depicted wearing the symbol of the Order of the Golden Fleece, in this instance hanging simply from a black ribbon around his neck. Although it was popular to do otherwise, members of the Order were not officially allowed to wear the symbol without a full collar until the rules were changed in 1516. His hat is adorned with a badge of the Virgin Mary and the discernible part of the Latin inscription reads *SANCTA MARIA ORA PRO NOBIS* ('Holy Mary, pray for us'). On the badge the Virgin is shown clothed in the sun, imagery taken from the Book of Revelation (12:1). Charles V is positioned in front of a parapet, a much-used device in the Renaissance, creating the illusion that the fictive space of the portrait is only separated from reality by a low stone wall.

The sitter delicately holds a sprig of rosemary in his left hand. Often used as a symbol of remembrance, as spoken by Ophelia in Shakespeare's *Hamlet*, rosemary also symbolises love and friendship. In Greek mythology rosemary was dedicated to Aphrodite, the goddess of love and fertility. As such its inclusion in this portrait may indicate that the image was created for a prospective bride. In 1514 the adolescent Charles V was betrothed to Henry VIII's sister Mary. A letter of 30 June 1514 mentions a portrait of Charles that had been sent to Mary 'where he is very badly depicted' (*où il est tres mal contrefait*), which may relate to no. 3.

ANONYMOUS
Emperor Charles V (1500–1558)
Oil on panel
43.8 x 32.4 cm
*c.*1514–16
RCIN 403439
First recorded in the collection of Henry VIII at Whitehall in 1542
Campbell, no. 82

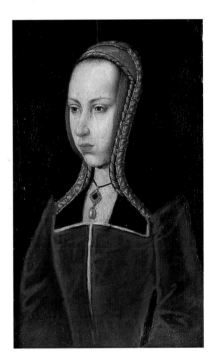

FIG. 28
Attributed to Pieter van Coninxloo, *Margaret of Austria*, 1490s; oil on panel (Royal Collection, RCIN 403428)

4

HANS MEMLING (*fl.* 1465–1494)
Portrait of a Man
Oil on panel
32 x 27 cm
*c.*1480
RCIN 404419
First recorded in the collection of Queen Anne
Campbell, no. 53

Though born near Frankfurt, Memling probably trained in the workshop of Rogier van der Weyden in Brussels, before becoming a citizen of Bruges in 1465, where he worked for the rest of his life. He built up a strong network among the European aristocracy, thereby generating a steady stream of work. No record exists of this commission and there is no clear clue within the portrait to identify the man. In his portrait style Hans Memling created a means of expressing not only the individual personalities of his sitters but also a sense of idealised beauty.

As in this example, Memling sometimes placed single figures with their heads turned at a seven-eighths angle rather than the more typical three-quarters view. The result is a distinctive almost full-frontal pose, creating an engaging illusion of the proximity of the sitter to the viewer, which is particularly effective in works with a plain-coloured, rather than a landscape, background.

In order to emphasise the most prominent aspects of a face – the eyes, nose and mouth – Memling often elongated the overall shape. Consequently, the scale of the face is not entirely true to life and the eyes, with their distinctive green irises, are slightly divergent, adding a sense of movement. The hair is immaculate, curling strictly to the shoulders and perfectly framing the face. The resolutely turned-down corners of the mouth imbue the sitter with a seriousness bordering on severity. Memling created the illusion of an even skin tone by carefully building up layers of thin glazes to give a pure, porcelain-like quality.

The man's simple dark tunic is worn over a grey collar fastened at the neck with three strips of cord. He gestures to a pendant hanging from a button on his tunic, a plaited cord emblem with two gold-embroidered material strips set with pearls. The significance of this ornament is not known. It has been suggested that this portrait commemorates the swearing of an oath. It is certainly not a devotional image because the man points so markedly towards himself rather than clasping his hands in prayer. It is possible that the portrait marked the sitter's initiation into a confraternity or society, or was intended as a gift to a prospective bride. In either case, the gesture indicates a hope of acceptance.

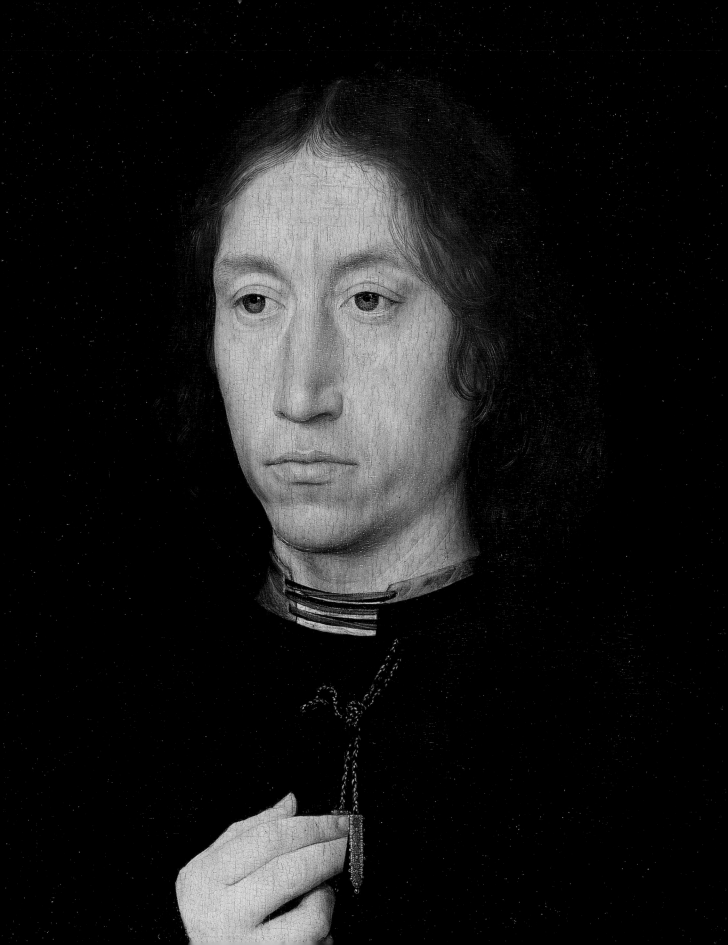

QUINTEN MASSYS (1464/5–1530)
Desiderius Erasmus (1466–1536)
Oil on panel
50 x 45 cm
1517
RCIN 405759
Recorded in the collection of Charles I,
recovered by Charles II at the Restoration
Campbell, no. 54

In 1517 the humanist and scholar Desiderius Erasmus and the town clerk of Antwerp, Pieter Gillis, decided to send portraits of themselves to Sir Thomas More, the lawyer, author and statesman who until his arrest and execution in 1535 had a prominent place at the court of Henry VIII. From the distance of Antwerp, Erasmus and Gillis wanted their likenesses, by the greatest artist living in Antwerp at that time, to serve as a virtual visit to their 'friend in London'. Surviving letters indicate the progress of the paintings. Erasmus's portrait was completed first because Gillis fell ill during his sittings. The men had informed More of their proposed gift, and More wrote impatiently to both of them questioning when he could see the result. Eventually the 'friendship diptych' was ready when the Englishman was visiting Calais and was sent directly to him there.

For many years the Royal Collection's portrait was not recognised as Massys's original because its dimensions are different from those of its pair, the portrait of Pieter Gillis (fig. 29). However, the Royal Collection picture has been cut down and the Longford Castle picture extended; the original dimensions must have matched perfectly. Both panels have the brand of Charles I on the reverse. The fact that they were together in the seventeenth century seems to confirm that they constitute the original pairing.

The Royal Collection panel shows Erasmus working in a study. This was a popular way of depicting St Jerome, and so the setting alludes to the fact that Erasmus had recently published a new edition of the writings of St Jerome. The books on the shelf behind the scholar have inscriptions relating to his recently published works: *Novum Testament[um]* and *Hieronymus* refer to Erasmus's editions of the New Testament and St Jerome; *Lovkianos* refers to Erasmus's and More's collaboration in translating Lucian's *Dialogues*; and *Hor*, which originally read *Mor* and must have been altered during an early restoration, spells the first letters of the Englishman's name and refers to the 'Praise of Folly' (*Encomium Moriae*), a satirical essay written whilst Erasmus stayed with More in Bucklersbury in London in 1509. The words on the paper are a paraphrase of St Paul's Epistle to the Romans, the handwriting is a close imitation of Erasmus's own hand, and the reed pen was Erasmus's favourite writing tool.

The purse on Erasmus's lap may be included in order to illustrate his generosity. Erasmus and Gillis made a point of informing More that they had split the cost of this gift because they wanted it to be a present from them both. Massys cleverly continued the bookcase behind both sitters, giving the impression that the men depicted in the two panels occupy the same room. Despite the fact that the humanist is depicted seated at his desk, his face is given an air of gentle openness and the direction of his gaze appears as though he has paused for a moment to think of More. The artist's highly sophisticated technique, coupled with a concentration on the contours of the face, render this an exceptionally accessible insight into Erasmus's character – the perfect gift for a respected and dear friend.

(Right) Detail of no. 5

FIG. 29
(Right) Quinten Massys, *Pieter Gillis*, 1517;
oil on panel (Private Collection)

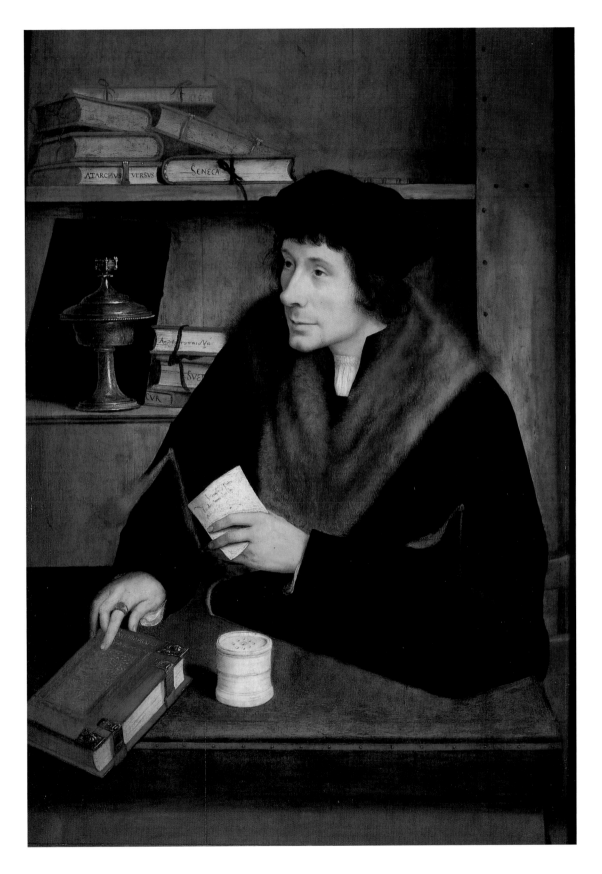

JAN GOSSAERT (also known as Mabuse,
fl. 1503–c.1533)
The Three Children of Christian II of Denmark
Oil on panel
34 x 46 cm
1526
RCIN 405782
Possibly acquired by Henry VIII
Campbell, no. 34

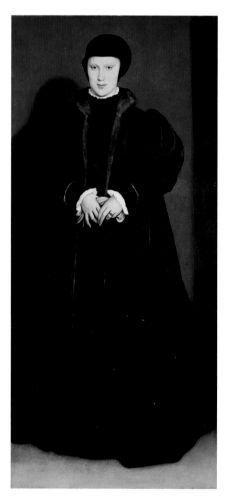

In January 1526 Isabella of Habsburg, Queen of Denmark and sister of the Emperor Charles V, died, leaving behind her three children: John, aged 8; Dorothea, aged 5; and Christina, aged 3. Christina was later portrayed by Hans Holbein the Younger (1497/8–1543) as a prospective bride for Henry VIII (fig. 30). In the Royal Collection's triple portrait, thought to have been painted in the year of their mother's death, these children are shown wearing the sombre clothes of mourning. Their father, King Christian II of Denmark, sent them to Mechelen to be raised by their great-aunt, Margaret of Austria, governess of the Netherlands, who had previously taken responsibility in the same manner for their uncle (no. 3).

The portrait is curious. The three figures seem to be cramped into a very small space, sitting around a table with a green cloth covering. John, in the centre, looks out towards the viewer, his head at a slight angle, emphasised by the tilt of his oversized black bonnet. The two girls stare vacantly ahead as though unaware that they are being observed. The artist uses this device to convey a sense of seriousness and grief. John's pose in particular is highly effective and serves to make him seem protective and questioning. The bond between the three is illustrated by their physical closeness, painted literally overlapping one another and forming a strong family unit, John's left hand placed firmly on the table underneath the arm of his younger sister and his right sleeve obscuring Dorothea's left arm. Gossaert's distinctive style conveys a sense of awkwardness in the positioning of the figures and an intensity in their expressions.

The composition is an illusionistic trick. Just inside the frame across the top and along two sides of the painting is an inner fictive frame painted to look like a continuation of the real one. Consequently it appears as though the children project out from the frame into our space. As a favoured artist of Philip of Burgundy (illegitimate son of Philip the Good), Gossaert was well versed in courtly conceits. It was common to portray important children as though they were already adults. Here the Crown Prince seems to be taking on the role of king, with Dorothea as his queen and Christina as their child, thereby demonstrating the children's royal status.

The only cheerful element of the portrait is the fruit: quinces for the girls and cherries for John. These do not seem to bear any specific meaning, though they may act as a generic symbol of ripening, just as these children, the fruit of their mother's womb, will ripen into adulthood.

FIG. 30
Hans Holbein the Younger, *Christina of Denmark, Duchess of Milan*, 1538; oil on panel (The National Gallery, London, presented by the National Art-Collections Fund with the aid of an anonymous donation, 1909)

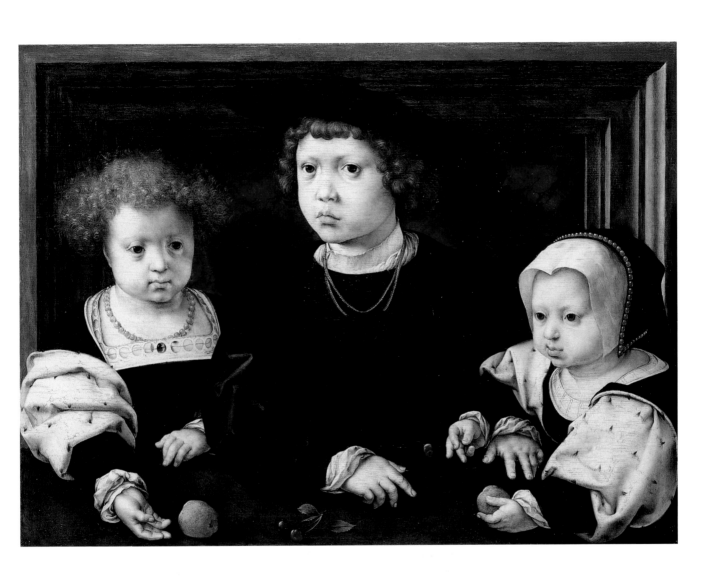

JOOS VAN CLEVE (*fl.* 1505/08–1540/41)

Self Portrait
65 x 50.8 cm
RCIN 405780

Katlijne van Mispelteeren, the Artist's Wife
65 x 50.2 cm
RCIN 405779

Both oil on panel
1530–35
Both acquired by Charles I
Campbell, nos. 13 and 14

These two portraits (see overleaf) are obviously a pair but are not universally accepted as images of the artist, Joos van Cleve, and his second wife. This difficulty partly stems from the fact that they were identified by Abraham Van der Doort in 1639/40 as depicting 'Sotton Cleve' and his wife. Van der Doort seems to have confused Joos with his son Cornelis (1520–67), known as 'Sotto' or 'foolish' Cleve, apparently because he went mad towards the end of his life. Others made the same mistake, writing as if Joos, not Cornelis, were 'Sotto' Cleve. A series of famous artists by Dominicus Lampsonius, published in Antwerp in 1572, included an engraving of Joos van Cleve, clearly based on no. 7 (fig. 31). The short poem underneath translates:

> See, among the great artists of the Netherlands/Our Muse shall surely not remain silent about you, Joos/ Who is no small jewel of the elevated art of painting./Yours and your son's art would have brought you good fortune/If you, poor man, had remained but sound of mind.

Karel van Mander repeats the error when, in his life of Joos, he relates that the artist suffered insanity whilst visiting England around the time of Philip II of Spain's marriage to Mary I (that is in 1554, fourteen years after his death). The question of identity is confused by another possible self portrait by Joos van Cleve, painted around 1520 (Thyssen-Bornemisza Collection, Madrid), which some have argued shows a different man. The Royal Collection portrait depicts a much older man, the beard adding to the sense of advanced years and endowing him with an air of worldly wisdom. The face shape, the contour of the nose and the colour and form of the eyes are, however, consistent with those in the Thyssen portrait, and the reddish-brown colour of the beard is the same tone as the wavy shoulder-length hair of the younger man. If we bear in mind that the Royal Collection portrait depicts a widower embarking on his second marriage, it is not surprising that the portrait has a different feel to it, but comparison of the faces alone is consistent with the author of both self portraits being Joos van Cleve.

The most striking aspect of the Royal Collection panels is the arrangement of the hands. The man addresses his wife and is spreading his fingers as if to reinforce a point. This rhetorical gesture is countered by Katlijne van Mispelteeren, with a more passive, contained placement of the hands gently laid one above the other and holding a rosary. Consequently the two portraits are perfectly balanced, conveying a sense of harmony and understanding between the couple.

The background of both paintings is plain green and both figures are dressed in dark, sober garments, the black of the man's hat complementing the starched whiteness of the woman's headpiece. The artist experiments with illusionistic conceits by including strong shadows behind the sitters. These not only unite the two by indicating that they are lit from the same source, they are also employed to trick the viewer by throwing shadows of the picture frames onto the background, blurring the boundaries of reality and fiction.

IVSTO CLIVENSI ANVERPIAN.
PICTORI.

Nostra nec artifices inter te Musa silebit
 Belgas, picturæ non leue, Iuste, decus.
Quàm propria, nati tam felix arte fuisses;
 Mansisset sanum si misero cerebrum.

FIG. 31
Jerome Wiericx, *Joos van Cleve*, engraving from D. Lampsonius, *Pictorum Aliquot Celebrium Germaniae Inferioris Effigies*, 1572 (The British Library, London)

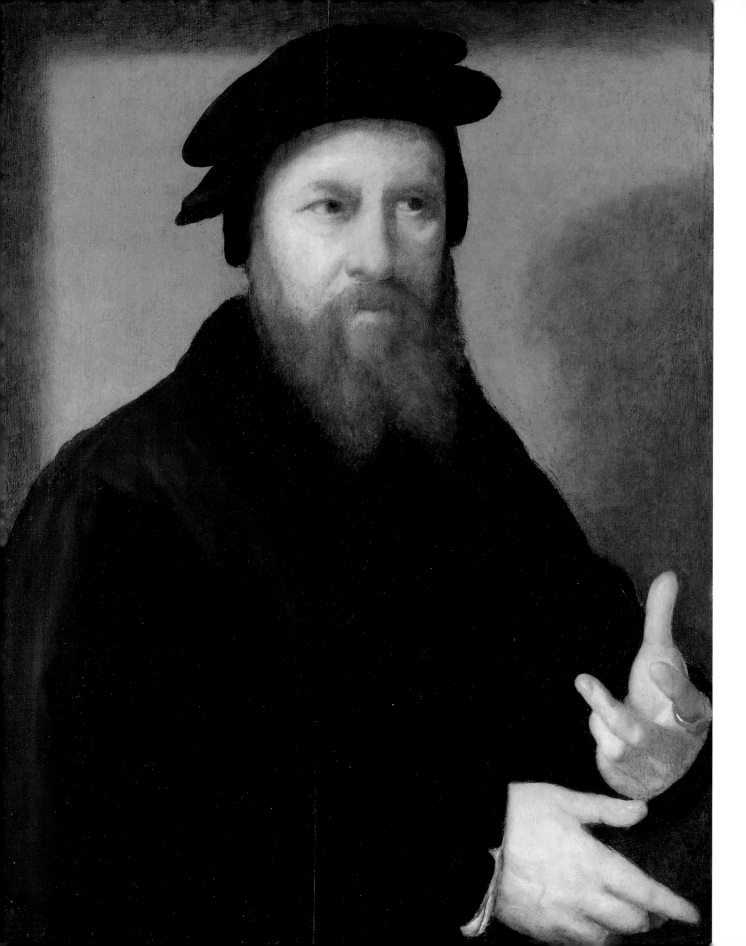

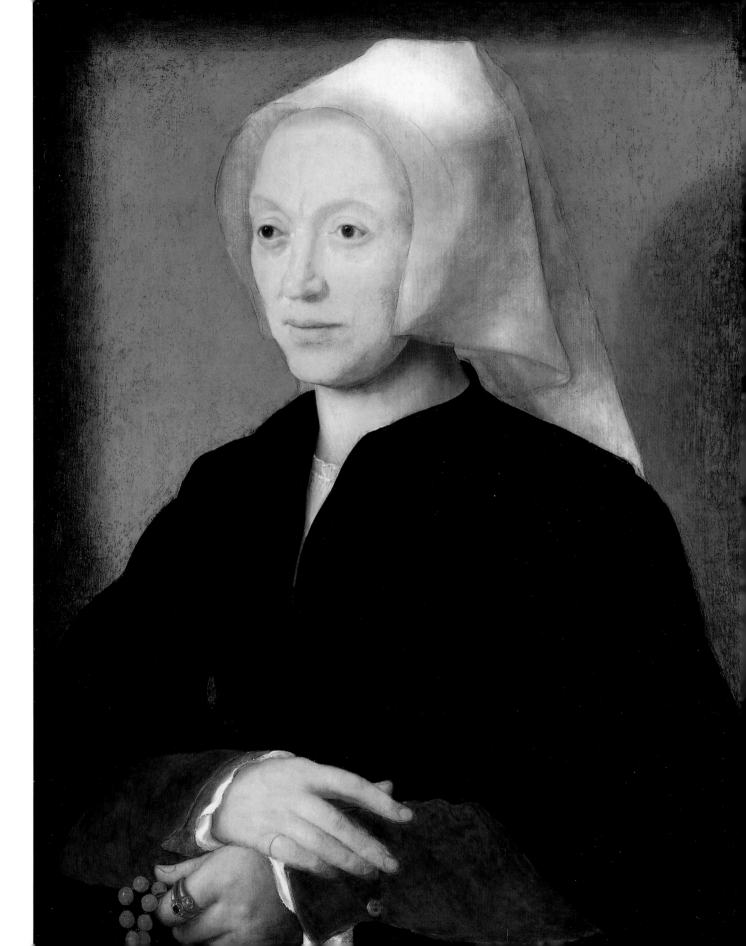

ANONYMOUS
Boy at a Window
Oil on panel
73.8 x 61.6 cm
*c.*1550–60
RCIN 404972
First recorded in the collection of Henry,
Prince of Wales (elder brother of Charles I)
Campbell, no. 83

Painted to look as though the painting itself is a window, this is an early example of a conceit which became highly popular in Dutch seventeenth-century art (fig. 32). The artist clearly hopes to entice the viewer to engage with the boy. He is painted staring directly out, his eyes and mouth at once mocking and welcoming. His left hand rests on the ledge of the window whilst his right finger is tapping the glass. The window, it would seem, is on the ground floor, because the gaze of the boy is level, rather than looking downwards.

The idea of the frame-within-a-frame derives from earlier portrait types where the sitter is placed within a fictive frame (no. 6) or behind a stone parapet (no. 3). These earlier sources are developed here so that the figure is positioned behind a realistic casement with lead partitions and hinges painted the same warm red colour as the window frame. The catch on the right is also red, and is a decorative shape. The boy's left hand held directly below the catch suggests that he may be just about to throw it open and talk to us.

It is difficult to say who the boy is and even where the painting was executed. With his plain dark clothes and cheeky manner, the boy would seem to be a servant, perhaps even a licensed jester. In the 1616 inventory of Anne of Denmark's collection the painting was described as 'A Picture of a Buffone' (that is, a fool or jester). The painting was once believed to depict one of Henry VIII's jesters, presumably painted in England by a Flemish master, but there is no evidence to confirm this.

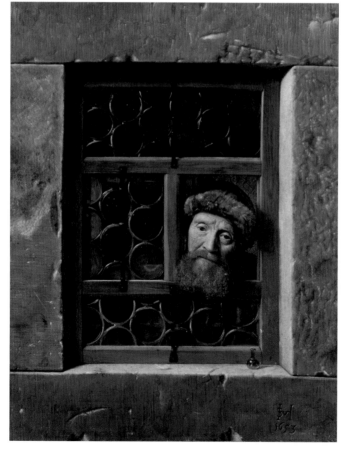

FIG. 32
Samuel van Hoogstraten, *Man at a Window*, 1653;
oil on canvas (Kunsthistorisches Museum, Vienna)

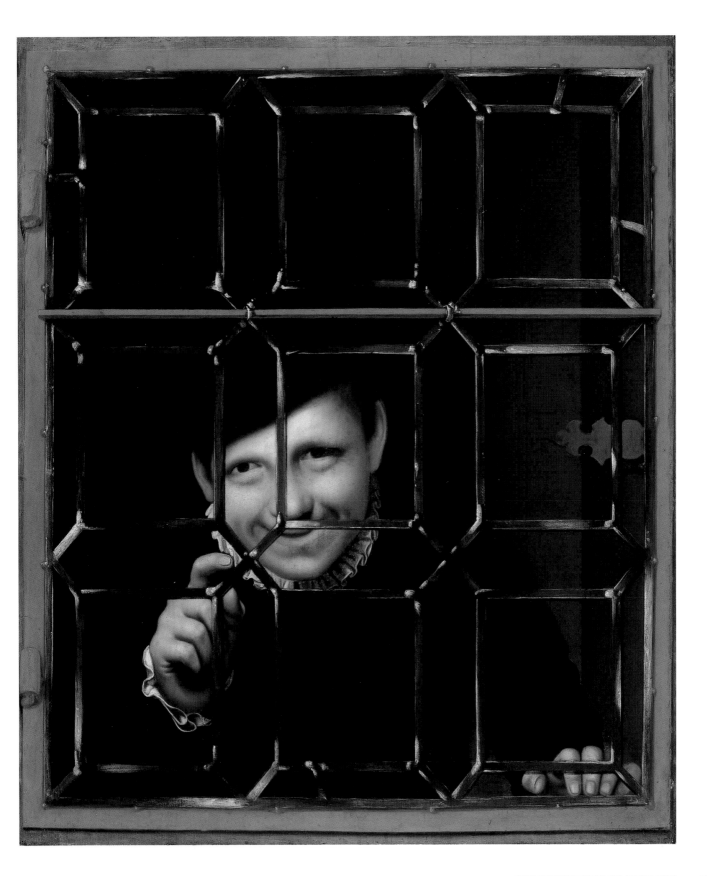

FOLLOWER OF CORNELIS MASSYS
(*fl.* 1510–1562)
Landscape
Oil on panel
24.6 x 22.5 cm
*c.*1550
RCIN 403378
Acquired by Charles I from the Gonzaga collection, 1628
Campbell, no. 41

The younger son of Quinten Massys (no. 5), Cornelis was born in Antwerp and, along with his brother Jan, became a master of the Guild of St Luke in 1531 after Quinten's death. Until about 1500 landscapes played a subsidiary role to history and religious paintings in Flemish art. It was only in the early sixteenth century that they began to have a serious artistic position in their own right, and Cornelis was one of the first painters to explore the possibilities of this, with fully detailed landscapes capable of conveying independent narratives through the inclusion of figures and animals. This example is cleverly conceived to fit into an illusionistic circular format. Painted within a 'false' moulding with a pink and green marbling effect, it has a seriousness that belies its small scale.

The tranquil scene is populated with figures engrossed in activity. In the background, below an almost dream-like idealised horizon, a shepherd looks after his sheep. The two houses at the centre of the composition convey a strong sense of homeliness and hard work, with figures depicted inside the foreground house, and a woman walking towards the door of the second. The middle and foreground areas are linked by the use of a bridge where a woman leading an ox and an ass crosses

over. Natural order is maintained by the inclusion of a man hammering a peg into the fence separating the main house from a field containing two cows. The left-hand edge of the painting is beautifully framed by tall trees, hinting at a forest beyond. These are balanced by a single tree to the right of centre, which curves satisfyingly to mirror the main tree of the forest area, in front of which runs a narrow river, with two swans swimming peacefully along.

The artist gives the viewer every aspect of country life in this idyllic painting. Water, fresh air, forest, houses, animals and plants exist together so that landscape and figures interweave harmoniously. A serious note is added with the inclusion of a beggar sitting, shoeless, underneath a shrine fixed to the tree that stands alone. Below the shrine is a makeshift prayer-bench. The beggar is not kneeling at the bench, but his positioning, looking out of the picture (see left), appears to be contemplative and engages the viewer with the fictional scene. He is included as a reminder of the less fortunate elements of society, and of the hope of salvation that comes through prayer. Consequently the circular scene contains a moral message as well as celebrating the wonders of fertile, well-maintained land.

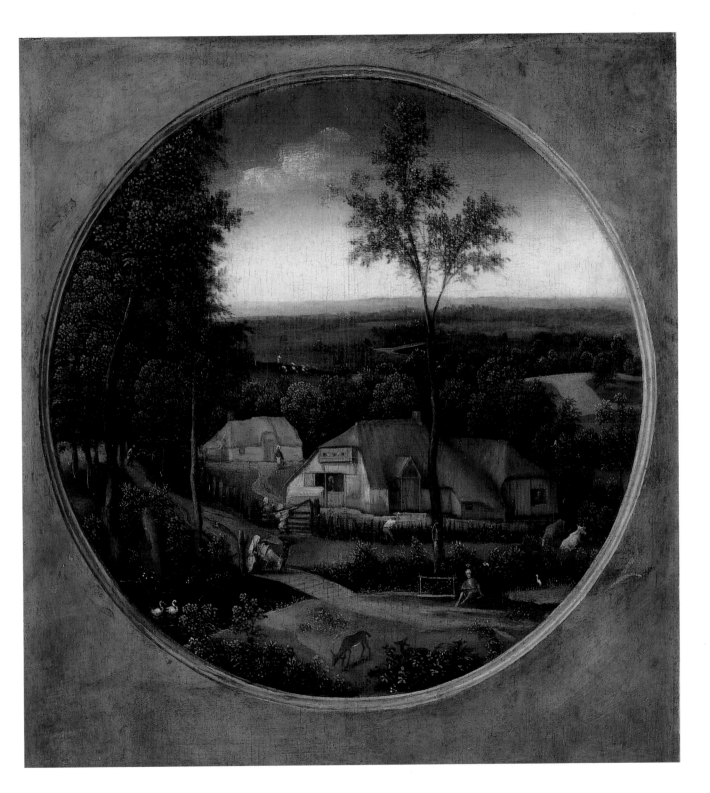

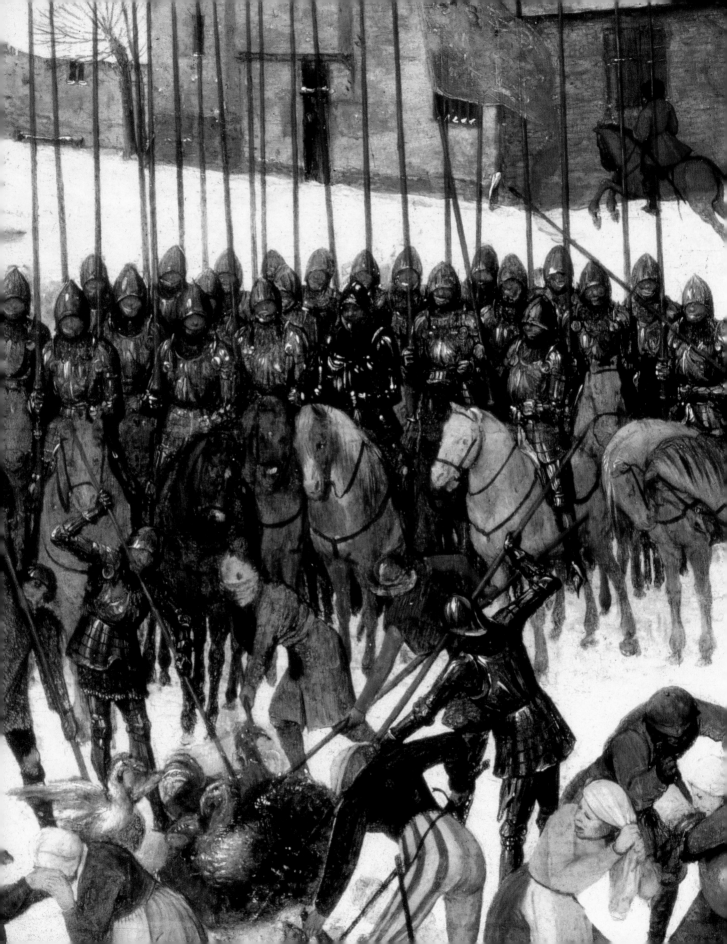

II

REVOLT
1555~1568

II REVOLT
1555~1568

Within this thirteen-year period after the abdication of Charles V, the United Provinces of the Low Countries were effectively lost to Spain. Initially Philip II lived in his northern dominions, conducting the Franco-Habsburg War of 1551–9, the decisive battle of which came in 1557 when a combined Spanish, Flemish and English army defeated the French at the town of Saint-Quentin near the Flemish border. This event is celebrated in Rubens's posthumous allegorical equestrian portrait of Philip II (fig. 34), painted in *c.*1635. After the peace treaty signed at Câteau-Cambrésis in April 1559, Philip II sailed for Spain. There he remained for the rest of his life, leaving Margaret of Parma, an illegitimate daughter of Charles V, as regent, with Cardinal Granvelle as her principal adviser (recalled in 1564; see fig. 1). Margaret's council also included loyal, Catholic and popular Flemish noblemen – men such as the Count of Horn, Stadtholder (governor) of Gelderland and Zutphen and Admiral of the Netherlands; the Count of Egmont, Stadtholder of Flanders and Artois and victorious general at Saint-Quentin; and William the Silent of Nassau, Prince of Orange and Stadtholder

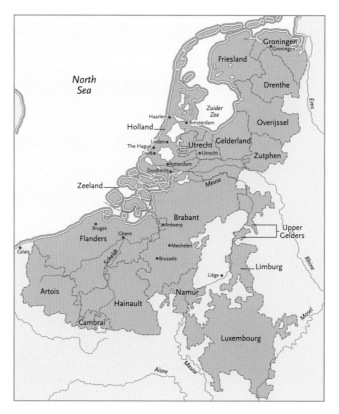

FIG. 33
The seventeen provinces of the Netherlands in 1555

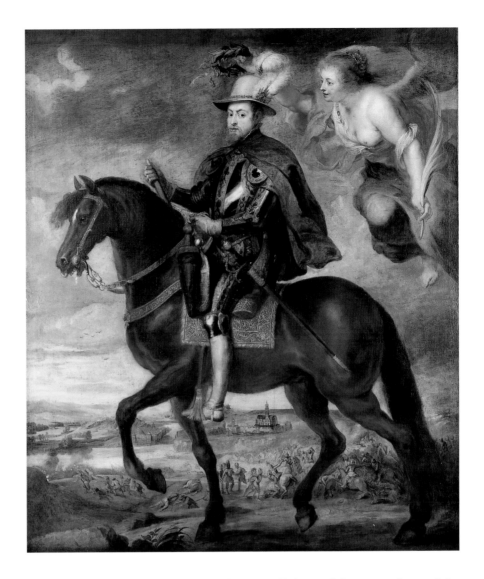

of Holland, Zeeland and Utrecht (fig. 43); all three of them members of the Order of the Golden Fleece. Unfortunately, however, Margaret and her advisers were ruled (and often overruled) by letters arriving from the King in Spain. The chain of command was slow, impersonal and frustrating and the commands inflexible, especially in the matter of religious tolerance and respect for local 'privileges'.

In 1565 Egmont went to Spain to present the grievances of the Netherlands in person. He received (or thought that he had received) assurances of a royal change of heart, yet the instructions contained in Philip's letters which followed him home were as inflexible and intolerant as ever. Undermining Egmont in this way proved counterproductive as it spawned a new confederacy of less loyal Netherlandish aristocrats, the 'League of the Nobility' led by Hendrick van Brederode and John Marnix, who were christened 'The Beggars' (*les gueux*) when, on 5 April 1566, they presented the Regent with a list

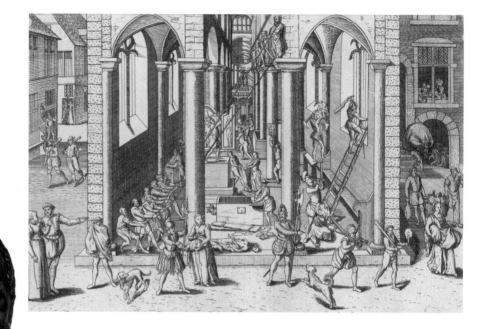

of their grievances. Soon afterwards came five days (19–23 August 1566) of destruction and desecration called the *Beeldenstorm* (fig. 35), when militant Calvinist mobs in several cities, including Antwerp, broke into churches and systematically destroyed all paintings, sculpture and stained glass, on the grounds that their existence contravened the Second Commandment. Margaret issued an Accord on 24 August 1566 permitting Protestant preaching, though later she claimed that this was done under duress and was therefore not binding. By this time an army of 10,000 led by the Duke of Alva (fig. 36) was already marching north from Italy to suppress the revolt by force.

In March 1567 Brederode and Marnix raised the standard of open revolt. On 10 April 1567 William the Silent, Prince of Orange, the eventual leader of the Dutch Revolt, resigned from the Council of State and fled to his estates in Germany. Alva arrived in Brussels on 22 August 1567; Margaret resigned as regent on 8 September; on 9 September Alva arrested Horn, Egmont and other fellow knights of the Golden Fleece, and on the same day he

set up the so-called Council of Blood to try the leaders of the revolt. When, on 3 March 1568, 15,000 prominent citizens were arrested, an English agent observed, 'now the very papists do perceive that the Duke of Alva doth go about to make them all slaves'.

In the year since his flight William of Orange had mustered an army to attempt to reconquer the Netherlands from the Duke of Alva. Two separate forces invaded in April 1568. On 23 May 1568 William's brother, Louis of Nassau, won a significant victory against the occupying Spanish forces in the village of Heiligerlee, near Groningen, in a battle that is traditionally said to mark the beginning of the Eighty Years War (fig. 42).

On 5 June 1568 the Counts of Horn and Egmont were executed on the orders of King Philip II of Spain in the main square of Brussels (fig. 37). In the 1630s the playwright Francisco de Quevedo (1580–1645) imagined a Spaniard explaining the recent history of his country to some Chilean Indians: 'The harsh spirit of Philip II placed the bloody punishment of the two noblemen above the retention of all those provinces and lordships. . . . In wars lasting sixty years and more we have sacrificed more than two million men to those two lives, for the campaigns and sieges of the Netherlands have become the universal sepulchre of Europe.'

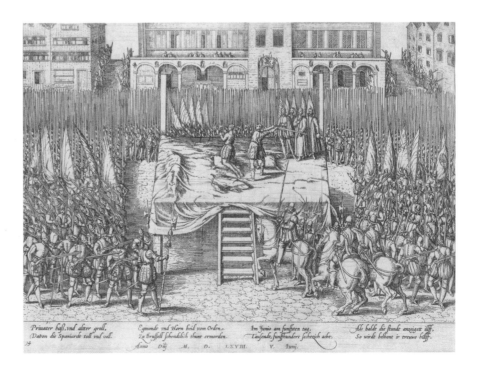

FIG. 37
Frans Hogenberg, *The Execution of Egmont and Horn, Brussels Town Square*, 1568; engraving (Rijksmuseum, Amsterdam)

Marten van Heemskerck was born in Haarlem, where he studied with Cornelis Willemsz. and, according to Karel van Mander, Jan van Scorel. He spent four years in Rome from 1532 to early 1536, a trip recorded in his later *Self Portrait* of 1553 (fig. 20). He spent the remainder of his career in Haarlem, except when the city was being besieged by the Spanish (in 1572–3), during which time he removed to Amsterdam.

According to the Bible, Jonah was sent by God to tell the sinful citizens of Nineveh that their city was to be destroyed utterly. The citizens repented and began to mend their ways, so God relented. This happy outcome unfortunately compromised Jonah's credibility as a prophet. Furious, he took up a position outside the city waiting for the cataclysm that never came. 'And the Lord God prepared a gourd', the story continues:

> and made it to come up over Jonah,
> that it might be a shadow over
> his head, to deliver him from his
> grief. . . . But God prepared a worm
> when the morning rose the next
> day and it smote the gourd that it
> withered. And it came to pass, when
> the sun did arise, that God prepared
> a vehement east wind; and the sun
> beat upon the head of Jonah, that he
> fainted, and wished in himself to
> die (Jonah 4: 6–8)

The point of the giving and the taking away of the gourd tree was that Jonah had learned to value it: should

MARTEN VAN HEEMSKERCK (1498–1574)
Jonah under his Gourd
Oil on panel
41 x 79.1 cm
Signed and dated 1561
RCIN 405465
Acquired by Charles II from William Frizell in 1662 for 250 florins
White 1982, no. 3

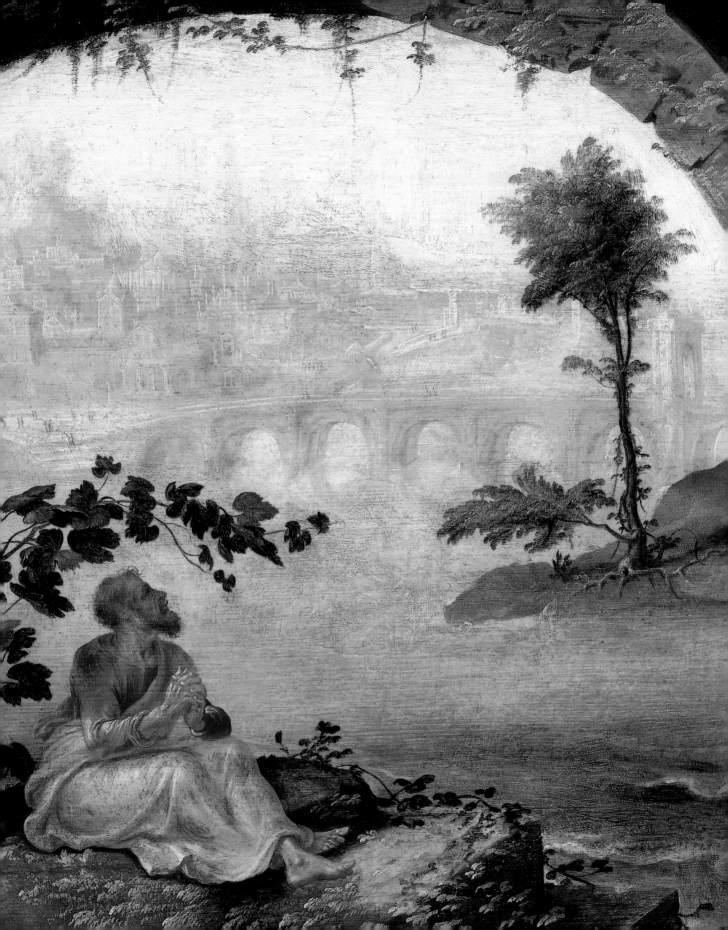

not God then value a city with 70,000 inhabitants?

Heemskerck paints the moment 'when the morning rose the next day': the entire scene is shrouded in an early morning mist that will clear to a day of intense heat. This veils the city so that its size and design can be only partially apprehended. This imprecision leaves the imagination to conceive a metropolis, described in the Bible as three days' walk in diameter. The whole scene is in fact set in sixteenth-century Rome: the structure in the foreground is a Roman aqueduct of a type that could be seen surrounding the city on all sides (sections are visible to this day). The apparent oddity of the perspective is caused by the fact that the aqueduct divides into two above where Jonah sits, one branch heading off towards the city. The background loosely resembles the view down the Tiber near the Vatican, with the addition of a structure much like the Milvian bridge (from the outskirts of Rome). A group of pen and ink drawings by Heemskerck survives, recording the monuments of ancient Rome; these were evidently executed on the spot in circumstances recorded in the background of his *Self Portrait* (fig. 20). Much of the architecture in the distance of no. 11 is fanciful and extravagant in order to evoke Nineveh, an ancient city more remote than Rome in time and location. However, using Rome as a starting point is an effective device: Heemskerck's viewers will have known about (and perhaps experienced) sightseers' heat-stroke; it must have been easy for them to conceive of the catastrophe threatening Nineveh against the background of a city which, in the sixteenth century, was mostly rubble. Montaigne described Rome in 1581 as 'no more than a sepulchre . . . dead, overthrown and mutilated' and that sepulchre itself 'for the most part buried'. Even the Roman aqueduct – dry, hot stone where once water flowed – is a powerful image of thirst and ruin.

This is a striking and somewhat eccentric image, where architecture, atmosphere and figure all contribute towards telling the story. An illusionistic paper label or *cartolino* (see below) appears to be stuck onto the surface of the painting with three spots of sealing wax, like the one in the *Self Portrait* (fig. 20). It must have been planned to contain a verse from the Bible – rather than the artist's signature, which occurs elsewhere as if carved into the stone of the aqueduct.

MARTEN VAN HEEMSKERCK (1498–1574)
The Four Last Things: Death, Judgement, Heaven and Hell
Oil on panel
68.6 x 152.4 cm
Signed and dated 1565
RCIN 405786
Acquired by Charles II from William Frizell in 1662 for 1,000 florins at the same time as its now lost pair, *The Flood*
White 1982, no. 2

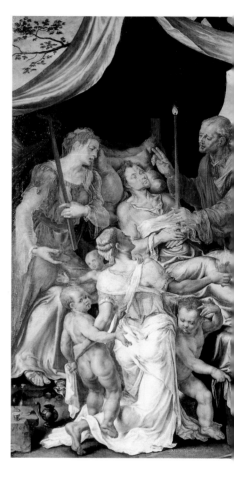

Karel van Mander described a work executed by Heemskerck for his pupil Jakob Rauwaert, depicting '*Four Extreme Endings, Death, Judgement, Eternal Life*, and *Hell*. It was a superb painting that required much study. There were many nudes and human figures in various poses. The variety of human emotions is to be noticed – the pains of death, the joy of Heaven, and the sorrows and horrors of Hell.'

The subject can be read from left to right. Firstly we see the Death of a single man – Everyman. The famous English medieval mystery play of that name is a version of a Flemish original, also called 'Everyman' (*Elckerlijc*) and first published in 1495. Both plays tell of the death-bed struggle for the soul of the hero. The dying man here has led a good life, the life of a pilgrim; on the floor lie staff, drinking gourd and hat, covered in shells and badges, tokens of his many pilgrimages. The man is surrounded by the three Cardinal Virtues: Faith with a cross and chalice, Hope with an anchor, and Charity with children and a flaming heart. The last rites are being administered by a priest, who hands a candle to the dying man.

The resurrection of the dead occurs across the centre of the composition, with nude figures emerging from their graves, in some cases (especially in the right foreground) their bones are being reclothed in flesh before our eyes. Christ sits in Judgement in clouds to the right, flanked by John the Baptist (advocating Justice) and Mary (advocating Mercy). Mary is accompanied by two other female saints, one of whom is certainly St Mary Magdalene, the archetypal penitent. Heaven is a small, golden break in the clouds, towards which the souls of the virtuous are praying. Hell is a burning land, with a bridge over the river Styx and what appears to be a castle (and indeed resembles the Castel Sant'Angelo in Rome). Upon closer examination it is clearly a giant cauldron. Hell is also represented by the open mouth of a huge fish guarded by Pluto, the classical god of the underworld, and his three-headed dog

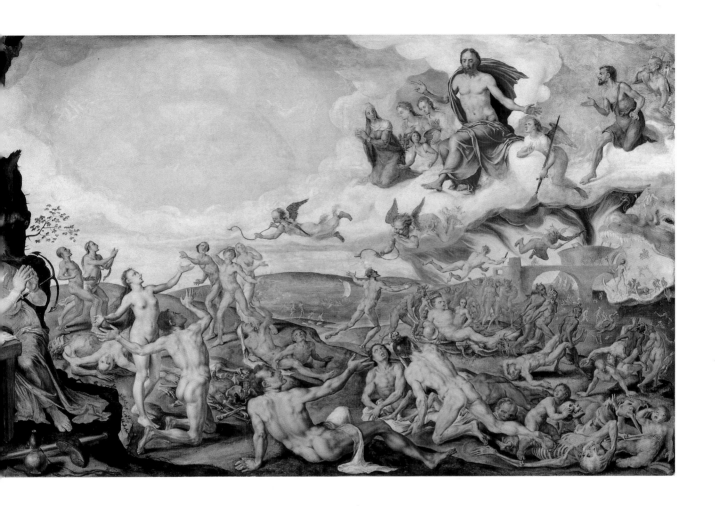

Cerberus. Devils are claiming all types of men, including an overfed king.

Most of this eschatological imagery is familiar from other depictions of the subject. One oddity is the way in which Christ is moved off-centre, away from the blaze of light (the rising sun of the Second Coming), which would normally act as His heavenly throne. This has allowed Heemskerck to suggest the passage of the sun during one day, from night on the left, through morning in the centre, towards the final sunset on the right.

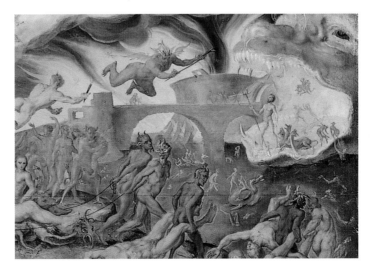

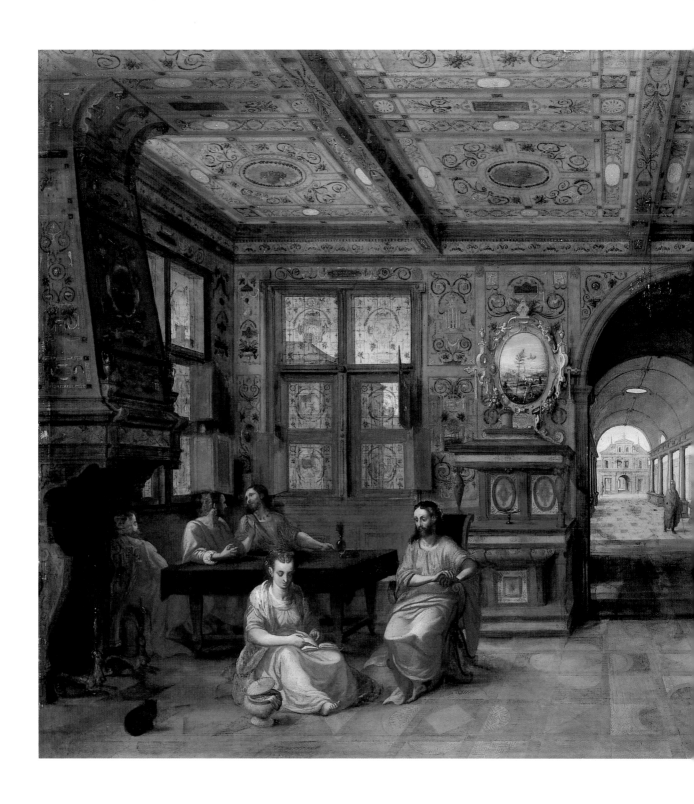

St Luke's Gospel (Luke 10: 38–42) tells of Jesus visiting the house of Martha and her sister Mary. Martha chides her sister for listening to Christ and not helping in the kitchen; Jesus replies, 'Martha, Martha, thou art careful and troubled about many things: but one thing is needful: and Mary hath chosen that good part, which shall not be taken away from her.'

When imagining the biblical scene, it is natural to think of a humble dwelling with no servants to help Martha in her frantic preparations. De Vries was a specialist in architecture and perspectival illusionism, which may account for his decision to set the scene in a chamber of luxurious splendour, the walls and ceiling covered in panelling embellished with sophisticated decoration. Three mini-images are included: a landscape painting over the mantelpiece, a depiction of the Sacrifice of Isaac over the buffet (cupboard), and a bust of Moses over the right-hand doorway. De Vries creates a perfect illusion of precisely articulated space filled with air and light, capturing the effect of daylight streaming through the colonnade and the kitchen window and the way in which the stained glass to the left seems to merge with the building seen through it. This interior is reminiscent of a precious jewel box.

HANS VREDEMAN DE VRIES (1526–1609)
Christ in the House of Mary and Martha
Oil on panel
79.4 x 109.2 cm
Dated 1566 on the step below the archway; incomplete signature in Greek and Latin letters
RCIN 405475
First recorded in the collection of Henry, Prince of Wales (elder brother of Charles I)
Campbell, no. 73

Mary sits 'at Jesus's feet' on a low stool, absorbed by her book and neglecting her workbox. Three characters – presumably disciples – appear behind, two arguing and one sleeping. In the kitchen to the right a man sits by the fire whilst a woman leans towards him holding a ladle (the attribute of Martha). Two further figures in the background – a boy drawing water from a well and a man (possibly a Pharisee) walking through the colonnade – facilitate the illusion of the picture plane receding far into the distance.

X-radiographs (fig. 38) reveal that the major figures have been painted over. Originally Martha occupied the centre foreground, while Christ and Mary looked up towards her. It was only when the standing figure was eliminated that the woman in the kitchen area was given Martha's attribute. The overpainting was possibly carried out by the artist Anthonis Blocklandt, at the behest of the owner, only a few years after completion. This implies that de Vries was not considered to be a master painter of the human form, and it is possible that he had not been responsible for the figures in the first place, drafting in a 'figure expert' instead. The removal of Martha from the foreground enabled a clear view through the archway to the impressive barrel-vaulted colonnade and buildings beyond, thereby shifting the emphasis from the religious scene to the magnificent architectural setting.

FIG. 38
X-radiograph of no. 13

PIETER BRUEGEL THE ELDER (*fl.*1551–1569)
Massacre of the Innocents
Oil on panel
109.2 x 158.1 cm
1565–7
Signed
RCIN 405787
Acquired by Charles II from William Frizell
in 1662
Campbell, no. 9

FIG. 39
Pieter Brueghel the Younger, *The Massacre
of the Innocents*, *c*.1610–20; oil on panel
transferred to canvas
(Johnny van Haeften, London)

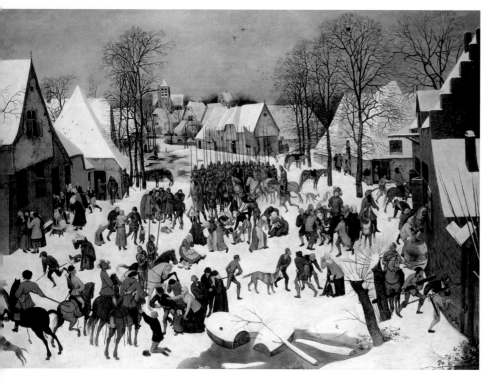

This extraordinary painting (also discussed in the Introduction) belonged to the Emperor Rudolph II, who presumably ordered it to be reworked as a scene of plunder rather than massacre. Karel van Mander described it as a Massacre in 1604; it had become a 'village plundering' when recorded in an inventory of 1621. The flames added in the sky over the houses were cleaned off in 1941, but it was then decided to leave the more substantial (and historically significant) alterations to the figures.

Admirers of this painting have agreed that it is a unique example of multiple narrative: van Mander found much in it to look at 'which is true to life', 'a whole family begging for the life of a peasant child which one of the murderous soldiers has seized in order to kill, the mothers are fainting in their grief, and there are other scenes rendered convincingly'. Reynolds, seeing another version of the composition, concluded that 'this painter was totally ignorant of all the mechanical art of making a picture; but there is here a great quantity of thinking, a representation of a variety of distress, enough for twenty modern [painters]'.

Bruegel's painting requires us to read these episodes one by one (see details reproduced on p. 90). Rudolph's visual censorship has made this more difficult, but fortunately many other versions of the composition (often by Pieter Brueghel the Younger, see fig. 39) record the original appearance. In the background, immediately below the church, a father tries to smuggle his baby to safety, though the mounted soldier on the bridge behind and the many horses tethered (their riders presumably searching houses) suggest that he is unlikely to succeed. His presence reminds us of the Holy Family who have escaped. In the left background a soldier urinates against a wall, a 'true-to-life touch' reminiscent of the Old Testament description of him 'that pisseth against the wall' (I Samuel 25: 22; 2 Kings 9: 8), which seems to mean no more than 'every mother's son'. The troop of armoured knights is led by a man, whose features have been altered. In other versions he has the distinctive drooping eyes and long beard of the Duke of Alva (compare detail on p. 72 with fig. 39, where the central man in a black cape is

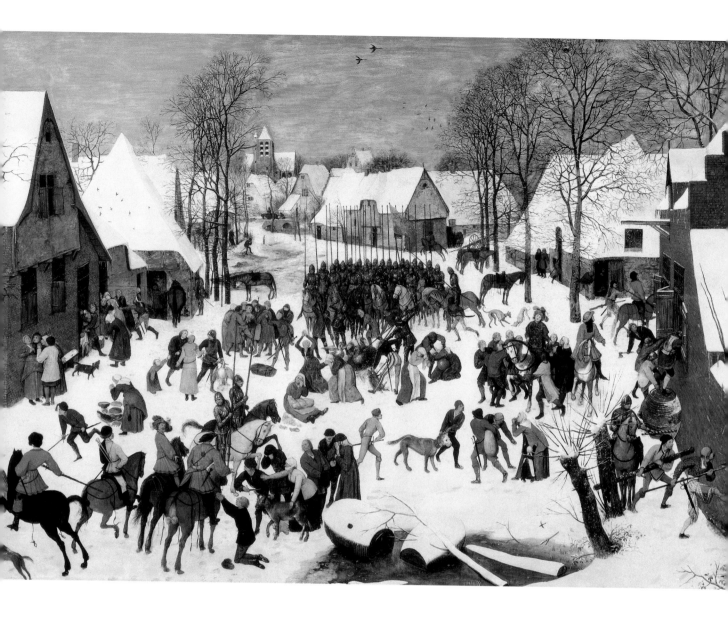

Alva). It is impossible to establish whether these features lie underneath the alterations here. The standard held by one of these soldiers displayed (before it was painted over) five gold crosses on a white ground – the arms of Jerusalem. This is obviously appropriate for the biblical story, but also for its modern adaptation as Philip II of Spain was also styled King of Jerusalem.

A soldier herds women into a house at the extreme left, presumably in order to keep them out of the way; another soldier carries a baby (one of the few that have not been changed) out of a nearer door, while against the wall of the same house some neighbours seem to be consoling a grieving mother. Moving to the right, a standing woman grieves over her dead baby lying in the snow (changed to an array of hams and cheeses); a couple beg a soldier to take their daughter rather than kill their baby son (fig. 40a; changed to a goose or swan); a huddle of villagers console or restrain a father who might otherwise attack the Lansquenet (German mercenary) in striped hose who guards a dead baby (changed to a bundle). A seated woman grieves with her dead baby (changed to a bundle) on her lap. A group of soldiers stab with pikes at a pile of babies (changed to livestock) to ensure that they are all dead; women run off in horror as another Lansquenet stabs a baby (fig. 40b; changed to a young boar); a soldier stabs at a baby (changed to a pitcher) cradled by a seated woman. At this point a distinct

group forms as ugly and ridiculous-looking townsfolk remonstrate with a young, handsome and elegantly dressed herald, who finds (to his obvious regret) that he is unable to help. This is a representative of the Roman Empire – the empire of Augustus that failed to stop Herod, and the Holy Roman Empire of Maximilian II who failed to stop Alva. The Habsburg eagle originally painted on his tabard was altered by Maximilian's successor, Rudolph II.

At the extreme right a sergeant in red tunic shouts up at the shuttered windows of an inn (presumably telling them to open up). The inn sign is inscribed: 'This is the Star' (*Dit is inde ster*) and illustrated the Star of Bethlehem (before this part was altered). This is another 'true-to-life touch': there was a house in the Kipdorp in Antwerp at this time called 'De Sterre van Bethleem', which belonged to Philip II's hated factor, Hieronimo de Curiel. Nobody answers the sergeant and so soldiers are forcing entry: one wields an axe and one a battering ram, three climb in at the shutters, one kicks down a courtyard door, thereby dislodging an icicle that will fall on his head like divine vengeance.

Reading across the foreground right to left we see a baby (changed to a bundle) torn from a mother and her daughter. A bloodhound (presumably trained to detect male babies) is handled by a soldier of unpleasantly canine physiognomy. Two generations of a family grieve for a baby about to be stabbed (fig. 40c; changed to a calf). Two mounted sergeants in red coats superintend this operation in spite of the kneeling man begging them to countermand the order. At the left foreground another sergeant pursues a fleeing mother and child, a group not painted over though partly lost when this side of the panel was cut down.

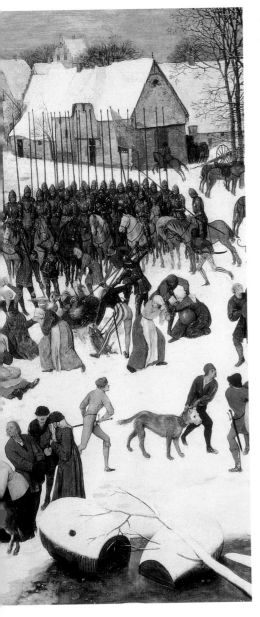

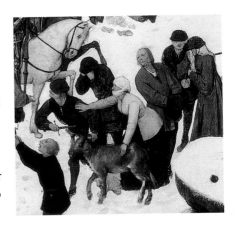

A

B

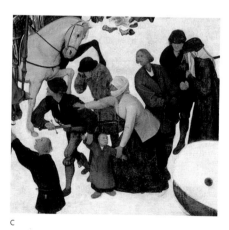

C

FIG. 40 A–C
Details from Pieter Brueghel the Younger,
The Massacre of the Innocents (fig. 39), alongside
corresponding details from no. 14

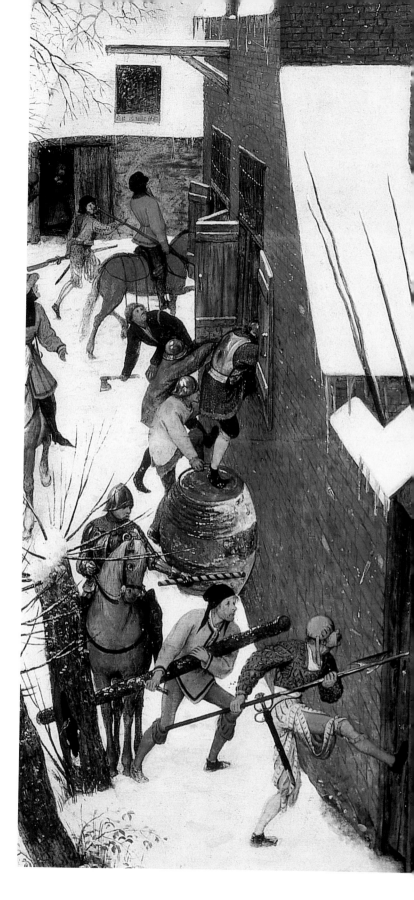

III

WAR
1568~1598

III WAR

1568~1598

The thirty years from 1568 to 1598 represent a fraction of the duration of the Eighty Years War (1568–1648), but it is the important fraction. In spite of the 'Dutch' victory at Heiligerlee (fig. 42), the Duke of Alva had entirely pacified the country by 1572, when the Council of State imposed a series of unpopular property and purchase taxes called the 'Hundredth', 'Twentieth' and 'Tenth Penny', after the proportion of money levied. In spring 1572 Dutch rebel ships called the 'Sea Beggars' captured the towns of Brielle, Flushing and Rotterdam on the coast of Holland and Zeeland. William the Silent (fig. 43) marched across the Rhine on 8 July 1572 and remained in the Netherlands as leader of the revolt until his assassination in 1584. Initially his forces were able to secure only a foothold within the northern provinces (fig. 41); however, his relief of the Siege of Leiden on 3 October 1574 made it clear that this was a firm and lasting foothold.

On 8 November 1576 unpaid Spanish troops garrisoned near Antwerp mutinied and sacked the city, killing 7,000 inhabitants. The cruelty and indiscipline of the 'Spanish Fury' (fig. 44) dealt such a blow to their rule that by 1579 the provinces of Holland, Zeeland, Utrecht, Gelderland, Friesland, Groningen, Overijssel, Flanders and Brabant were almost entirely in rebel hands (fig. 41). Their representatives at the Estates General of 26 July 1581 ratified the Act of Abjuration declaring that Philip II was no longer a prince but a tyrant, which permitted his subjects to 'disallow his authority' and 'legally proceed to the choice of another prince for their defence'. For many years that choice proved difficult; eventually the Dutch Republic made the title of Stadtholder (governor), conferred by Philip II on William of Orange, into that of a

FIG. 41
Gains and losses in the early years of the Eighty Years War

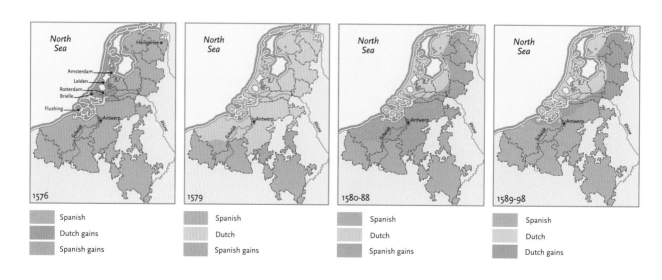

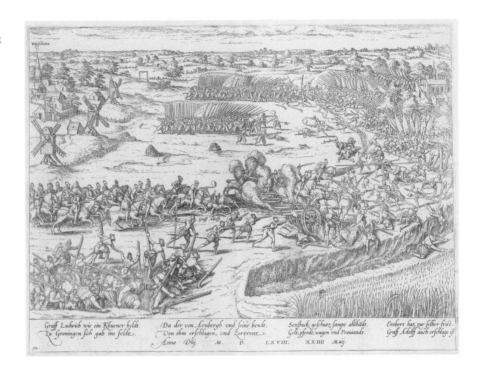

hereditary head of state. It was as stadtholder that William's great-grandson crossed the North Sea in 1688 to assume the thrones of England, Scotland and Ireland as William III.

By 1581, however, the Spanish had already begun the reconquest of the southern provinces under the command of the most effective soldier-governor of the period, Alexander Farnese, Duke of Parma. The son of Margaret, regent during the early 'troubles', he led the Spanish 'army of Flanders' from 1578 until his death in 1592.

The key moment in Parma's advance was the capture of Antwerp on 17 August 1585. Three days later, at Nonsuch Palace in Kent, Queen Elizabeth I pledged to support the Dutch with military aid, thus beginning eighteen years of Anglo-Spanish conflict. The limit of Parma's reconquest was reached in 1588 (fig. 41), when he planned to link up with the Armada sent from Spain and to undertake the conquest of England. The only real sea-battle of the Armada campaign was fought near the port of Gravelines in Artois on 29 July 1588 and prevented this embarkation. After the destruction of the Armada (by storms rather than battles), the Dutch forces began to recapture some lost territory. By 1598 the war in the Low Countries had settled into a costly and bloody stalemate, with minor frontier oscillation, which lasted for the next fifty years (fig. 59).

At some time during these years the seventeen provinces united by Charles V split irrevocably into two. The first example of a 'loyal' southern Netherlands acting independently of a 'rebel' north occurred in 1579 with the Union of Arras, when the French-speaking provinces of Hainault, Artois and Walloon Flanders were reconciled to Spain and joined the already occupied provinces of Namur, Limburg and Luxemburg.

It is no accident that this thirty-year period in the history of the Low Countries produced so few pictures (no. 15). Van Mander lists a large number of artists driven out of Flanders by Mars, 'the bitter enemy of art'. Italy attracted

some of the best, England some of the more workmanlike; nearer havens – Aachen, Frankenthal, Cologne and Frankfurt – attracted those who perhaps hoped to return at the first opportunity. As the front became more settled, many artists, especially Protestants like Roelandt Savery (nos. 20 and 21), made the short journey north.

The skills that fuelled the Flemish economy were also of use to individuals when that economy was shattered; in his life of Joris Hoefnagel (1542–1601), a minor artist who made a career in England, van Mander writes, 'I think the Netherlanders have a better custom than most other people, because parents, though wealthy, let their children learn an art or a handicraft early in youth; this kind of training may be useful in time of war, when people have to flee.'

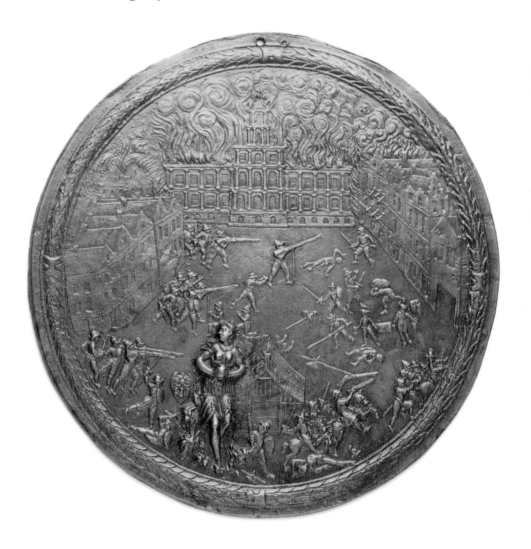

FIG. 44
Attributed to Jacques Jonghelinck, *The Spanish Fury*, *c*.1580; bronze (Victoria and Albert Museum, London)

15

CRISPIN VAN DEN BROECK (1524–c.1590)
Christ Healing the Sick
Oil on canvas
91.4 x 142.2 cm
Signed with a monogram and dated 1577
on the crutch
RCIN 405524
Acquired by Charles II from the collection
of John Michael Wright, mid-1660s
Campbell, no. 8

Whether the Antwerp-based artist Crispin van den Broeck ever travelled to Italy is not known for certain, but the influence of the Venetian style of Jacopo Bassano (c.1510–92) is evident in his employment of large, tangible figures set within a landscape. Having been trained by Frans Floris (c.1518/20–70), who did travel to Italy, it is possible that he was simply influenced by this Italianate master and by engravings after Italian originals, which were extremely popular at the time. Another technique that van den Broeck learnt from Floris was that of applying a brown preparatory ground underneath the main colours of his paintings, which accounts for the predominantly brown hue that characterises his works.

As well as a distinctive colour scheme focusing on pink, brown, grey and yellow tones, van den Broeck's treatment of form is striking. In *Christ Healing the Sick* the figures are the focal point, dominating the landscape and the view of Jerusalem beyond. It was perhaps this attention to the contours of form that made his art perfectly adapted for engraving work; he supplied numerous illustrations and designs to the Antwerp engravers, providing, for example, the illustrations for Lodovico Guicciardini's *Descrittione di tutti I Paesi Bassi* of 1567.

This painting probably does not illustrate a specific story but rather conveys more generally Christ's mission to save the unfortunate and heal the sick. The figures are divided into two sections, the healthy to the left and the sick to the right. Christ is opening the eyes of a blind man, who kneels at his feet, in a posture reminiscent of a man receiving baptism. His dog stares out of the painting, a reminder that soon he will no longer be needed to lead his master. Behind them stands St Peter praying, and to their left a richly dressed man, probably a Pharisee, coolly appraises the miracle. He turns his back to the viewer to lead the eye into the composition and (with the blind man) offers a perfect contrast of pride and humility.

There are three principal unfortunates in the right-hand group: a lame beggar, with crutch and bowl, and two mad men. One of the latter is manacled, his chain held by a keeper; the other is cured of his possession, as an evil spirit (looking rather like a winged lizard) leaves his mouth. The family beyond may be supplicants or onlookers.

There are no records to indicate the original location of this painting, but it seems likely to have been commissioned by a hospital where its theme of healing and salvation would have been appropriate.

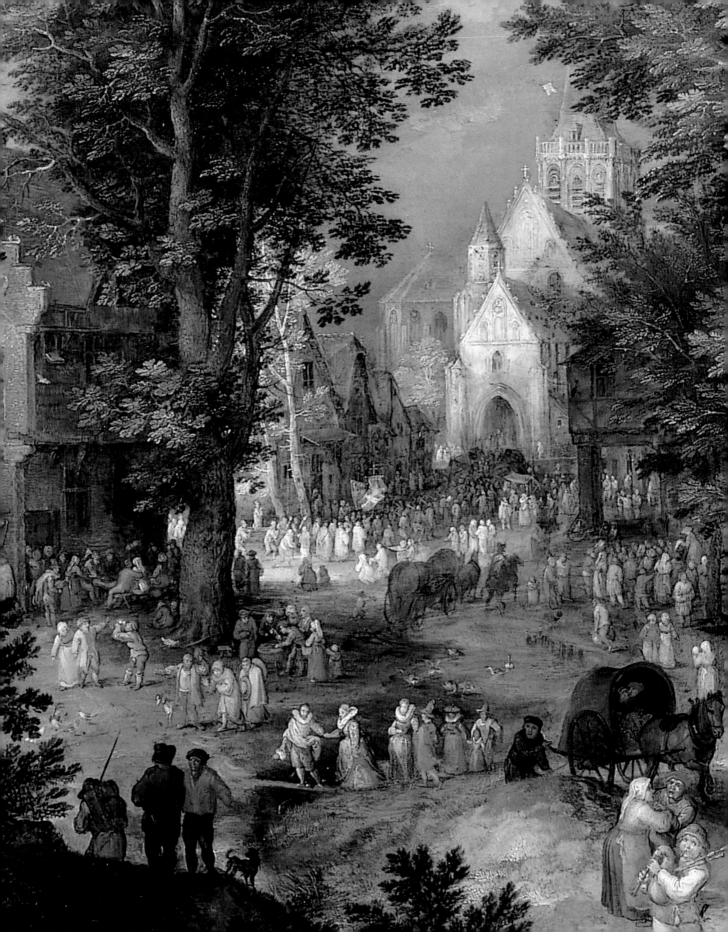

IV

THE ARCHDUKES
1598~1633

IV THE ARCHDUKES
1598~1633

During the months before his death in September 1598 Philip II set his affairs in order, leaving his territories in the Low Countries to his beloved daughter Isabella Clara Eugenia (fig. 48), and arranging her marriage to her second cousin, Archduke Albert (fig. 47), which was celebrated in April 1599. The rule of the 'Archdukes', as the couple were called, was different from that of the various regents and governors during the preceding century. Isabella was a sovereign regent in a line of succession from Charles V and Philip II, rather than from Margaret of Parma, the Duke of Alva, and so on. Her children were to inherit the title. The only limit on her power was the stipulation that the supreme command of the Spanish army within Flanders and foreign policy rested with her half-brother, Philip III, King of Spain.

The new reign gave grounds for hope. The Archdukes lived permanently in Brussels; they were obviously prepared to 'jump through the hoops' demanded by local customs, and they made themselves liked and admired. Rubens described Isabella as 'a princess endowed with all the virtues of her sex', adding that

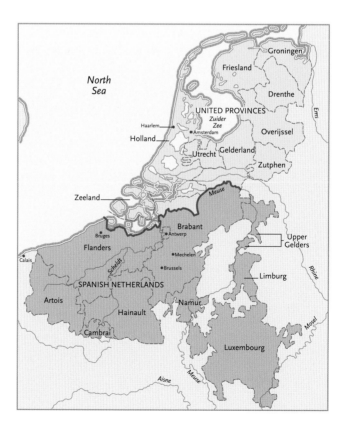

FIG. 45
Borders agreed at the Twelve Year Truce in 1609

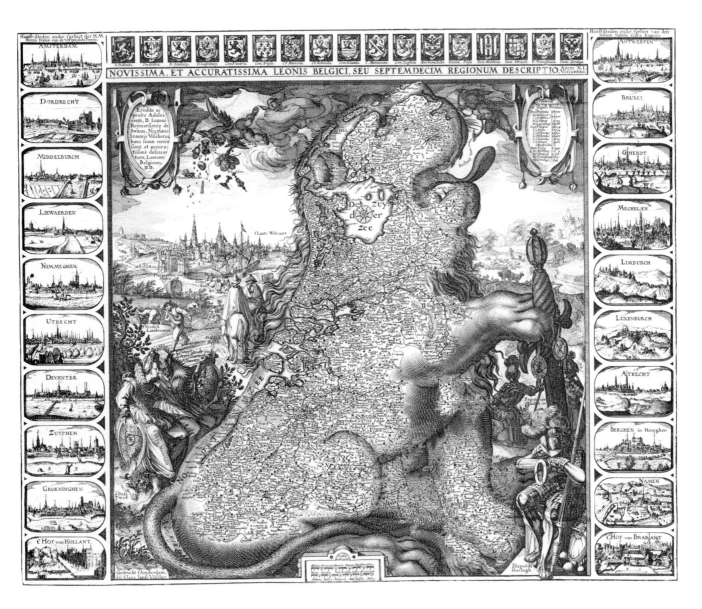

'long experience has taught her how to govern these people and remain uninfluenced by the false theories which all newcomers bring from Spain'. Albert was a successful commander, capturing Ostend in September 1604 after a three-year siege, a military deadlock which is thought to have inspired Hamlet's famous meditation upon war, as he watches 20,000 men fight for a plot 'Which is not tomb enough and continent / To hide the slain' (*Hamlet*, Act IV, scene 4). By this date there were also encouraging developments in the foreign policy initiatives issuing from Spain: a treaty was signed with James I on 28

FIG. 47
Peter Paul Rubens, *Portrait of Archduke Albert (Albert VII)*, *c.*1615; oil on panel (Kunsthistorisches Museum, Vienna)

August 1604 making peace between Spain and England, and the Twelve Year Truce with the Dutch Republic was signed in Antwerp Town Hall on 9 April 1609, agreeing borders shown in fig. 45. The war seemed finally to be over.

This relief was evidently long overdue. The English poet Sir Thomas Overbury (1581–1613) visited what he called 'the Archduke's country' in 1609 and beheld:

> a Province distressed with war. The people heartless; and rather repining against their Governors than revengeful against their enemies. The bravery of that gentry which was left, and the industry of the merchant, quite decayed. The husbandman labouring only to live, without desire to be rich to another's use. The towns (whatsoever concerned not the strength of them) ruinous. And, to conclude, the people here growing poor with less taxes, than they flourish with on the States' [Dutch] side.

The Spanish Netherlands were already recovering when Overbury visited but, perhaps more importantly, they had become 'the Archduke's country', an entity recognised by citizens and visitors alike and identified with a local sovereign.

In spite of the legacy of the war, there was an optimism in these years that is summed up by a map of 1609–11 by Claes Visscher (1587–1652; fig. 46). The land mass of the southern and northern Netherlands assumes the form of the rampant 'Belgian Lion' burying a sword in the ground. A sleeping soldier alludes to the cessation of internal strife, and a watching soldier guards the frontier from invasion. The north and south embrace and together stamp upon their 'old quarrel'. Behind the land is again being sowed and rebuilding begins. This is one of the last images which expresses the hope that the seventeen provinces (whose arms are arranged across the top) might be reunited. A map showing the borders at this date (fig. 45) tells a different story. This section is full of landscapes (nos. 17–21 and 27–9) evoking the same idea of resowing the old battlefields. The number, quality and variety of the paintings exhibited here from this thirty-year period in comparison to the previous section (of the same duration) is a tribute to the rebirth of Flemish culture during the rule of the Archdukes.

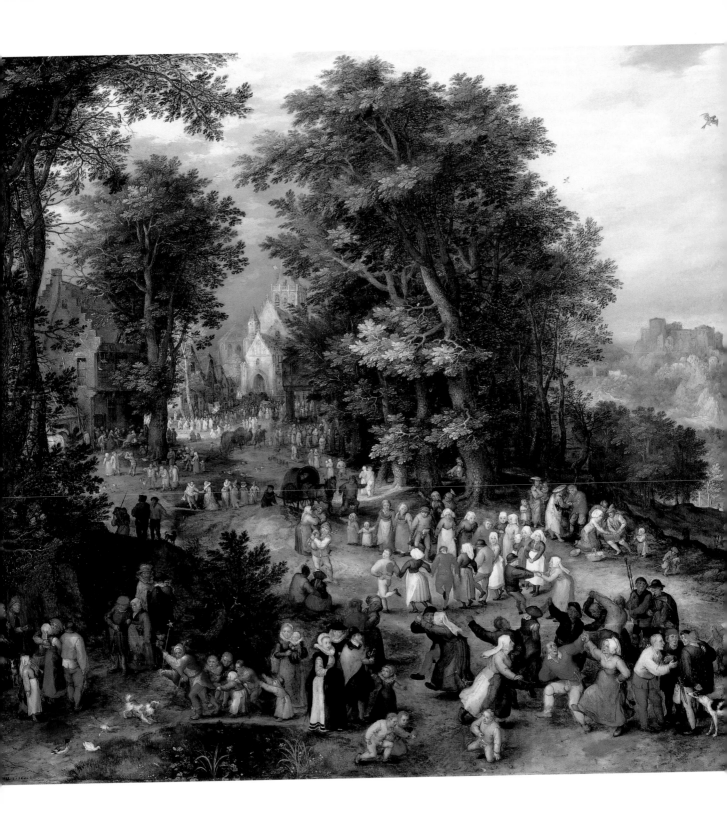

Jan Brueghel was the son of Pieter Bruegel the Elder, born a year before his father died. He spent the years 1592–5 in Italy, where – unlike his friend Rubens – he seems to have presented himself as the archetypal Flemish artist, specialising in landscape, flower and animal painting and employing a meticulous jewel-like technique. As we have seen from Cardinal Federigo Borromeo's panegyric of his friend's work (quoted on p. 29 above), Italian patrons were perfectly capable of appreciating these qualities, whatever their thoughts about what the highest form of art should be like.

This magnificent landscape (in perfect condition) depicts a *Kermis* or fair, during which a religious festival is celebrated by a rustic street party. The same subject had been treated by Pieter Bruegel the Elder, in his *Peasant Dance* of *c*.1568 (fig. 11), as a 'Vanity Fair' of drink-fuelled folly and vice. Jan Brueghel by contrast sees the Kermis as an emblem of the happiness of a well-ordered society at play. He adopts his father's technique, seen better in the *Massacre of the Innocents* (no. 14) and other works than in the *Peasant Dance*, of the universal panorama of life, with as many legible mini-incidents as space and ingenuity permit. This small copper is an inexhaustible record of life, which its original owner must have spent

18

JAN BRUEGHEL THE ELDER (1568–1625)
A Village Festival
Oil on copper
47.6 x 68.4 cm
Signed and dated 1600
RCIN 405513
Bought by Frederick, Prince of Wales, in 1750
(along with no. 19, though the two works were not originally conceived as a pair)
White, no. 9

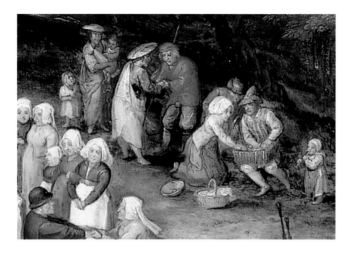

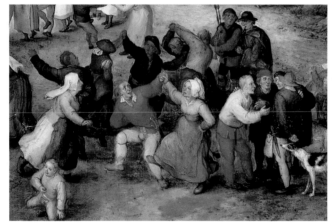

many hours reading and probably understood in a way that we never can. In the background bystanders kneel before the religious procession approaching the church. The inn in the left background is full; amongst many groups we can just make out a ring of peasants playing dice on a tree-stump table (*Stammtisch*). In the middle ground two groups of peasants dance in a ring to the sound of bagpipes and hurdy-gurdy; a pair of children are trying to learn the same moves. One elderly woman in the near group has a ring of keys held on a cord, which flies out from her waist as she spins. Behind the nearer ring to the right there is a toy-seller (who has recently sold a hobbyhorse), a beggar or peddler in red talking to a man and his wife who appear to be in biblical fancy dress, with hats designed to look like haloes (see Introduction, p. 20). The festivities are enjoyed by two groups of prosperous middle-class observers: one party of gallant young lovers (in the middle ground) have courtly manners which contrast with the peasant couple billing in the cart; the nearer group seems to include three generations of a single family, with their nursemaid. A jester is chased away (or possibly restrained with demands for an encore) by a group of children. Some beggars arrive at the extreme left foreground; children play *boules* across the centre; and an elderly couple share a ride home to the right, taking their flag and a basket full of produce.

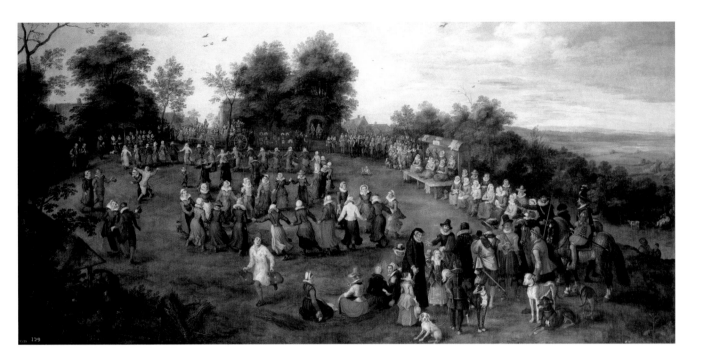

It is difficult not to see all this fun as a celebration of the abatement of the war and an expression of hope for lasting peace. This mood perhaps emerges more clearly when we remember that Jan's brother, Pieter Brueghel the Younger, was painting replicas of their father's *Massacre of the Innocents* (no. 14 and fig. 39) at this date, allowing these two visions of village life in Flanders to be compared by their contemporaries. This is an early example of a type of image which defined the hopes and ideals of the rule of the Archdukes Albert and Isabella. Later examples of this subject, also by Jan Brueghel (e.g. fig. 49), depict the Archdukes themselves watching the festivities, as the city-dwellers do here. Such images express the way in which the Archdukes (though foreign dynastic overlords) sought to present themselves as 'embedded' in Flemish society.

The arrangement of the landscape in no. 18 has the same combination of Flemish foreground and Alpine distance seen in Pieter Bruegel the Elder's work (compare fig. 54). Jan Brueghel here loses the mountains in the clouds with an indistinctness especially admired by the English theorist Edward Norgate, who advises artists to 'express your remote *Mountaines* and grounds with a certaine airie *Morbidezza,* or softnes, which is another remarkable grace and ornament to your worke'.

FIG. 49
Jan Brueghel, *Peasant Dance in Honour of the Archdukes,* 1623; oil on panel
(Museo Nacional del Prado, Madrid)

19

JAN BRUEGHEL THE ELDER (1568–1625)
Adam and Eve in the Garden of Eden
Oil on copper
48.5 x 65.8 cm
Signed and dated 1615
RCIN 405512
Bought by Frederick, Prince of Wales, in 1750
(along with no. 18, though the two works
were not originally conceived as a pair)
White, no. 10

Jan Brueghel was a meticulous but not an unintellectual painter. It is clear that he had a considerable knowledge of natural history and that his paintings were (and may still be) enjoyed as reliable and encyclopaedic accounts of the natural world. As court painter to the Archdukes, Brueghel was able to study botanical specimens in their garden in Brussels and fauna in their menagerie (though, like Rubens, he chose to live and work in Antwerp). Also he had visited Prague in 1604, where he must have seen the more famous menagerie and zoological library of Rudolph II. According to the Scriptures, the male and female of every species in the world were present in the Garden of Eden, where they had been named by Adam in a universal (pre-Babel) tongue. In theory therefore the whole of pre-Darwinian zoology could be retrieved through a depiction of this subject. This is clearly the spirit in which this work would have been enjoyed; we are invited to recognise and name as many species as we are able. Some of Brueghel's animals – the horse, lions and leopards – have been copied from paintings by Rubens, but he may have checked them against the real thing or against other images. The elephants perhaps seem to rely on hearsay, but the general standard of zoology is remarkably high.

The animals have sometimes been read emblematically; in particular, the elephants are seen as symbols of virtue in counterbalance to the evil represented by the snake. The kingfisher in the foreground may

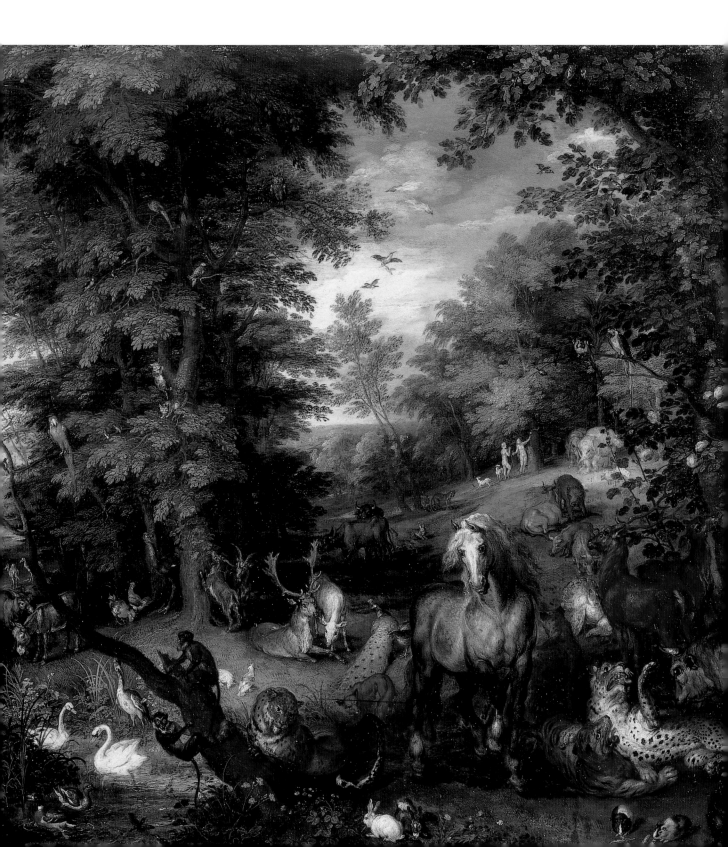

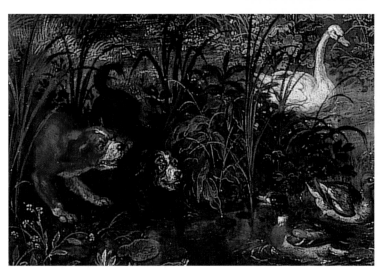

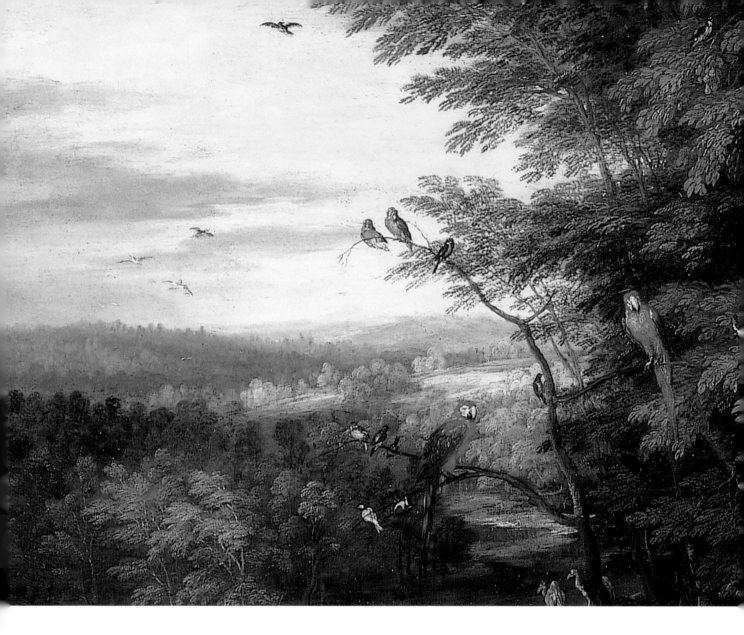

refer to the peace enjoyed in the Garden of Eden as this bird (genus *Halcyon*) was said in Greek mythology to make its nest on the waves of the sea during times of calm (hence 'halcyon days'). The scene certainly expresses the more general idea that in the Garden of Eden 'the lion lay down with the lamb'; in this depiction the leopard plays near the ox and the spaniel befriends the duck.

 The landscape here tells us what paradise looked like in the imagination of Brueghel and his contemporaries. Soft morning light is seen through an interrupted cloud cover, promising an alternation of sunshine and soft showers. The gently rolling terrain is a mixture of clearings and woodland (the trees laden with fruit). The entire landscape of Eden possesses a vivid blue-green colour cast. It corresponds closely with van Mander's description of the spring written a few years earlier: 'During the joyful Spring time we should notice the land's adornment with colours of precious stones, and endeavour to paint the emerald green and sapphire blue cover of the land with its subtle variegation. And through the midst of this let the crystal-clear, murmuring stream meander between its green and grassy banks.' It is worth noting the contrast between this terrain and the improbable Alpine vista of no. 18 or the torrid hillsides of no. 17, and, more revealingly, its remarkable similarity to the lie of the land and the weather conditions in Rubens's Eden-like vision of Flanders (no. 29).

ROELANDT SAVERY (1576–1639)
Landscape with Birds
Oil on panel
39.8 x 60 cm
Signed and dated 1615
(which could be read 1612)
RCIN 405510
Acquired by James II
White, no. 75

The Savery family were Protestants from Kortrijk (Courtrai), who fled to the northern Netherlands when the town fell to the Spanish in 1580. Roelandt Savery worked for his entire career in the Dutch cities of Haarlem, Amsterdam and Utrecht, except for the decade he spent at the court of Rudolph II in Prague (1603–13). While in Prague Savery must have encountered Jan Breughel (who was there in 1604); he studied Rudolph's menagerie and made a trip to the mountainous Tyrol region in 1606–7, which he recorded in numerous topographical drawings.

Roelandt Savery and his brother Jacob both painted the animals in Eden in the encyclopaedic manner of Jan Breughel's *Adam and Eve in the Garden of Eden* (no. 19). This landscape displays a similar interest in natural history – many species of bird can be recognised, including herons, storks and bitterns – but this is no Eden. We are in the depths of a pathless and swampy forest, a place of fear. This is the *Urwalt*, which haunted the European imagination from Albrecht Aldorfer to Wagner. The ruin, which clearly prompts a meditation upon decay and death, provides the most obvious contrast with the fruit trees of Eden. Savery expresses the fear and fascination of this scene with a linear (almost graphic) application of paint, creating tangled Gothic patterns reminiscent of the prints of Albrecht Dürer (1471–1528), which were much admired in Prague at this time.

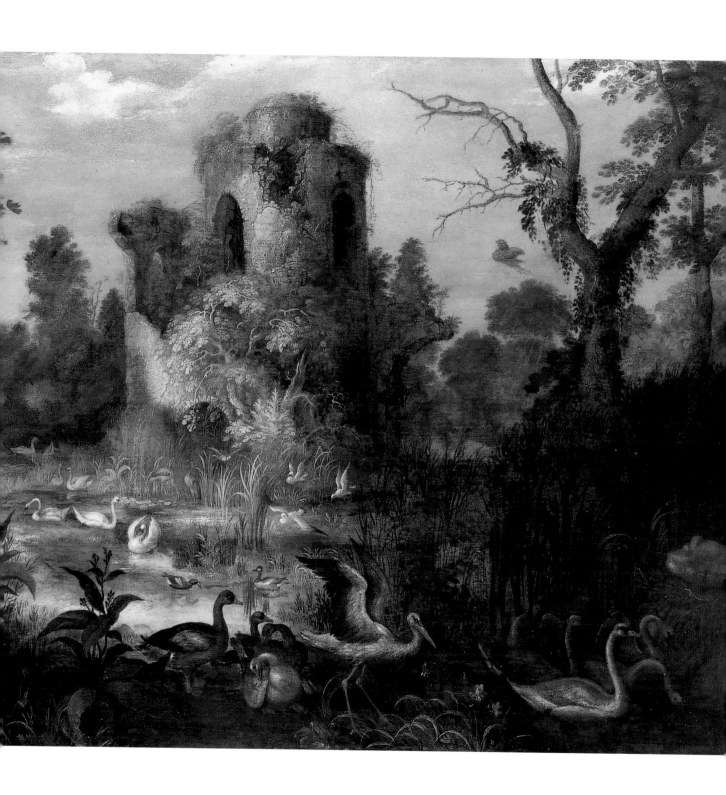

21

ROELANDT SAVERY (1576–1639)
Lions in a Landscape
Oil on panel
28.3 x 39.8 cm
Signed and dated 1622
RCIN 405627
Presented to Charles I by his nephew Charles
Louis, Elector Palatine
White, no. 76

Like no. 20, this painting draws upon Savery's familiarity with the menagerie of Rudolph II in Prague, though it was executed after his return to the northern Netherlands, where it must have been acquired by a member of the family of the Elector Palatine, who from 1622 was living in exile in The Hague. Even more than the previous scene this represents hostile nature, the 'forests of the night', where savage beasts lurk in the shadows and seem almost to embody the fear of darkness.

There is perhaps a religious overtone to this scene; we are in a dark cave (the top of which is clearly visible on both sides) surrounded by lions and looking out into the light. Like Rubens's contemporary *Daniel in the Lions' Den* (National Gallery of Art, Washington DC), this would surely have reminded even a Protestant viewer of the words of the *Offertorium* of the Requiem Mass: 'Jesus Christ, Master, King of Glory, deliver the souls of all the faithful dead from the pains of hell and the deep abyss; deliver them from the mouth of the lion, that the pit may not swallow them and that they may not fall into darkness, but may St Michael, the standard-bearer, bring them back into the holy light.' In this context the brightly lit hill surmounted by trees is suggestive of Calvary (the hill where Christ was crucified between two thieves), from which all hope of salvation comes. Rembrandt's print *The Three Trees* (Bartsch 212) employs exactly this symbolism.

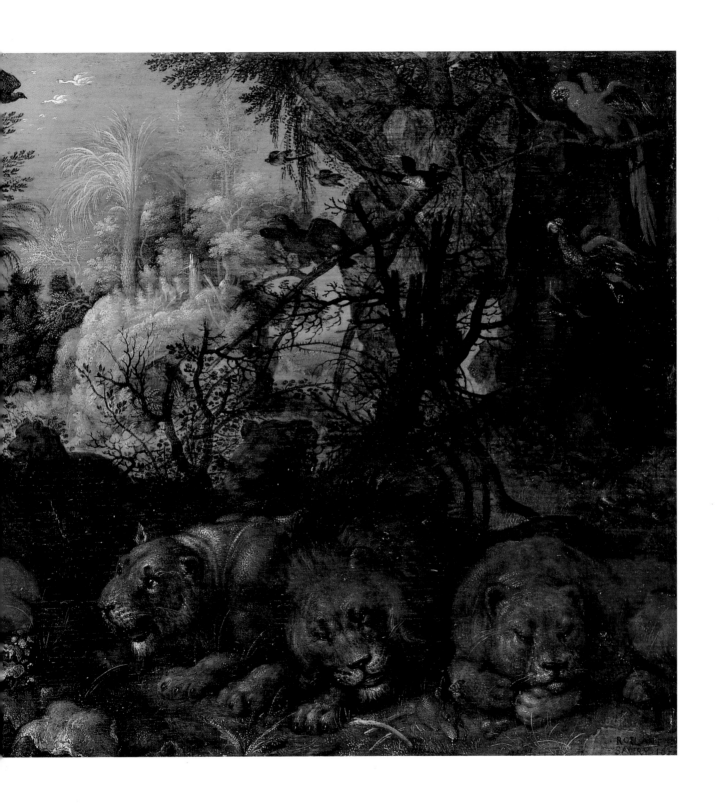

22 and 23

HENDRICK VAN STEENWYCK THE YOUNGER
(c.1580–1649)

Figures on a Terrace
11.9 cm diameter
RCIN 404718

Liberation of St Peter
12.5 cm diameter
RCIN 404719

Both oil on copper
c.1615
Both first recorded in the collection
of Charles II
White, nos. 89 and 90

According to Karel van Mander, Hendrick van Steenwyck the Elder (c.1550–1603) was a pupil of Hans Vredeman de Vries (1526–1609; no. 13). His son Hendrick the Younger was born in Antwerp in c.1580 and in 1585, after the Spanish reconquest of Antwerp, Hendrick the Elder took the family to Frankfurt in order (in van Mander's words) 'to escape the cruelties that Mars, a bitter enemy of art, inflicted on the people there'.

Having trained with his father, Hendrick II probably returned to Antwerp some time in the first years of the seventeenth century, before departing for London. There he seems to have lived from 1617 to 1637, during the heyday of the courts of James I and Charles I. He finished his career in The Hague in Holland.

These two tiny roundels can both be dated to c.1615 and are similar but not identical in size and technique. They

may have been conceived as a pair or been joined in the collection of Charles II (or before) as a 'marriage of convenience'. They demonstrate two aspects of Steenwyck's art: the bright fantasy palaces, learned from de Vries, and the expressive torch-lit dungeons, inspired by prints after Adam Elsheimer (an artist he might have known in Frankfurt in the 1590s).

Both these scenes have morals that complement each other, whether or not they are conceived as a pair. Scenes of young aristocrats courting in pleasure gardens, to the sounds of the lute, would immediately have suggested to a contemporary viewer the idea of the heedless vanity of youth and the transitory nature of its joys. An illustration in an emblem book published in Strasburg in 1580, 'Octonaries [eight-line verses] on the Vanity and Inconstancy of the World' (*Octonaires sur la Vanité et Inconstance du monde*), shows a similar formal garden with the words 'The world is a garden, its pleasures are flowers . . . but Death is winter'. It is even possible that the transparent appearance of the buildings and the thread-like paint application (almost as if the scene is spun out of a spider's web) are intended to suggest that the pleasure garden is a dazzling but insubstantial phantom. St Peter's prison (for the subject, see no. 24) appears considerably more substantial.

HENDRICK VAN STEENWYCK THE YOUNGER
(*c*.1580–1649)
Liberation of St Peter
Oil on copper
48.3 x 66 cm
Signed and dated 1619
RCIN 403041
Perhaps acquired by Frederick, Prince of Wales
White, no. 84

The subject comes from the Acts of the Apostles (12: 6–7): 'the same night Peter was sleeping between two soldiers, bound with two chains: and the keepers before the door kept the prison. And, behold, the angel of the Lord came upon him, and a light shined in the prison: and he smote Peter on the side, and raised him up, saying, Arise up quickly. And his chains fell off from his hands.' The subject was popular because it suggests the idea of the soul of man liberated from the prison of the tomb, especially when, as in both no. 23 and no. 24, Peter is seen led up from out of a dark vault.

The angel bringing light into the prison had provided artists, from Raphael onwards, with an opportunity to create effects at once realistically observed and magically evocative. Steenwyck rationalises the aura of light surrounding the angel, by suggesting a flaming torch concealed immediately behind him. A similar device is used in *Jupiter and Mercury in the House of Philemon and Baucis* (Gemäldegalerie, Dresden) by Adam Elsheimer, which Steenwyck may have known through Hendrick Goudt's print of 1613.

Steenwyck also throws a variety of artificial lighting into the mix: fires, oil lamps and a false hint of daylight in the distance, to create the effect of a dungeon peopled with spirits and will-o'-the-wisps.

The development of architectural painting in the Netherlands leads from the simply aligned, linear and diagrammatic perspectives of Hans Vredeman de Vries (no. 13) towards the oblique views, textured surfaces and 'breathing' spaces of Gerrit Houckgeest (*c*.1600–1661) and Johannes Vermeer (1632–75). In this context Steenwyck's work appears forward-looking; the view here is frontal, but there is an extraordinary feel for the rough stone blocks and the way in which their textures and forms are unreliably and intermittently revealed by the light playing over their surfaces. As in the de Vries (no. 13), the perspective here demands that the eye be brought close to the surface of the copper (about 40 cm away); we are meant to peer into the darkness, to lose ourselves in this labyrinthine undercroft and to smell the dank air of a prison.

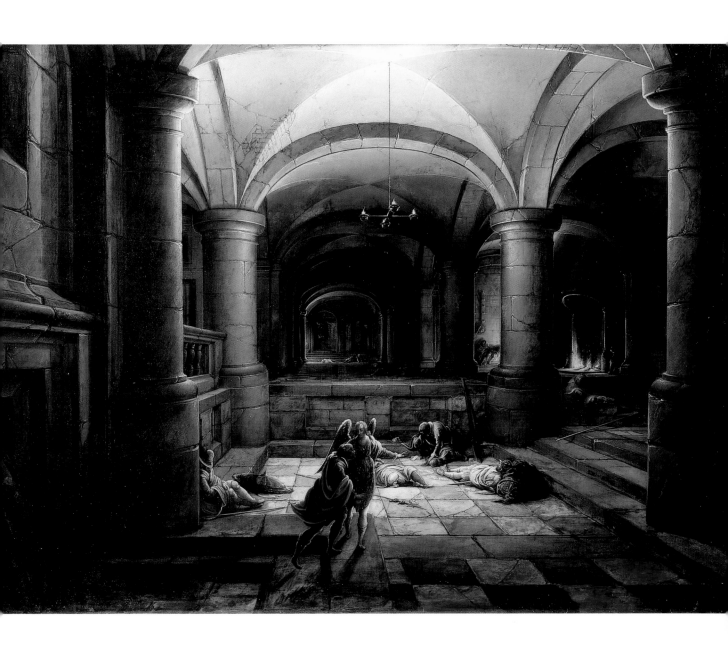

25

FRANS FRANCKEN THE YOUNGER (1581–1642)
Cabinet of a Collector
Oil on panel
77.1 x 119.2 cm
Signed and dated 1617
RCIN 405781
Acquired by George III from the collection
of Consul Smith
White, no. 32

Frans Francken the Younger was the
most famous of an Antwerp dynasty
of painters; he trained with his father,
Frans the Elder (1542–1616), and
joined the Antwerp guild in 1605. He
was a painter of religious and historical
subjects as well as being the inventor
of the genre presented here, the
collector's cabinet.

Collectors throughout Europe
tended to keep their most prized and
smaller possessions in a small private
study, called a 'cabinet' in French and
English (sometimes 'cabinet of
curiosities' or 'varieties'); in Italian it
might be called a *gabinetto*, *studiolo*
or *camerino*; in German a *Kunst-*,
Schatz- or *Wunderkammer*. These
spaces tend to be packed (rather than
arranged) with paintings, objets d'art
and natural curiosities. The crucial
word here is 'curiosity'; such collections
were formed to stimulate intellectual
curiosity, in every branch of human
enquiry, as well as providing aesthetic
pleasure. The English theorist of natural
philosophy Francis Bacon (1561–1626)
recommended in 1595 that a learned
gentleman should have a 'goodly huge
cabinet, wherein whatsoever the hand of
man by exquisite art or engine hath
made rare in stuff, form, or motion;
whatsoever singularity chance and the
shuffle of things hath produced;
whatsoever Nature hath wrought in
things that want life and may be kept;

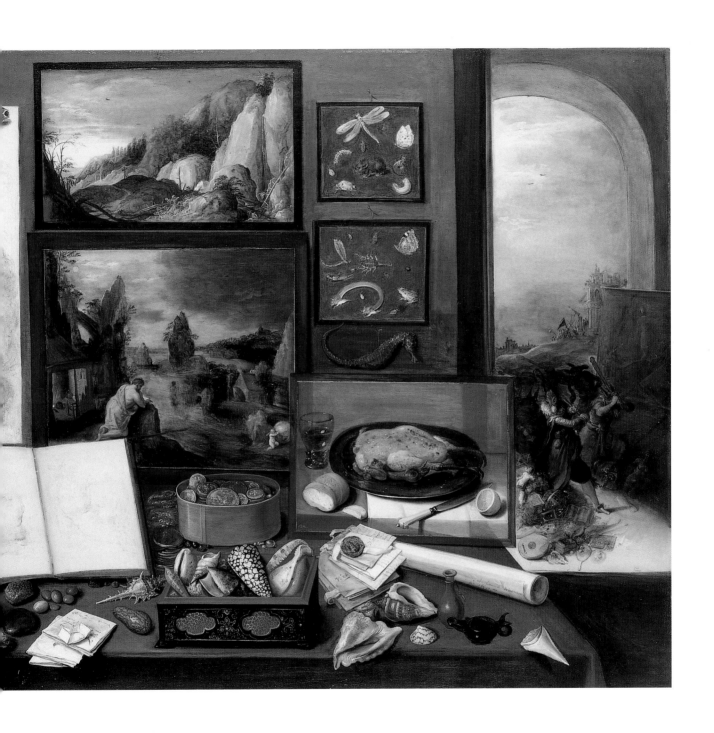

shall be sorted and included' (Bacon, *Gesta Grayorum*).

This assemblage includes a landscape by Joos de Momper (1564–1635); a still life of a mundane table set for a meal; and a small, nocturnal *Flight into Egypt*. The other religious painting deals with the subject of human enquiry; St Augustine is trying to comprehend the idea of the Trinity and sees a baby struggling to pour the entire sea into a pool in the sand with a shell – both tasks being equally beyond the compass of man. The drawings – two studies for Michelangelo's Sistine Chapel ceiling and a preparatory drawing for Raphael's *Madonna della Perla* (Prado, Madrid) – stress the intellectual side of painting. The two 'specimen paintings' depicting a range of fauna, including an

impossible two-headed eel, connect the works of art with the natural curiosities – shells, stones and stuffed fish. There are also letters, perhaps suggesting the exchange of scholarly opinion; exotic weaponry, a reminder of the importance of travel and trade; a handful of Roman coins and a bowl of modern ones, probably included to celebrate the achievements of great men, rather than as currency.

The most interesting passage occurs beneath the arch to the right: in the background a church is demolished and nearby donkey-headed fops with cudgels destroy a pile of objects associated with learning, science, the arts and sport. According to van Mander, a man with a donkey head is a symbol of ignorance. The episodes

depicted here recall two historical events: the *Beeldenstorm*, an outbreak of iconoclasm carried out by Protestants in 1566 (pp. 75–6 and fig. 35); and the 'Spanish Fury', the sack of Antwerp in 1576 (pp. 94–5 and fig. 44). It is interesting that for Frans Francken the sin of the donkey-heads is not sacrilege (the iconoclast's sin in the eyes of Roman Catholics) or anger (or whatever other sin might be ascribed to violent Spanish soldiery) but stupidity.

One of the coins bears the names of the Archdukes Albert and Isabella, the rulers of the southern Netherlands at this time of the Twelve Year Truce (1609–21); the painting would seem to celebrate the wisdom of their rule, which can allow curiosity to flourish and keep ignorance at bay.

SIR PETER PAUL RUBENS (1577–1640)
Assumption of the Virgin
Oil on panel
102.1 x 66.3 cm
1611–12
RCIN 405335
Acquired by George IV
White, no. 57

Rubens epitomises the cultural regeneration of Flanders during and after the reign of the Archdukes. His father was a Calvinist who fled to Cologne in 1568 at the very beginning of the war (Rubens himself was born in Siegen in Germany). Rubens's Catholic mother brought the family back to Antwerp, where Rubens trained as an artist with Tobias Verhaecht (1561–1631), Adam van Noort (1562–1641) and Otto van Veen (1556–1625), all more important names in the 1590s than today. He spent eight years and built a successful career in Italy, and seems only to have been attracted back to the Netherlands by the prospect of the truce (1609–21). He served the Archdukes as a court painter (with dispensation to live in Antwerp rather than Brussels) and

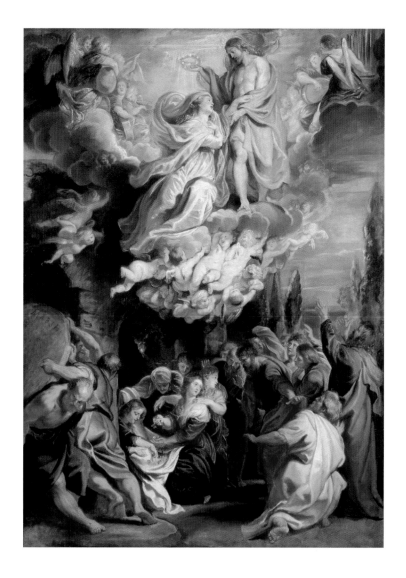

FIG. 50
Peter Paul Rubens, *The Coronation of the Virgin*, 1611; oil on panel, transferred to canvas (State Hermitage Museum, St Petersburg)

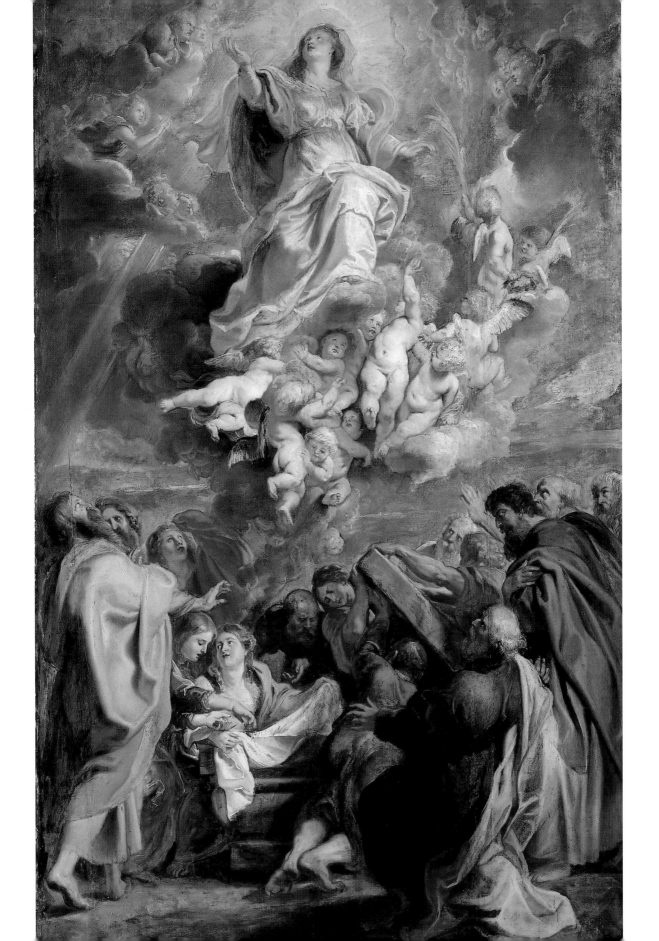

131

diplomat. A loyal glimpse of the gold chain given to him by Archduke Albert appears in his 1623 *Self Portrait* (no. 30).

The subject of the Assumption of the Virgin is described in no. 16 above; Rubens departs from usual practice in including the sisters, Sts Mary and Martha, symbols of the active and contemplative life, with the Apostles round the tomb.

The best explanation for this painting is that it was one of two presentation oil sketches (*modelli*) which Rubens made in 1611 in a bid to secure the commission to paint the Assumption of the Virgin for the high altar of Antwerp Cathedral. The other is in the Hermitage Museum (fig. 50); the final altarpiece, which Rubens did not deliver until 1620, is now in the Kunsthistorisches Museum in Vienna (fig. 51). Obviously the nuns of the church did not make a simple choice of one or the other design, but went rather for a mix-and-match of elements: the upper half largely following the oil sketch in the Royal Collection and the lower half that in the Hermitage. The only problem with this explanation is that

no. 26 has appeared to many scholars to be later in date than its Hermitage counterpart, though when they were hung together in the recent exhibition at the National Gallery, *Rubens: a Master in the Making*, it seemed quite possible that they were painted at the same time. If these two oil sketches were presented as alternatives, then this provides a valuable insight into the kind of changes Rubens felt that he could ring. The iconography differs: no. 26 is an *Assumption*; the Hermitage painting a *Coronation* with music-making angels; this one has a sarcophagus tomb, that one a cave in the rock. The most interesting variation occurs in the lighting: the Hermitage panel shows a torch-lit, nearly night scene with a golden heaven; no. 26 shows a naturally lit evening scene with an azure heaven. Blue is the keynote colour here, suggestive of a luminous sky and symbolic of heaven. The Virgin here wears white to symbolise purity; she is usually shown wearing a blue cloak alluding to her status as Queen of Heaven. It is this symbolic blue that has somehow permeated every centimetre of this panel.

The other talent, which Rubens would wish his patrons to appreciate here, is variety. Twelve Apostles witness the same event and yet Rubens finds twelve different postures and emotions for them to adopt. The tangle of baby angels teases (literally amazes) the eye like a knot – as, in a different way, do the innumerable angel heads merging with clouds. For William Hogarth (1697–1764) one of the pleasures of painting is that it 'leads the eye a merry kind of chace'. But here this complexity has a spiritual meaning: it conveys the 'great multitude of angels' said to be keeping the Virgin company in her Assumption, and more generally the idea that heaven is beyond the compass of the human mind. Rubens's source is the *Assumption of the Virgin* painted on the dome of the cathedral in Parma in the 1530s by Correggio (*c*.1489–1534). A similar effect in the dome of S. Andrea della Valle in Rome painted by Lanfranco (1582–1647) in 1624 was described by Bellori as being like the sounds of a full choir where you appreciate the total effect without being able to distinguish the individual voices.

FIG. 51
Peter Paul Rubens, *The Assumption of the Virgin*, 1611–20; oil on panel (Kunsthistorisches Museum, Vienna)

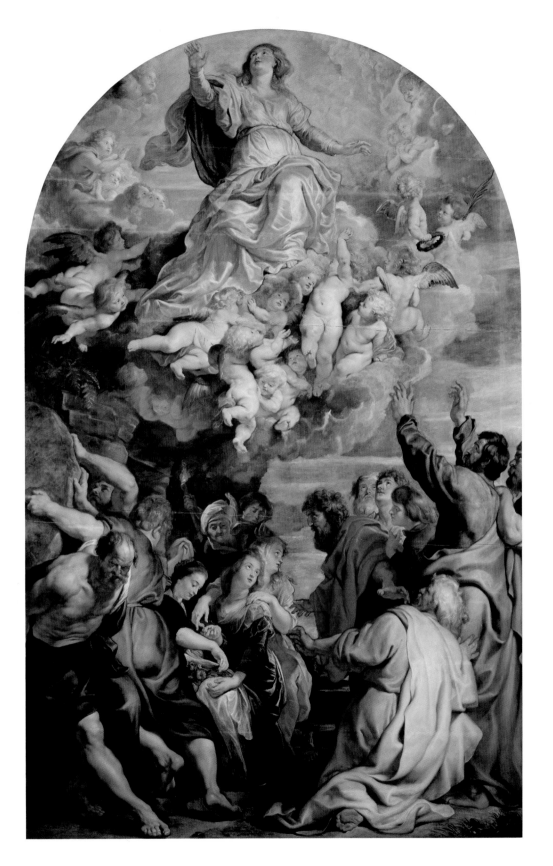

SIR PETER PAUL RUBENS (1577–1640)
Milkmaid with Cattle in a Landscape,
'The Farm at Laken'
Oil on panel
85.9 x 125.9 cm
1617–18
RCIN 405333
Acquired by George IV from the
collection of the Lunden family
White, no. 58

This magnificent landscape almost certainly came from Rubens's own collection (for a discussion of the provenance of the Lunden pictures, see no. 31). It was described in an inventory drawn up between 1634 and 1649 as a 'view of Laken' (a village near Brussels often spelt 'Laeken'), which is how it acquired its present subtitle. The church in the background with an avenue of trees does resembles (in a generic way) the now destroyed church of Our Lady at Laken (recorded in old photographs), which in the seventeenth century housed a famous relic – a girdle of the Virgin – and was a popular place of pilgrimage, especially for women wishing to conceive. The Archdukes attended processions to the church every year, and Albert commissioned a new window for the church following

its restoration in 1601. Rubens seems to have included the church in the same way that Brueghel does in his *Village Festival* (no. 18) to suggest that all good things take place with the blessing of the Church and perhaps, in view of the identification of the Archdukes with this particular shrine, under their watchful eye.

Rubens also tries to express these 'good things' through a depiction of autumn, when fruits and vegetables are being harvested (the ploughing for next year's grain crop is just visible on the hillside centre left). The figure group here derives from a Rubens *Adoration of the Shepherds* (Musée des Beaux-Arts, Marseilles), commissioned in 1616 for the church of St John in Mechelen and delivered in 1619. This echo provides a date for *The Farm at Laken*, but also strengthens the impression that the figures here are used almost as personifications: the central woman is without shoes (indicating idealisation rather than poverty); she resembles a caryatid, bearing a basket of produce on her head, and reads like an allegory of Plenty. In another context one might assume that the kneeling figure was offering a libation at an altar of Pan or some god of the woodlands. The flock of doves dramatically flying out of the picture towards us also conveys the familiar Rubensian idea of Peace, mother of Plenty.

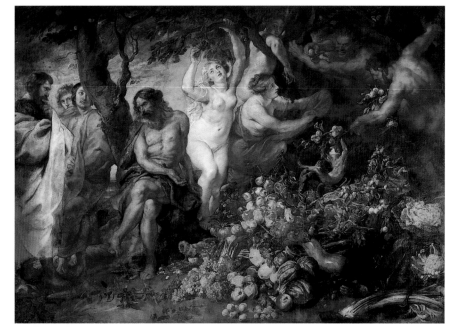

FIG. 52
Peter Paul Rubens and Frans Snyders, *Pythagoras Advocating Vegetarianism*, 1618–20; oil on panel (Royal Collection, RCIN 403500)

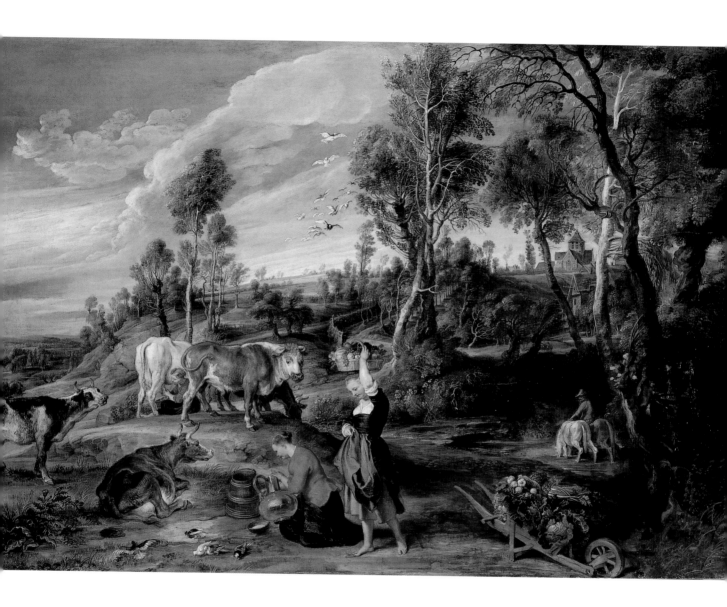

This is one of Rubens's earliest landscapes; his other essays in the genre at this date were hunts, violent scenes of danger set in wild woodlands – like the *Boar Hunt* of 1616–18 (Gemäldegalerie, Dresden). It is possible to imagine a pairing of *The Farm at Laken* and a hunt scene (possibly in Rubens's dining room)

to express the contrast between the activities and terrain, which bring meat and vegetarian fare to the table. If so, this painting becomes a sort of allegory of vegetarian fertility and anticipates Rubens's depiction of Pythagoras urging his followers to eat vegetables (fig. 52), also created for his own house.

Like most Rubens landscapes, this one has grown in the making, gaining 15 cm to the right, 7 cm to the left and 13 cm at the top. It is possible to pick out the original painted area with the naked eye: the top-left corner would just have included the bright cumulus cloud formation, the bottom-right corner the wheelbarrow.

SIR PETER PAUL RUBENS (1577–1640)
Winter: The Interior of a Barn
Oil on canvas
121.4 x 223.1 cm
*c.*1618–19
RCIN 401417
Bought from Rubens by George Villiers,
1st Duke of Buckingham; subsequently
acquired by Frederick, Prince of Wales
White, no. 67

This landscape and the following one seem to have been a pair in the collection of the Duke of Buckingham, but may not have been when Rubens originally executed them for his own amusement and delight. It is possible that Rubens attached the 60-cm strip to the left-hand side here (adding everything to the left of the upright just behind the farmer leaning on his fork) in order to make the widths identical. But, as we have seen, Rubens seems to have enjoyed 'growing' his landscapes without any such purpose. This is a typical example of an 'original' composition which works very well as it is – with a simple barn stage, framed by the farmer and his wife – to which he has added a new episode and almost a new vanishing point.

This scene is a rare example of Rubens exploring the mundane technology of farming, and as such it belongs with his *Prodigal Son* of 1618, also in his own collection (fig. 53), and a group of drawings of farm labourers, apparently observed from life. Rubens's *Prodigal Son* is a powerful treatment of the biblical subject, not just an excuse to paint a farmyard, and it is tempting to look for something similar here. In a general way a depiction of a barn in winter is reminiscent of the Nativity. There are other allusions which suggest that Rubens wishes to encourage us to explore the meaning of the figures in this scene: the boy blowing on a coal refers to a lost antique painting by Lycius, pupil of Myron, and made famous through Pliny's description of a 'boy blowing a dying fire' (Pliny XXXIV, 79). There is also an echo of the three ages of man, with the children, their mother and grandmother, whose grotesque yawn is a typical piece of low-life comedy in the tradition of Bruegel. The subject of a woman tending several children, with an exposed breast, would remind a seventeenth-century viewer (at least one educated enough to be visiting Rubens) of an allegory of Charity, a virtue also suggested by the crippled beggar (shoeless with a crutch) who has been invited to join the family by the fireside. The message of the Nativity is thus conveyed without depicting Bethlehem.

FIG. 53
Peter Paul Rubens, *The Prodigal Son*, 1618;
oil on panel (Koninklijk Museum voor Schone Kunsten, Antwerp)

SIR PETER PAUL RUBENS (1577–1640)
Summer: Peasants Going to Market
Oil on canvas
143.4 x 222.9 cm
*c.*1618
RCIN 401416
Bought from Rubens by George Villiers,
1st Duke of Buckingham; subsequently
acquired by Frederick, Prince of Wales
White, no. 68

As discussed above, this landscape has
been treated as a pair with no. 28 as
they hung together in the collection of
the Duke of Buckingham. They are of
similar (though not identical) size and
depict contrasting seasons and times of
day. This landscape may be the 'Aurora'
mentioned by Edward Norgate as
having been at York House (the London
residence of the dukes of Buckingham).
Aurora is the goddess of the dawn and
there are examples of this name being
used as the title of landscapes depicting
sunrise, without mythological figures,
such as Elsheimer's tiny copper *Aurora*
of *c.*1606 (Herzog Anton Ulrich
Museum, Brunswick), widely known

through Hendrick Goudt's print
of 1613.

This scene clearly represents early
morning, when everyone sets off for
market, even if the sun is relatively high
in the sky. There are other examples
where Rubens uses the hour to set the
mood of a landscape; in *Winter* (no. 28)
it is the approach of nightfall that
prompts the characters to huddle round
the fire. Here farmers issue from every
corner of the landscape, as if called by
the rising sun, and pour down from the
hills into the valley. This metaphor of
'pouring' seems to be quite deliberately
expressed – in the middle distance
a flock of sheep are painted in an ever

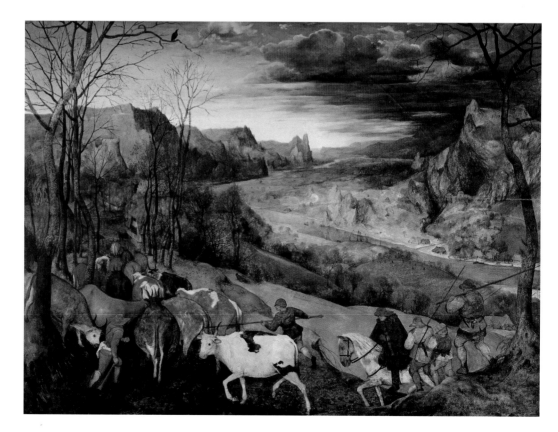

FIG. 54
Pieter Bruegel the Elder
The Return of the Herd, 1565;
oil on panel
(Kunsthistorisches
Museum, Vienna)

more coalesced fashion as they move away from us until they become a single molten mass. The way in which the dawn light is painted over the tops of the hills also seems to express this idea of light 'pouring in' over the landscape. Rubens was familiar with the pastoral poetry of antiquity and would have believed that painting should be able to match the effects of poetry. This human river leads towards the market town in the middle distance, with a church spire clearly visible. The church and the shafts of light piercing the clouds above (in a moist summer sky such as occurs in Eden, no. 19) seem to confer a divine blessing on the scene. The landscape also expresses the idea of abundance, which finds a specific personification in the peasant woman riding side-saddle with a copper vessel in the centre – an idealised shoeless figure like that in *The Farm at Laken*, no. 27. Abundance flows from peace – this landscape and the previous one are in this sense the archetypal Archduke paintings, expressing the optimism of the Twelve Year Truce.

This is Rubens's first essay in the Bruegelian panorama (sometimes called *Weltlandschaft*) and can be compared to Bruegel's *Return of the Herd* of 1565 (fig. 54). The terrain is subtly different: though the elevated viewpoint suggests a mountainous landscape (as in the background of no. 18), everything beyond the immediate foreground depicts the flat, fertile plains of the Low Countries, with what slight hills may be found exaggerated to create a rolling sea-like terrain. We are looking onto this garden from the fringes of the wilderness – the forest to the left and the mountains to the right. The castle to the left seems to straddle the two worlds – at once a fort (like the one seen in the background of no. 18) – and a formal garden.

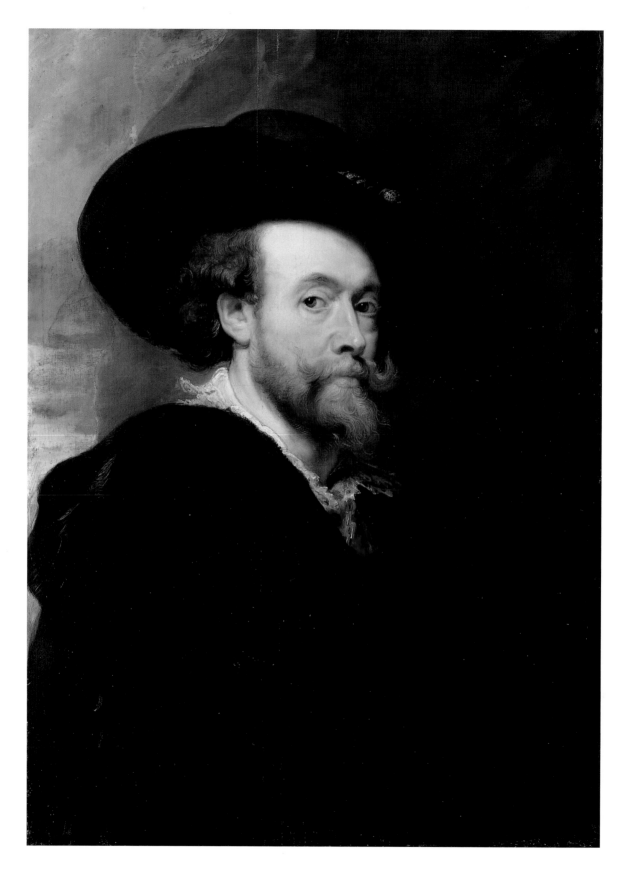

This painting seems to have been something of a face-saver. In 1621 Rubens supplied Lord Danvers with a *Lion Hunt* (now lost), a studio work, not knowing that it was intended for Charles, Prince of Wales. Danvers had it sent back as 'a peese scarse touched by his own hand'. Rubens seems to have planned with Lord Danvers to make a peace offering to the Prince the moment he realised his mistake. Later Rubens claimed that he was concerned at the arrogance of sending a self portrait under these circumstances: 'though to me it did not seem fitting to send my portrait to a prince of such high rank, he overcame my modesty' (Rubens, letter of 10 January 1625 to Palamède de Fabri, Sieur de Valavez; 1582–1645). The most important thing, however, was that the work should be executed by Rubens and not his assistants: Lord Danvers wrote to William Trumbull in Brussels, asking 'for his owne picture made originall and every part of it wrought with his owne hand' (letter of 18 December 1622). Danvers adds in the same letter that this is a self portrait 'which I heare hee hath made alreadie'; it is difficult to know if this means that Rubens redirected an existing (obviously recent) self portrait, or whether enough progress had been made on the portrait which Danvers himself instigated (through some previous, now lost, instruction) for word to get out that it was 'made alreadie'. Whatever the explanation, the portrait is signed and dated 1623 and seems to have arrived in London in that year.

This is an interesting piece of self-promotion; it does not advertise Rubens's invention, figure drawing or story-telling, important elements of his art. Instead we see purely pictorial qualities at their most intense: contrast of light and dark, with shades of deep black and a softly luminous face; strong accents of colour on the face and sky (again contrasting with the areas of black); variations of paint application from thinly scrubbed areas in the background, where brown underpaint shows through, to the thick, mobile rivers of oil paint, drawn by the brush, over the face. Rubens's 'owne hand' is obviously and everywhere at work.

The objects in the background of this portrait could be described as 'a rock and a reddening sky', which, in Latin, would read, *Petrus et caelum rubens*. It has been suggested that the artist included them as a play on his own name (reinforcing the Latin signature), or indeed that the whole portrait depicts a shame-faced, blushing or *rubens* Rubens.

SIR PETER PAUL RUBENS (1577–1640)
Self Portrait
Oil on panel
85.7 x 62.2 cm
Inscribed: *Petrus Paullus Rubens / se ipsum expressit / A.D MDCXXIII / Aetatis Suae XXXXV* (Peter Paul Rubens depicts himself, in the year 1623, when his age was 45)
RCIN 400156
Commissioned by Henry Danvers, Earl of Danby, as a present for Charles I when Prince of Wales
White, no. 61

31

SIR PETER PAUL RUBENS (1577–1640)
Portrait of a Woman
Oil on panel
86.8 x 59.3 cm
Late 1620s
RCIN 400118
Acquired by George IV from the collection of the Lunden family
White, no. 62

The Lunden and Rubens families were connected by marriage; in 1622 Arnold Lunden married Susanna Fourment (1599–1643); in 1630 Rubens married her younger sister, Helena Fourment (*b.*1614). In 1660 Arnold's nephew, Jean-Baptiste Lunden, married Rubens's granddaughter, Hélène-Françoise Rubens. The Lunden family collection included paintings, like *The Farm at Laken* (no. 27), which would seem to have come from Rubens's own collection, as well as specifically Lunden works, like the portrait possibly depicting Susanna Lunden, the *Chapeau de Paille* (fig. 55). No. 31 may be the 'picture of a woman with her hands one vppon another' listed in Rubens's house at his death. When the Lunden collection became available in the early nineteenth century, George IV bought this painting (along with *The Farm at Laken*, no. 27), as a portrait of Rubens's wife, Helena Fourment. The *Chapeau de Paille* was offered to him and is the only work he is ever known to have refused on grounds of cost. Both these portraits (no. 31 and the *Chapeau de Paille*) have an informal and engaging charm entirely consistent with their claim to be portraits of Rubens's own extended family. In neither case is there much evidence for a more precise identification; the Royal Collection portrait does not seem to depict

FIG. 56
Peter Paul Rubens, no. 31 verso: *Three Studies for Occasio*, 1630s; oil on panel

Helena, whose features are well recorded in other images, but the name of another Fourment sister, Elizabeth (born 1606), has been suggested.

On the back of this panel (fig. 56) is a summary oil sketch by Rubens for an allegorical subject, a warrior seizing Opportunity (*Occasio*) by her forelock, which can be connected with a (now lost) painting of the 1630s. Unlike most of Rubens's oil sketches, which can be (and were) enjoyed as completed paintings (see no. 26), this is a 'work-in-progress'. It appears from the technical evidence that Rubens used the back of his portrait for the oil sketch rather than vice versa – another reason to suppose that this portrait remained in his studio. The fact that Rubens made temporary use of a spare panel surface does not mean however that this beautiful portrait was ever despised or discarded.

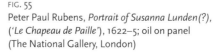

FIG. 55
Peter Paul Rubens, *Portrait of Susanna Lunden(?)*, (*'Le Chapeau de Paille'*), 1622–5; oil on panel (The National Gallery, London)

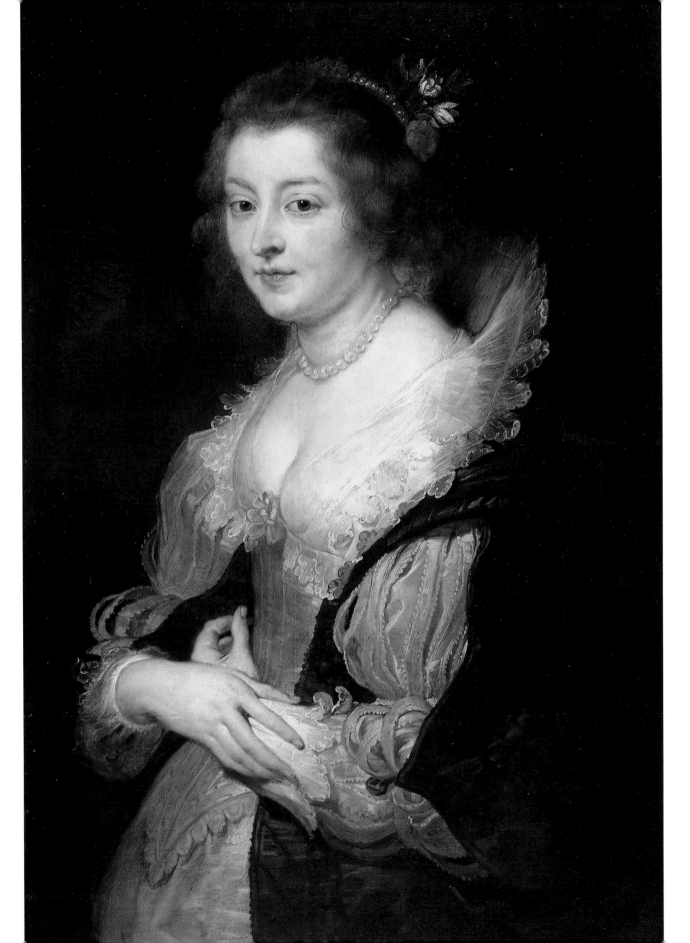

SIR PETER PAUL RUBENS (1577–1640)
Anthony Van Dyck
Oil on panel
64.9 x 49.9 cm
1627–8
RCIN 404429
First recorded in the collection of Charles II
White, no. 60

This portrait is a testament to the friendship of the two greatest masters of Flemish seventeenth-century painting. Anthony Van Dyck (1599–1641) was born in Antwerp and studied with Hendrick van Balen (*c.*1575–1632); in 1618 he became a master of the Antwerp guild at the extraordinarily young age of 19; at the same time he elected to join Rubens's studio (as an assistant rather than a pupil, while maintaining his own studio with pupils), remaining there until 1620 and painting some of his most dramatic figure compositions (including no. 34). Van Dyck spent the winter of 1620–21 in London in the service of James I. In October 1621 he set off for Italy (initially in the retinue of the Countess of Arundel), where he worked in Palermo and Genoa as well as visiting the major artistic centres, Venice, Rome and Florence. Van Dyck was back in Antwerp by July 1627, where

he was created court painter by the Archduchess Isabella; he remained there until July 1632 when he was in London, being knighted and created 'Principalle Paynter in Ordinarie to their Majesties' Charles I and Queen Henrietta Maria. He was largely domiciled in England for the rest of his life, though he seems to have had plans in late 1640 to return to Flanders, perhaps to profit from Rubens's death in May of that year.

This portrait must have been painted between July 1627, when Van Dyck returned to Antwerp from Italy, and August 1628, when Rubens left Antwerp for Spain. It is copied precisely in the much smaller portrait of Van Dyck, which appears with a group of Antwerp luminaries – including the Archdukes Albert and Isabella and Rubens himself – in Willem van Haecht's *Gallery of Cornelis van der Geest*, signed and dated 1628 (Rubenshuis, Antwerp).

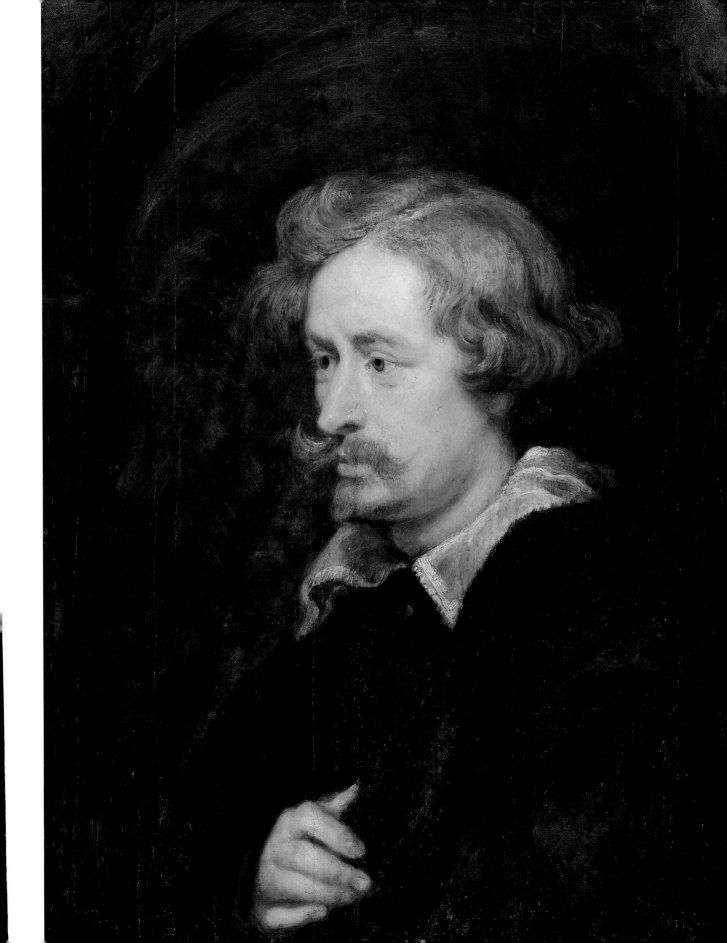

33

PHILIP FRUYTIERS (1610–66)
Four Children of Peter Paul Rubens and Helena Fourment with Two Maids
Watercolour and bodycolour on vellum, laid down on panel
25 x 34 cm
1638–9
RCIN 452433
First recorded in the Royal Collection in 1890
White and Crawley, no. 362

It has often been thought that Philip Fruytiers was taught by Rubens, and this informal watercolour of four of Rubens's small children certainly seems to indicate a close relationship between the two artists. The group portrait was very likely to have belonged to Rubens himself, who died shortly after its creation.

Despite the fact that Fruytiers is relatively unknown today, he was celebrated in the seventeenth century as one of the best artists of the Antwerp school, and numerous paintings and designs by him were engraved. Sadly, it is now only through the resulting prints that we can glean his output since only a handful of works can be firmly linked to his name.

This scene depicts a group of four children accompanied by their maids. They have been identified as Clara-Johanna, Frans, Isabella-Helena and Peter-Paul, children of Rubens's second marriage, to Helena Fourment, who was known as 'the most beautiful woman in Antwerp'. They would have been aged approximately 7, 6, 4 and 2 respectively. The group is articulated much like a Roman frieze, moving from right to left along the picture plane. The eldest girl looks out to engage the viewer, whereas the brother next to her is more intent on their destination, gazing firmly ahead, his impatience marked by the manner in which he holds his sister's hand as though to hurry her along. Likewise the two younger siblings are joined by their hands, Isabella-Helena turning back to help her little brother, who is riding a hobbyhorse.

The maids convey two separate emotions. The younger of the two enthusiastically leans down towards Peter-Paul, her right hand gesturing in the direction of their procession. The older maid is depicted sharply in side-profile, her left hand holding a basket of fruit. The stern expression on her face seemingly indicates her character, but the awkwardness of her pose gives the viewer a glimpse into the reality of the image. Although the group apparently are heading off to play and to picnic on the fruit in the basket, it is of course wholly staged, set by Fruytiers with a theatrical backdrop of two classical archways leading down to the countryside beyond. Whilst the children and younger maid readily participate, the severe immobile figure framing the right hand of the image slightly mars the charming illusion of spontaneity in the scene.

34

SIR ANTHONY VAN DYCK (1599–1641)
Christ Healing the Paralytic
Oil on canvas
120.7 x 149 cm
*c.*1619
RCIN 405325
Acquired by George IV
Millar, no. 164

This is the work of a supremely brilliant 20-year-old artist working in Rubens's studio and very possibly executing a Rubens design, under the supervision of the elder master. This compositional type – an intense, spectator-jostling drama where the canvas area is barely able to contain a small number of half-length figures – was invented by Caravaggio (1571–1610). An excellent example, *The Calling of Sts Peter and Andrew* of *c.*1605, is in the Royal Collection. The type was frequently copied by Italian and Netherlandish artists during the first two decades of the seventeenth century. Caravaggio also invented the idea of divine, classically dressed figures rubbing

shoulders with the meanest member of the modern street. This encounter has been rendered more acceptable by basing the paralytic on an antique statue, then thought to depict the death of Seneca and recorded by Rubens in a series of drawings – one of which (when reversed) provides the model for this figure (fig. 57). The man is clearly a wretch: he has the bodily imperfections – rounded back, gnarled muscle forms, prominent veins and mean physiognomy – which contemporaries would have read as the outwards signs of an unfortunate and a sinner. Yet at least his wretchedness is expressed in the language of classical antiquity. He makes an obvious contrast with the nobility of the Apostle to the right, who could be based on one of a variety of classical busts familiar to anyone working in Rubens's studio.

In this intense drama Van Dyck (or more probably Rubens) follows St Matthew's Gospel (9: 2–8) in describing a calling as well as a healing. The episode immediately precedes the calling of Matthew himself (9: 9). Christ sees the faith of those attending the paralytic and outrages some Pharisees by first telling him that his sins are forgiven. This, he says, is more difficult than the simple task of healing, which is then duly accomplished. In this powerful image Christ draws the man up from his knees, and ushers him from out of darkness into the light, in an interaction similar to depictions of the Harrowing of Hell. The Apostle here is most likely to be the recently called St James, the pilgrim saint; all three characters in the drama seem to be setting off on a pilgrimage.

FIG. 57
Peter Paul Rubens, *The African Fisherman, 'Dying Seneca'*, *c.*1606–8; black chalk (Biblioteca Ambrosiana, Milan)

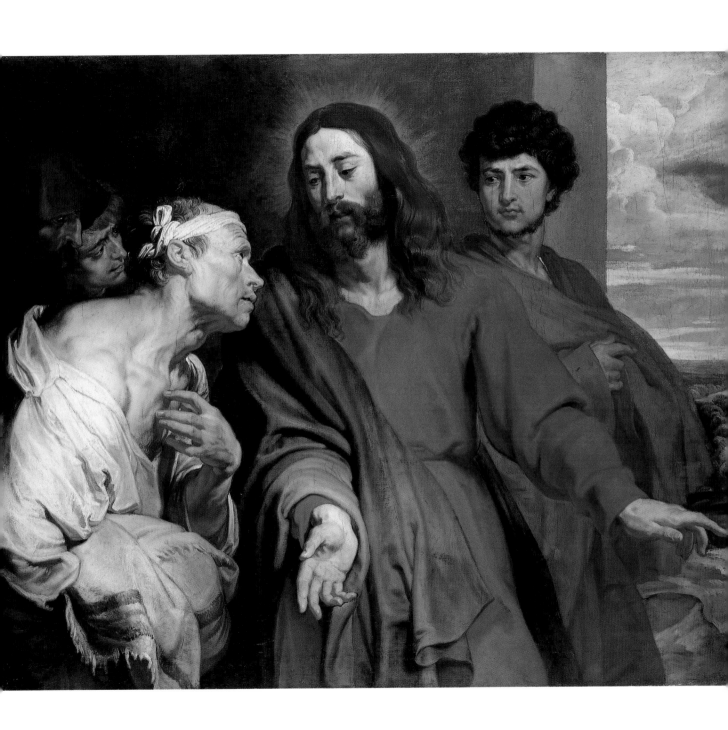

SIR ANTHONY VAN DYCK (1599–1641)
Mystic Marriage of St Catherine
Oil on canvas
126.4 x 119.4 cm
c.1630
RCIN 405332
Acquired by George IV
Millar, no. 162

Van Dyck first went to Italy in 1621 in the company of the Countess of Arundel; while in Venice it is possible that the party was shown around the city by Tizianello, the son of Titian's cousin and assistant, Marco Vecellio. Whether or not this special privilege was necessary, Van Dyck's Italian journey seems to have been dominated by his discovery of Titian (*c*.1487–1576), an artist whose works are constantly mentioned in the drawings and notes he made during his trip (the so-called 'Italian Sketchbook' now resides in the British Museum). According to Joachim von Sandrart (1606–88), he avoided academies in Rome studying Raphael and the antique, nor does he seem to have been any more interested in his Italian contemporaries; if anything, he influenced their work rather than vice versa.

The influence of Titian can be seen in a comparison between *Christ Healing the Paralytic* (no. 34) and this painting, one executed soon before and the other soon after his Italian sojourn. Both paintings show three principal figures ranged across the canvas, moving step-wise into depth. But in contrast to the robust sculptural forms of the *Healing*, this later composition is dominated by a pattern of shapes on the surface, a map of seas and continents fitting neatly together. The important colours – the blue, red and white of the Virgin – saturate entire zones. The use of pure colour and the arrangement of forms diagonally across the front plane in a 'soft' perspective derives from Titian and may be seen in Teniers's reduced copies (nos. 48–9).

St Catherine of Alexandria was contemplating an image of the Virgin, when the Christ Child seemed to come to life and offer her a ring as a symbol of their mystical betrothal. We must imagine here that the same episode is occurring 'in reality' in heaven, after she has been martyred, which is why she holds a martyr's palm and rests upon the broken wheel, with which the Emperor Maxentius tried unsuccessfully to tear her to pieces. The appearance of the Virgin's glowing white face and straight-nosed profile derives from the translucent stone of an antique cameo. As in the previous painting, a serene divine figure greets a suffering earthly one. St Catherine was a princess and no paralytic; however, her unbound hair (an unthinkable style at this date) speaks of the ordeal she has just suffered. The deformation of the breast of the Christ Child is a deliberate reference to the 'milk of human kindness' and accompanies his sympathetic expression. This composition is repeated, with an elderly couple instead of St Catherine, in Van Dyck's *Virgin and Child with Two Donors* (Louvre), also of *c*.1630.

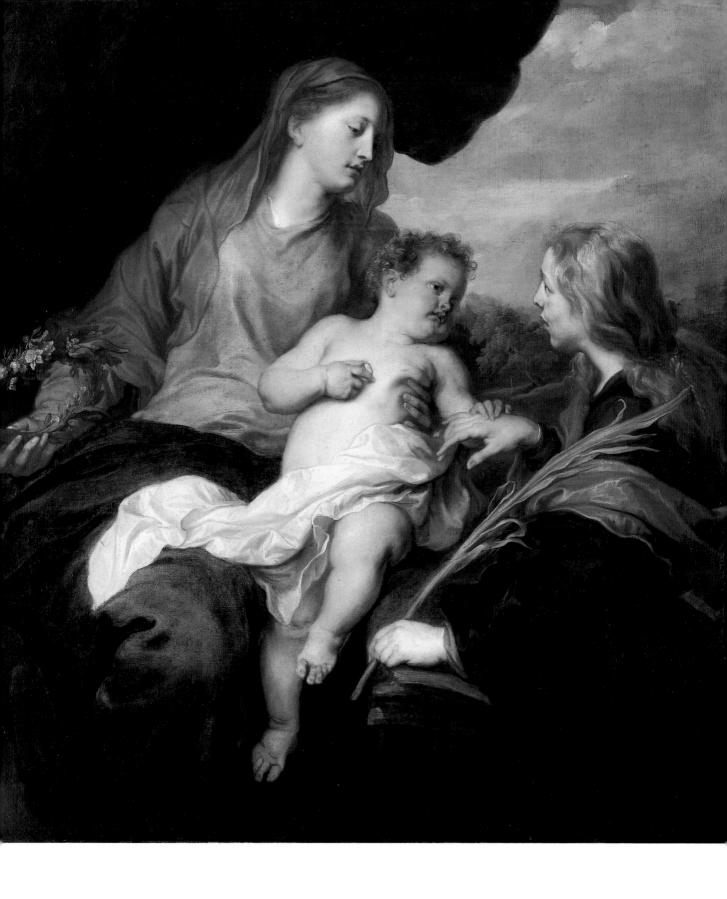

36

SIR ANTHONY VAN DYCK (1599–1641)
Zeger van Hontsum
Oil on canvas
108.6 x 84.5 cm
*c.*1630
RCIN 405323
Acquired by George III from Consul Smith
Millar, no. 155

Like the previous work, this portrait of a canon of Antwerp Cathedral, clutching his biretta and prayer book, dates from the years (1627–33) that Van Dyck spent in Antwerp, between his Italian and English trips. It was painted at one of the most exciting moments in the history of portraiture, when Rubens and Frans Hals (*c.*1580–1666) were at the height of their powers and when Velázquez (1599–1660) and Rembrandt (1609–69) were launching their careers.

Part of Titian's appeal to Van Dyck and his contemporaries lay in the richness of his effects, seen emulated in the brilliant colour and silky textures of the *Mystic Marriage of St Catherine* (no. 35). There is however another, more economical side to Titian's art, seen particularly in certain of his portraits. In these cases he appears to use his canvas and colour rather like the paper and chalks of a draughtsman, laying in as few colours as possible – just enough of them to realise a figure and no more. This effect appealed (in different ways) to every one of the portrait painters listed above and is what Van Dyck seeks here.

The most popular form of drawing at this time was executed in black, white and red chalks on grey paper. The background here is a light blue-grey, with no particular reference to any architectural surface, just like the untouched paper of a drawing. The figure is executed entirely in black, with white added to achieve the one effect of richness – the snaking highlights of the silk ecclesiastical robe. The red is kept back as the single accent of colour for the small areas of exposed flesh on the face and hands. We seem to witness the moment at which a monochrome mould cracks open. The result also has the effect of a drawing, which we read always as 'becoming' what it depicts, rather than merely being incomplete. The way in which the figure here is surrounded by an unbroken fringe of shadow echoes the strong chalk outline of a drawing and creates an eye-catching éclat, like a cut-out. Identical effects are much commented upon in later works by Velázquez and Edouard Manet (1832–83).

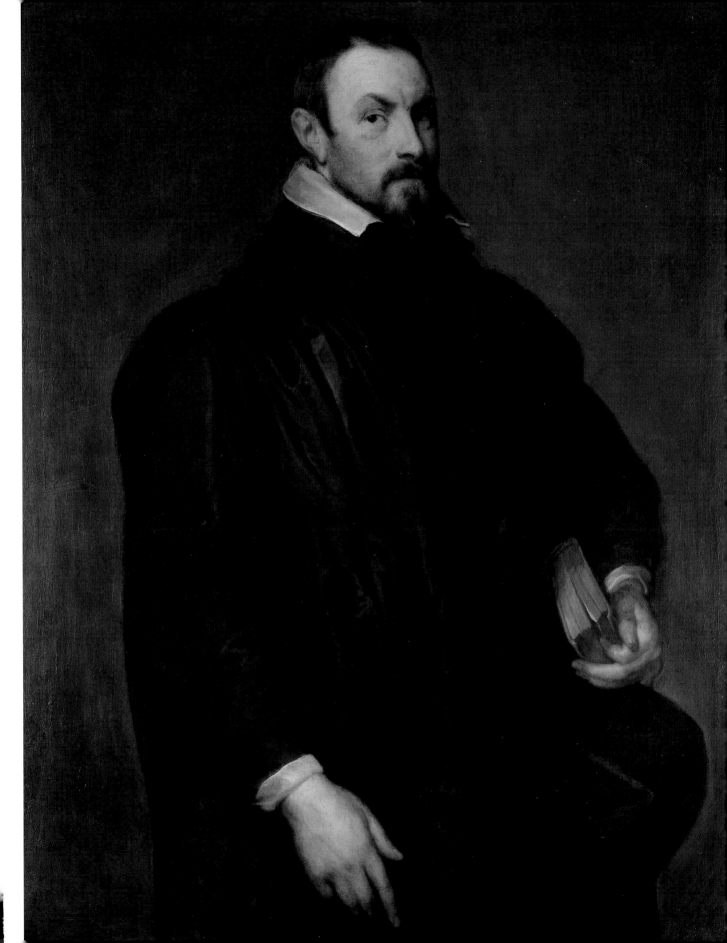

37

SIR ANTHONY VAN DYCK (1599–1641)
Margaret Lemon
Oil on canvas
93.3 x 77.8 cm
*c.*1638
RCIN 402531
Acquired by Charles I
Millar, no. 157

Margaret Lemon was Van Dyck's mistress and is unfortunately known to us today only through contemporary tittle-tattle. A fellow artist of Van Dyck, Wenceslaus Hollar (1607–77), described her as violently jealous, even on one occasion attempting to bite Van Dyck's thumb off. It is believed that this portrait was left unfinished because of the artist's marriage in February 1640 to the more respectable court beauty Mary Ruthven (*c.*1622–44).

This portrait appears to be Van Dyck's response to Rubens's *c.*1635–40 portrait of Helena Fourment as Venus, the so-called *Little Fur* or *Het Pelsken* (Kunsthistorisches Museum, Vienna), though there is no

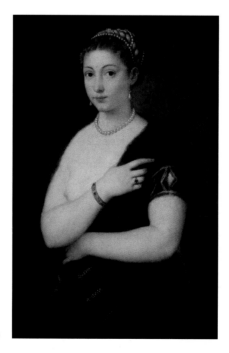

FIG. 58
Titian, *Portrait of a Woman in a Fur Wrap*, *c.*1535; oil on canvas (Kunsthistorisches Museum, Vienna)

record of Van Dyck's returning to Antwerp to be able to see the painting between March 1635 and 1640. If the similarities are coincidental it is because both paintings depend upon the same Titian model, his *Woman in a Fur Wrap* (fig. 58), then in the collection of Charles I, which had been copied by Rubens during his 1629–30 stay in England and which Van Dyck could study daily.

Van Dyck follows Titian more closely than Rubens does, except in rejecting fur in favour of the equally sensuous and suggestive textures of silk. The poses of all three paintings (by Rubens, Titian and Van Dyck) derive from the antique statue called the *Venus Pudica* or *Modest Venus* because she seeks to conceal her breasts with her arm. Margaret Lemon similarly presses a silk wrap against her body, while Titian's figure appears to be donning or doffing a fur garment. From other Titian paintings Van Dyck takes the idea of a uniformly hot colour scheme, clearly symbolic of the 'flames of love' or some such metaphor of burning desire. This effect can be especially appreciated in contrast to the sober grey 'colour-coding' of the previous portrait.

This portrait was sold at the Commonwealth Sale to the artist Jan Baptist Gaspars (*c.*1645–92), who may have smartened up a then more obviously unfinished picture; recent cleaning has revealed some evidence of the work of separate hands.

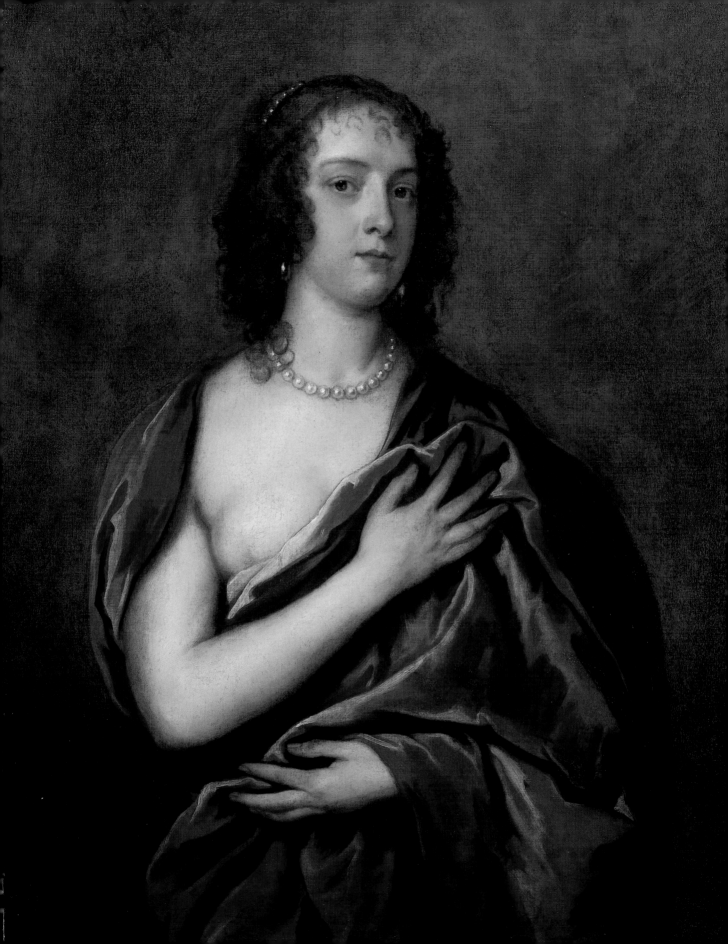

38

SIR ANTHONY VAN DYCK (1599–1641)
The Infant Christ and St John the Baptist
Oil on canvas
75.6 x 60.6 cm
*c.*1639
RCIN 405630
Acquired by Charles II
Millar, no. 163

This subject was a popular one in Italy and the Low Countries throughout the Renaissance, and derives from apocryphal texts dealing with the early life of Christ. It depicts the infant John the Baptist greeting his cousin Jesus upon his return from exile in Egypt. Christ's attribute here is a cross resting upon a globe, a symbol of the power of his salvation throughout the world; John has a small cross made from reeds in the wilderness and a scroll inscribed with the words he utters in St John's Gospel (1: 29) and which, of course, refer to Christ: '*Ecce Agnus Dei, qvi tollit peccatum mundi*' (Behold the Lamb of God, which taketh away the sin of the world). Here John genuflects to the Christ Child, who is kissing him and raising him from his knees. The relationship between the two figures is a premonition of the Baptism of Christ, as related in Matthew's Gospel (3: 13–17), when John refuses baptism, saying 'I have need to be baptised of thee' and Christ has to overcome his reluctance.

This small sacred image is probably an autograph repetition of the painting in Lamport Hall, Northamptonshire. Both versions date from towards the end of Van Dyck's life.

V

THE LATER GOVERNORS

1633~1665

V THE LATER GOVERNORS
1633~1665

The optimism of the early years of the Archdukes' reign soon faded. The couple failed to produce a child that survived infancy. Albert died in 1621, the same year as Philip III of Spain. The new King, Philip IV, took over direct control of the Netherlands, demoting Isabella to governor, and recommended the war with the United Provinces at the expiry of the Twelve Year Truce (1609–21). Another twenty-seven years of war achieved nothing for the south (fig. 59). The one Spanish triumph was the capture of Breda in 1625 by Isabella's Genoese general Ambrogio Spinola, an event celebrated by the huge print of 1626–8 by Jacques Callot (*c.*1592–1635) and the famous painting of 1634–5 by Velázquez (1599–1660). The Dutch recaptured the city in 1637, almost before the paint had dried.

By the time the Infanta Isabella died in 1633, her successor – the King of Spain's brother, the Cardinal-Infante Ferdinand (1609–41) – had already been proclaimed. Though he was appointed as governor only (rather than regent), Ferdinand's exceptional rank gave high hopes that he might act the part of a local sovereign, as the Archdukes had done. On his way from Spain to the Low

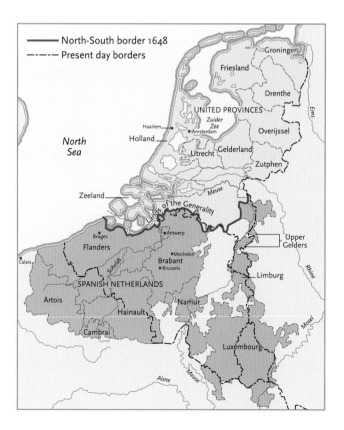

FIG. 59
Present-day borders and those agreed in 1648

FIG. 60
Jan van der Hoecke, *The Battle of Nördlingen*,
*c.*1637; oil on canvas (Royal Collection,
RCIN 400100)

Countries Ferdinand brought a large army from Spain's Italian possessions and joined forces with his uncle, Ferdinand III of Hungary. Together, on 6 September 1634 they vanquished the Swedish army at Nördlingen, one of the decisive battles of the Thirty Years War.

On 17 April 1635 the youthful Cardinal-Infante Ferdinand entered Antwerp in triumph as the new governor of the Netherlands and as the victor of Nördlingen. He was welcomed by a series of triumphal arches and 'stages', wood and canvas structures designed by Rubens. The Arch of Philip celebrated the Spanish succession and honoured Philip IV of Spain as supreme ruler. The Arch of Ferdinand celebrated the victory of Nördlingen and included a huge painting of the battle which survives in the Royal Collection (fig. 60). Next came a stage depicting the Temple of Janus, which the ancient Romans kept

shut except in time of war. Rubens uses this conceit to depict the struggle between the horrors of war and the blessings of peace. Three figures strive to close the door: Peace, Piety and the late Infanta Isabella. The inscription, composed by Rubens's friend Gevartius (1593–1666), begged Ferdinand to emulate the efforts of his predecessor:

> Having won triumphs on both land and sea, O Prince, would that you might close the inmost shrine of warlike Janus! And may savage Mars, who has now oppressed the Belgians for almost seven decades, and the fierce Harpies, and Grief and *Furor*, depart hence to the distant recesses of Thrace and Scythia: and may Peace, so long desired, return to the people and the land!

The next stage, the 'Stage of Mercury' (fig. 61), was erected near the docks and shows an even more bitter consequence of the seven decades of war:

Mercury, the god of trade, takes his leave of the grieving impersonation of the city of Antwerp. Behind the ships have furled sails, and beside sit the two sleeping figures of a sailor and a river god with manacled feet. This is *Scaldis*, the river Scheldt, which had been blockaded by the Dutch fleet since 1585. To the left a scene depicts Abundance and Wealth, the blessings of free trade; on the opposite side Poverty, the result of the blockade, is seen enacted by a sailor scratching a living for his family with a shovel.

Open access to the sea became Antwerp's only aspiration. Already in 1627 Rubens described the city as 'a consumptive body, declining little by little'. The Dutch were unwilling to lift the blockade and the Spanish were in no position to demand or even negotiate for such a concession. When peace was finally concluded at the Treaty of Münster in 1648, the war in the Low Countries was only a part of a wider European conflict known as the Thirty Years War. Spain capitulated, agreeing to recognise the Dutch Republic, with frontiers that had been a matter of fact for decades (fig. 59), and to accept an indefinite blockade of the river Scheldt.

By this date the southern Netherlands had a new enemy: France. The French King Louis XIII had already threatened the province of Artois in 1640. In the fifty years after the period covered in this exhibition, from 1665 to 1715, French armies invaded the Netherlands five times: during the War of Devolution, 1667–8; the Dutch War, 1672–8; the *Chambres de Réunion*, 1679–84, which annexed Luxemburg; the War of the Grand Alliance, 1688–97; and the War of the Spanish Succession, 1702–13. At the Treaty of Utrecht in 1713 the French abandoned all further claim to the Netherlands. The frontiers then agreed survive to this day (fig. 59) and include the substantial French gains of the previous century. The southern provinces, the old 'Spanish Netherlands', became again part of the Holy Roman Empire, under the sovereignty of the Emperor Charles VI of Austria.

39

DANIEL SEGHERS (1590–1661)
A Relief Embellished with a Garland of Roses
Oil on panel
75.5 x 53.8 cm
1640s
RCIN 405615
First recorded in the reign of Queen Anne
White, no. 77

Though certainly not created as a pair, these two flower-pieces are typical of Seghers's work and were both probably painted at the same time.

Jan Brueghel the Elder (nos. 18–19) seems to have invented the type of a flower garland surrounding a religious scene (often executed by another hand); one is visible with Jan Brueghel's

Allegory of Sight (fig. 10). In 1611 Daniel Seghers became Jan Brueghel's pupil in Antwerp. After he became a Jesuit in 1614 he seems to have worked exclusively on this type of painting, devoting his flower-painting skills to the service of religion. During the years he spent at the Jesuit College in Rome (1625–7) he collaborated with

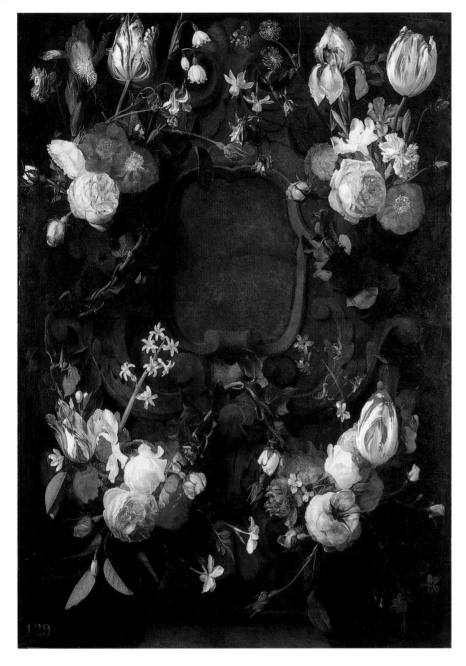

40

DANIEL SEGHERS (1590–1661)
A Cartouche Embellished with a Garland of Flowers
Oil on copper
87 x 60.9 cm
1640s
RCIN 405617
Possibly acquired by Charles II
White, no. 78

Domenichino and Poussin. Upon his return to the Jesuit House in Antwerp in 1627 (where he remained for the rest of his life) he worked with Rubens and Erasmus II Quellinus (1607–78). The nature of a Jesuit's vows meant that Seghers's paintings belonged to the Order rather than to him personally. Many were given away as tokens of esteem, especially to the powerful and influential. In 1649, during his exile in the Low Countries, the future Charles II visited Seghers and was presented with a flower-piece (which may be no. 40).

It is clear from both these paintings that Seghers bore the lion's share of such collaborations as he created the fictive 'strapwork' architectural surrounds as well as the flowers. His partner in no. 39, possibly Quellinus, had only to add a small, single figure (again made to appear as if carved in stone). It is also clear which contribution came first: the original owner of no. 40 (whether or not Charles II) was presumably expected to find an artist to add the religious figure or scene in the centre.

KARL PHILIPS SPIERINCKS (*c*.1600–1639)
Venus with Satyrs and Cupids
Oil on canvas
146.1 x 170.2 cm
1630s
RCIN 405568
Acquired by Charles II in 1662
White, no. 83

Spierincks was a pupil of Michel de Boerdous in Brussels and joined the guild there in 1622, but he was in Rome by 1624 and briefly a pupil of Paulus Bril (no. 17), before the latter's death in 1626. By 1630 Spierincks is documented as sharing a house with the Flemish sculptor François Duquesnoy (1597–1643), who had also previously shared with the Frenchman Nicolas Poussin. More than any other factor it was the example of Poussin that formed Spierincks's style.

During Poussin's first decade in Rome (1624–34) he created a genre of mythological landscapes based upon Titian's famous *Bacchanales* (one now in the National Gallery, London, and two in the Prado, Madrid) and on the pastoral love poetry of classical antiquity such as the *Eclogues* of Virgil. Some of these early Poussins, like *Venus and Adonis* (fig. 62), seem to be playful and erotic celebrations of the idyllic life of Arcadia, as well as having a serious undertone. No. 41 is modelled on this lighter side of early Poussin so closely that it was attributed to him within a few years of its arrival in England. However, in the original list of paintings bought by Charles II from William Frizell in 1662 it is described as by 'Carlo Filippo', the usual way in which Italians referred to Karl Philips Spierincks. The style of this painting is consistent with documentary references

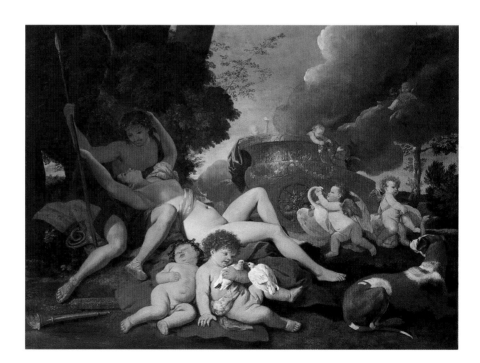

FIG. 62
Nicolas Poussin, *Venus and Adonis*, *c*.1628–9; oil on canvas (Kimbell Art Museum, Fort Worth, Texas)

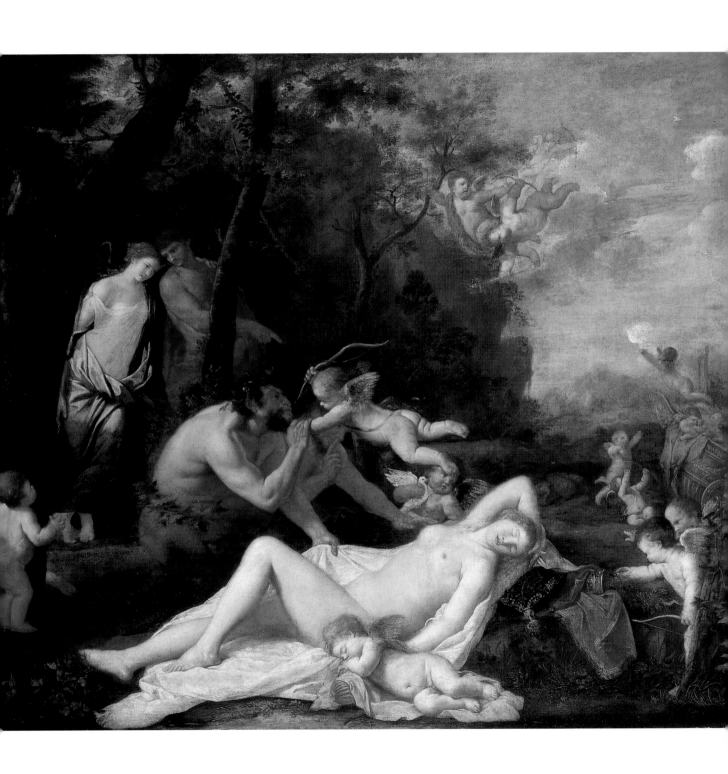

to Spierincks, and it has become an important work in reconstructing an oeuvre for this otherwise elusive artist.

On one level this painting illustrates the traditional contrast between sacred and profane love. The figure of Venus is erotically displayed in the careless abandon of sleep. Two satyrs – hideously red-blooded and bestial – spy upon her voyeuristically. One *putto* fights off a satyr by grabbing him by the beard, a classic image of the struggle between love and lust. Two *putti* descending, one with a torch (symbol of Hymen, god of marriage), seem to be coming to the aid of their companion. However, to the pure in heart Venus appears bright as well as alluring; with her drapery she makes a crescent of white like a new moon (that symbol of her spiritual opposite, the chaste Diana). A pair of rustic lovers contemplate her with reverence, as if she might bless their union, while they embrace each other with a spiritual tenderness.

On another level the painting reminds us that when Venus sleeps her infant attendants run amok, like naughty boys exploiting a lapse in supervision. One steals arrows, another releases Venus's doves in order that his friends can use them for archery practice. In the top right corner a tiny *putto* is seen pursuing a fleeing dove with an arrow far into the distance. One *putto*, sheltering a dove and red-faced with indignation, tries to wake Venus to prevent the carnage.

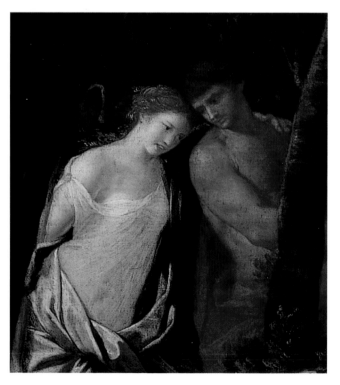

FRANS WOUTERS (1612–60)
Landscape with a Rainbow
Oil on panel
36.9 x 50.7 cm
1635–40
RCIN 404735
In the collection of Charles I and identified as
'wouter' in the Commonwealth Sale
White, no. 138

As a youth Frans Wouters was a pupil of Peeter van Avont (1600–1652) in Antwerp, whom he left to work with Rubens in 1634. Wouters entered the service of the Emperor Ferdinand II (1578–1637) in 1636 and went to England with his ambassador; after the Emperor's death he stayed in England until 1641 at the court of Charles I. Even after his return to Antwerp in 1641 he remained in contact with Charles II during the Civil War and Commonwealth periods; in 1658 he is described as Charles's *ayuda de cámara* (chamberlain).

This is an early work painted during Wouters's time in Rubens's studio or perhaps, in view of its provenance, during his English years. It belongs to a tradition of small, atmospheric, poetic landscapes (often with religious subjects) invented by Adam Elsheimer and developed by Rubens in such works as his *Landscape with Moon and Stars* of c.1637–8 (Courtauld Institute). As in several examples of the type, the scene is almost nocturnal (in this case late evening); the shadows are 'closing in' and the perception of space in the landscape is clouded and fitful. The way in which the light seeps through the trees, giving their fringes a golden halo,

derives from Elsheimer's *St Anne and the Virgin* (Petworth House, National Trust Collection), from the set of tiny saints in landscapes which Wouters may have seen in the collection of the Duke of Buckingham at York House. Like Elsheimer, Wouters has observed that the colour drains out of forms as night approaches. This landscape is an hour away from being entirely grey; the remaining colour within the light of the sunset is seen in scattered patches on the leaves, ground and sky, each with a mini-spectrum of blue–red–yellow.

Such a moody landscape seems to suggest a subject. The receding storm to the left and the glimpse of rainbow suggest that, like so many Rubens landscapes, this is a (premature) celebration of the passing of the storm of war and the arrival of peace, with its benefits of commerce (a sailing ship is passing down a canal in the middle distance) and agriculture (sheep, goats and pigs browse in the foreground). One of the most famous images of the blessings of peace comes from Isaiah 2: 4: 'and they shall beat their swords into ploughshares, and their spears into pruninghooks: nation shall not lift up sword against nation, neither shall they learn war any more'. The farmer here ploughs into the sunset.

DAVID TENIERS THE YOUNGER (1610–90)
Fishermen on the Sea-shore
Oil on canvas
92.8 x 123.1 cm
Signed
Late 1630s
RCIN 405348
Acquired by George IV
White, no. 91

David Teniers II was son and pupil of David Teniers I; son-in-law of Jan Brueghel (see pp. 26–7) and friend of Rubens. He dominated post-war Flemish painting, becoming court painter and *ayuda de cámara* to Archduke Leopold William in Brussels, founder of the Antwerp academy of art in 1664, acquiring his country seat, Drij Toren, in 1662 and his patent of nobility in 1680. His work was greatly admired throughout Europe during the eighteenth and nineteenth centuries.

This landscape appeared on the London art market in 1810 and again in 1812, when it was bought for George IV. J.M.W. Turner (1775–1851) seems to have seen it at this time and been inspired to create a group of coastal paintings and watercolours: *Lyme Regis, Dorsetshire: A Squall* (Glasgow Art Gallery), a watercolour of *c*.1812, which appeared as a line engraving in

1814; and *Calais Sands at Low Water: Poissards Collecting Bait* (fig. 63), exhibited at the Royal Academy in 1830. It is easy to see what would have excited Turner: the flat, empty block of monotonous silver-grey, failing to distinguish sea and sky, which makes up three-quarters of the picture and runs without interruption onto the sandy colour of the foreground; the dramatic touch of red against the grey; the suggestion of casual heroism, as old man and hobbledehoy extract a meagre living in a hostile and dangerous environment; the drama of the storm; the contrast of rainbow and sunburst; the way in which a lone tower seems to symbolise man's struggle against the elements.

It would be tempting to claim that Teniers meant no such thing. But the contrast between these barren and desolate wastes and depictions of inland Flanders (as seen in the previous exhibit, no. 42) suggests that Turner may have read the mood correctly and that Teniers did intend to convey the harsh economy of the fishing communities and the idea that a tower and rainbow might allude to fortitude through faith. Guicciardini in his description of the Low Countries wrote that the 'sea may well be tearmed, not only a neighbor but also a member of thes low Countrys, as well as for the great benefite that it bringeth to them: as also for the harme that it doth them when it rageth'.

FIG. 63
J.M.W. Turner, *Calais Sands at Low Water: Poissards Collecting Bait*, 1830; oil on canvas (Bury Art Gallery, Museum and Archives)

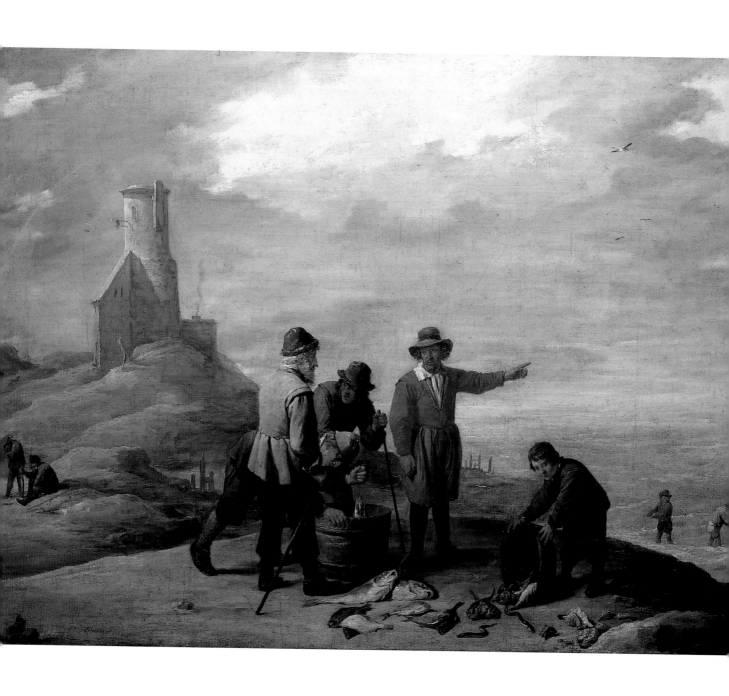

44 and 45

DAVID TENIERS THE YOUNGER (1610–90)

Interior of a Kitchen with
an Old Woman Peeling Turnips
Oil on panel
50.6 x 71.2 cm
Signed
Early 1640s
RCIN 405945
Acquired by George IV
White, no. 94

Interior of a Farmhouse with Figures,
'The Stolen Kiss'
Oil on canvas
71.6 x 87.4 cm
Signed
c.1660
RCIN 405342
Acquired by Frederick, Prince of Wales
White, no. 107

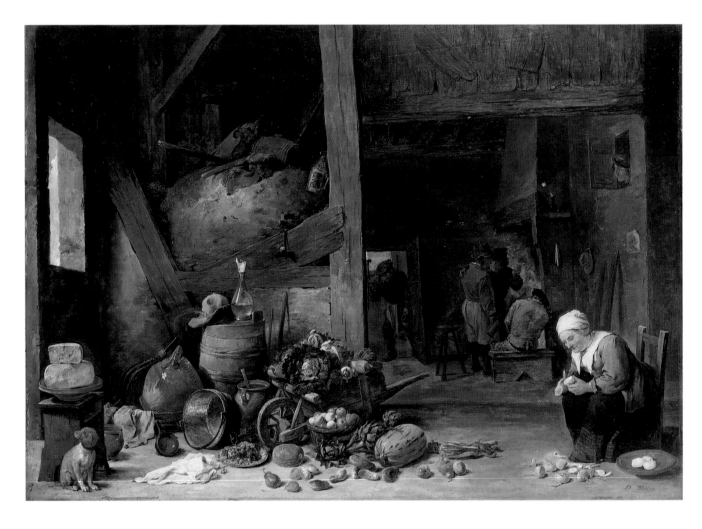

These two paintings are not a pair and come from different times in Teniers's career. They depict slightly different households. The *Old Woman Peeling Turnips* appears to be set in a crude tavern, with customers drinking in the background, a roughly constructed bread oven in the left middle ground, and a servant or innkeeper's wife at work in the foreground. The idea of the still life to the left would seem to be that of 'poor plenty': of an abundance of basic fare.

The Stolen Kiss takes place in the outbuildings of a farmhouse, again with a bread oven and a similarly lavish supply of humble fare. As often in low-life genre painting of the period, the servants are misbehaving – in this case flirting with the farmer's daughter (assuming the old woman in the background to be his wife).

In spite of these differences, both these paintings belong to the same distinctive tradition, one of the most

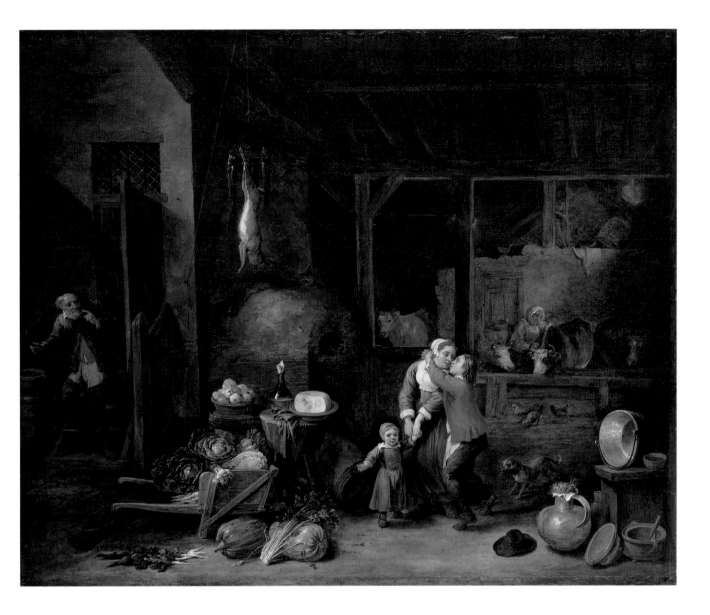

enduring within Dutch and Flemish (and even British) painting. The comic peasant interior goes back ultimately to Pieter Bruegel the Elder, but his ideas were taken up again in the 1620s by a Flemish artist, Adriaen Brouwer (1605–38), who in a brief career worked in Haarlem in the northern Netherlands, as well as in Antwerp in the south, and whose works appealed alike to Rubens and Rembrandt. Brouwer invented the type of interior we encounter here: a barn-like hovel with dirt floor and wooden beamed ceiling, poorly lit by a single, small shuttered window. The smoky drabness of these spaces can be appreciated by contrast with the high glass windows, stone floors and brightly decorated walls of a merchant's house (see nos. 13 and 50–51). Brouwer depicted his interiors frontally (like a stage set) and peopled them with carousing and brawling boors. He

suggested the uncertainty of peering into a drab and smoke-filled room by leaving visible the scrubbed pattern of the brown underpaint layer. Against this a single light source (usually to the left) picks out a haphazard assortment of objects across the foreground, realised in thicker and brighter (though still sketchily applied) paint. By the time of his death in 1638, Brouwer's theme was material for a range of variations, in Holland by Adriaen van Ostade (1610–85), Gerrit Dou (1613–75) and Rembrandt, and in Flanders by David Teniers the Younger.

In both these examples, Teniers follows the formula precisely, making much of the picturesque textures of wood grain and daubed walls, while at the same time turning the foreground into an opportunity for a full still life. Teniers seems to give each foreground object a droplet of highlight from the

window. This quality of light and technique creates a kind of interior aerial perspective. At the extreme front verge of the painting objects are light, brightly coloured, tactile, fully modelled and in every way illusionistically realised. As you move back in space objects become darker, drabber, flatter and more elusive, as if enveloped in dusk and smoke. The contrast in techniques required to achieve this effect was especially admired by Reynolds, who wrote in his *Journey to Flanders and Holland* in 1781 that Teniers's handling 'has perhaps never been equalled; there is in his pictures that exact mixture of softness and sharpness, which is difficult to execute'.

The tradition of the Netherlandish 'smoke-filled-room' underwent an extraordinary revival in Britain at exactly the time that the *Old Woman Peeling Turnips* was acquired (Sir Francis Baring bought it in 1802 and George IV in 1814). In 1806 Sir David Wilkie (1785–1841) painted his *Blind Fiddler* (Tate Gallery), a homage to Teniers with echoes of both these works; in 1810 and 1813 George IV commissioned two similar scenes from Wilkie (both Royal Collection): *Blind Man's Buff* and *The Penny Wedding* (fig. 64). Turner's absurdly named *A Country Blacksmith Disputing upon the Price of Iron, and the Price Charged to the Butcher for Shoeing his Poney* (Tate), exhibited at the Royal Academy in 1807, is part Wilkie parody and part Teniers tribute.

FIG. 64
David Wilkie, *The Penny Wedding*, 1818; oil on canvas (Royal Collection, RCIN 405536)

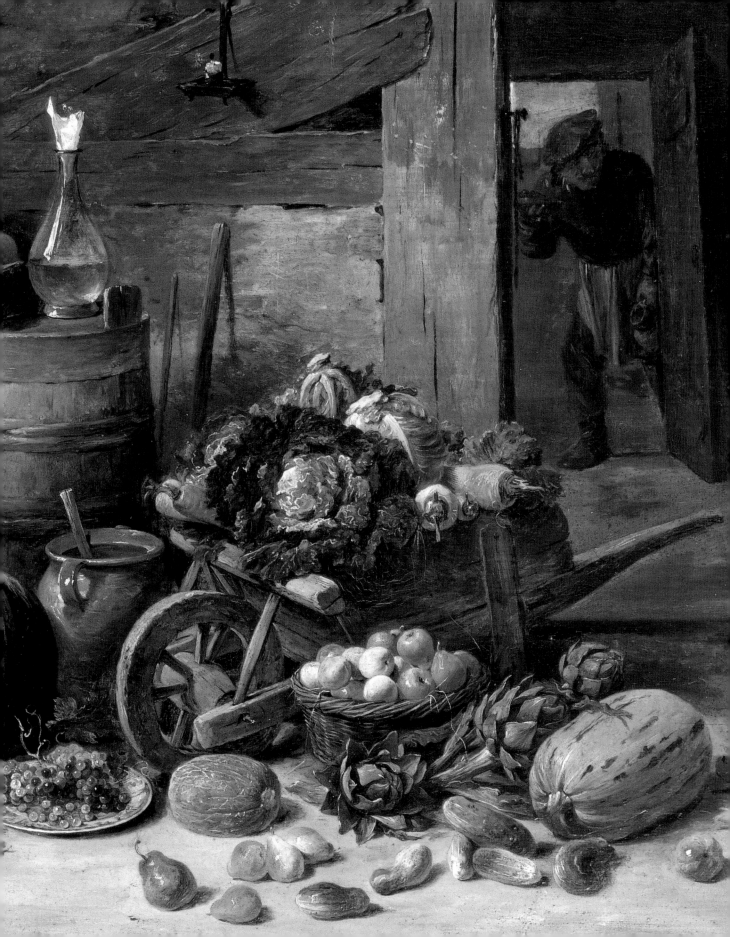

DAVID TENIERS THE YOUNGER (1610–90)
The Drummer
Oil on copper
49.5 x 65.3 cm
Signed and dated 1647
RCIN 406577
Acquired by George IV
White, no. 97

Military subjects were popular on either side of the frontier during the Eighty Years War (1568–1648). The most common image of the soldier's life was the guard-room scene, a glamorous version of the tavern scene, where soldiers smoke, drink and play cards. This painting may have been executed for Teniers's master, the Archduke Leopold William, who was commander-in-chief of the Spanish army in Flanders. It is rare in depicting the camp rather than the guard-room, but tries to convey the same aimless boredom of military life. Almost all military scenes provide an excuse for the artist to depict a still life of as many different weapons as possible; the glint of light off steel is rendered especially effectively here on this painting executed on the reflective medium of copper.

Flemish artists like Jan Brueghel had made a speciality of depicting allegorical figures surrounded by the attributes or results of the thing they personify: the element of Fire, for example, might be surrounded by a huge pile of metal objects which had been created in the heat of a forge. The same convention is employed here and in the *Old Woman Peeling Turnips* (no. 44); she could be an allegory of hearth and home balanced by a pile of vegetables; the drummer here could be an allegory of war matched by a pile of armour.

47

DAVID TENIERS THE YOUNGER (1610–90)
A Kermis on St George's Day
Oil on canvas
79.7 x 88.7 cm
Signed and dated 1649
RCIN 405952
Acquired by George IV in 1821
White, no. 100

This is one of the most perfect of Teniers's many Kermis scenes and is a conscious tribute to Pieter Bruegel the Elder's treatments of the subject (see fig. 11). Like Bruegel, Teniers creates episodes in which we can recognise the vices of Lechery (in the man molesting a woman to the right of centre), Wrath (two men are kept from each other in the background), drunkenness (in the figure sleeping it off to the lower right) and general boorishness (seen throughout). The mood is much more concerned, however, with characteristic behaviour (the two sealing a bargain to the left), careless folly and comical high spirits, especially in the principal couple dancing with such cheerful and inexpert abandon. The way in which the old man looks on to the left suggests the indulgent wisdom of the village elder.

It is tempting to conclude that this happy scene is a celebration of the Treaty of Münster of 1648 (the year before the painting was executed), which had brought to an end eighty years of war. In the same year as this work (1649) David Ryckaert III (1612–61) clearly alluded to the recent conflict in a pair of paintings called *Peasants' Sorrow* and *Peasants' Joy* (Kunsthistorisches Museum, Vienna), the former a scene of soldiers plundering (like no. 14) and the latter a Kermis like this one. Another version of Teniers's design (now lost) seems to have been painted for William II, Prince of Orange (1626–50), the stadtholder and Dutch commander-in-chief. A drawing recording the

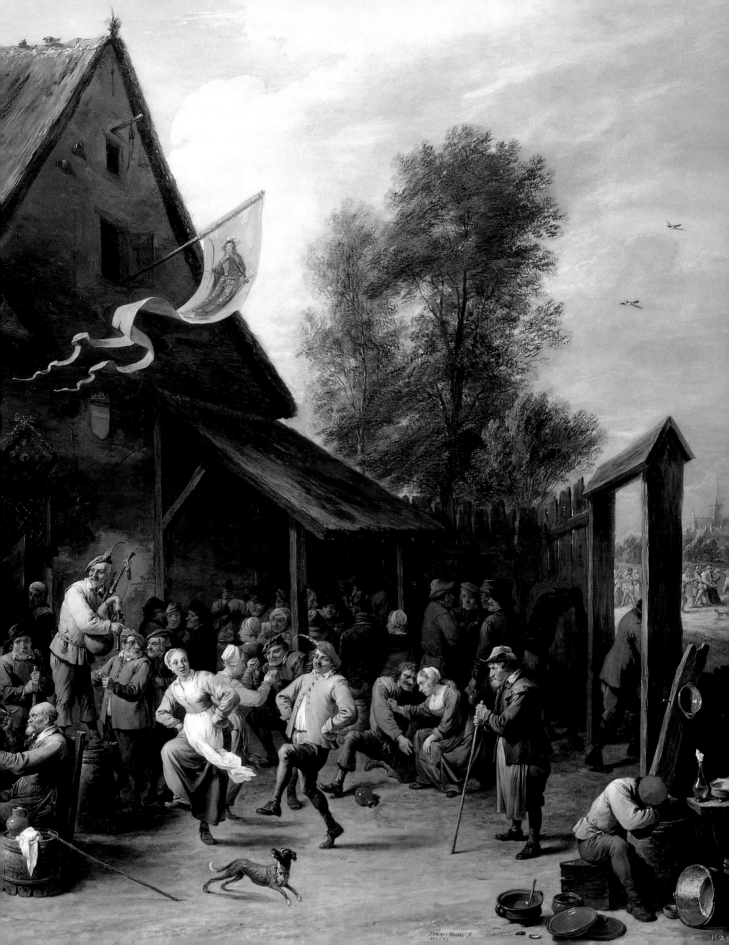

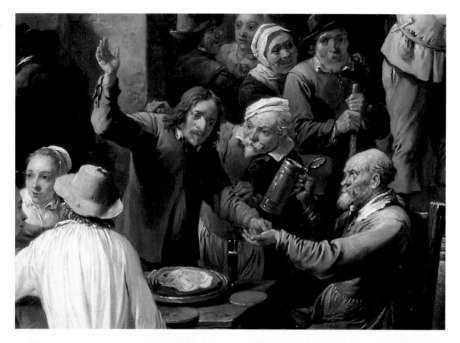

design (Hessisches Landesmuseum, Darmstadt) is inscribed with an instruction to execute a painting from it for 'His Highness my Lord the Prince of Orange'. This is not the Prince of Orange's painting, as was once believed; apart from anything else it includes a coat of arms with the double eagle of the Habsburgs – hardly appropriate for a Dutch soldier. The existence of the other version raises the interesting possibility that two versions of this design were created at the time of the truce, one for each of the two sides involved in the war. If so, then the painting perfectly sums up the rural customs and the Bruegelian artistic heritage, which were equally valued by both sides, at the same time as providing an image of harmony and reconciliation.

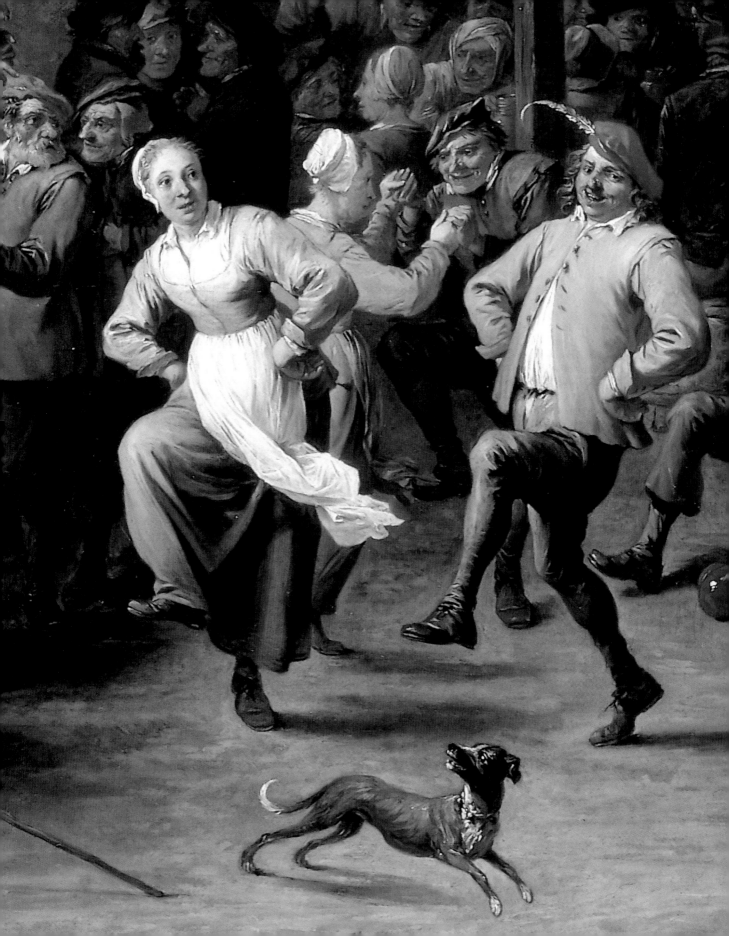

48 and 49

DAVID TENIERS THE YOUNGER (1610–90)

The Virgin and Child (after Titian)
17.1 x 23.2 cm
RCIN 400932

The Virgin and Child with Sts Stephen, Jerome and Maurice (after Titian)
17.1 x 22.9 cm
RCIN 400693

Both oil on panel
1650s
Both acquired by Frederick, Prince of Wales
White, nos. 105 and 106

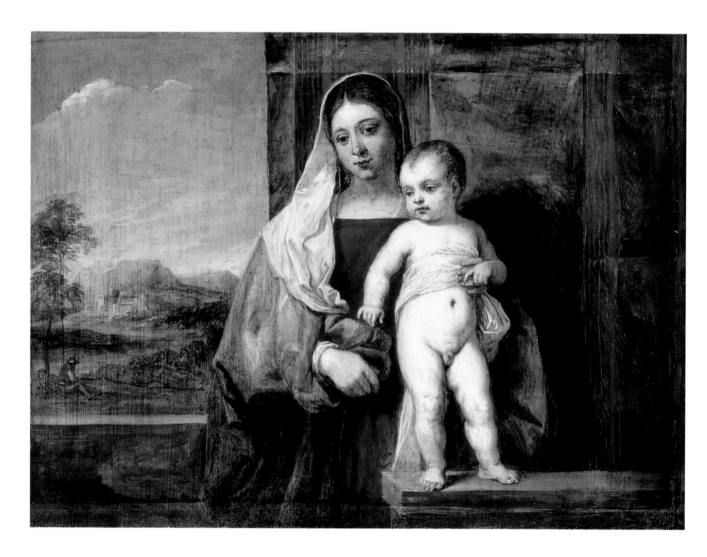

Archduke Leopold William, Philip IV's cousin, was governor of the Spanish Netherlands from 1647 to 1656 and had one of the most important collections of Italian old master paintings in Europe. Some of his acquisitions were made in London at the sale of Charles I's collection (the so-called Commonwealth Sales of 1649–53), with Teniers acting as his agent. Teniers was also commissioned in 1650 to prepare for publication a catalogue of the best of Leopold's pictures. The resignation of the Archduke as governor of the Netherlands in 1656 and his return to Vienna greatly complicated and retarded work on the project, which was eventually completed with the publication in 1660, at Teniers's own expense, of the *Theatrum Pictorium*. This famous work contains prints

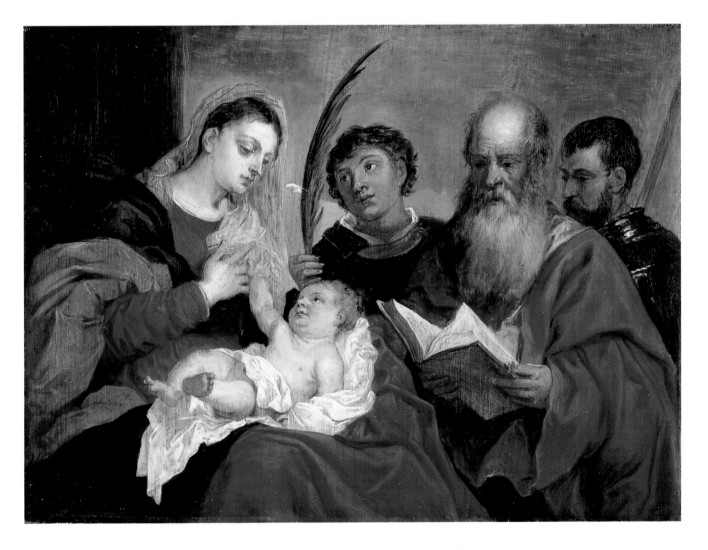

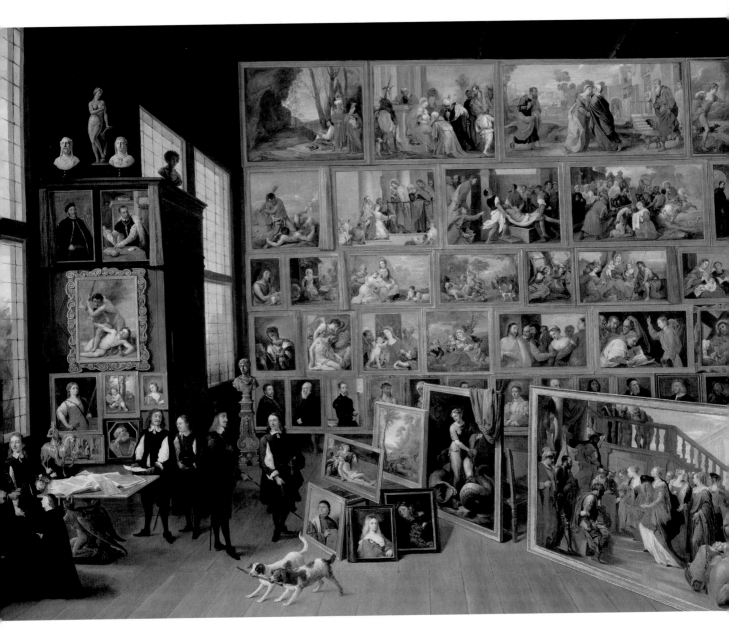

David Teniers the Younger, *Archduke Leopold William in his Gallery in Brussels*, *c*.1651; oil on canvas (Kunsthistorisches Museum, Vienna)

of 243 Italian paintings within the collection, with captions giving the author and dimensions of the original; this is the first illustrated collection catalogue ever produced. In the third edition the title page states that the work is 'of use for all lovers of the art of painting'. The paintings themselves have almost all remained in Vienna, where they formed the core of the Kunsthistorisches Museum.

Though it is possible to create small prints after large paintings, Teniers elected to paint miniature oil sketches of every work, each of identical scale to the engraving. These postcard pastiches, of which two after Titian are included here, are brilliant exercises in compression but also in stylistic parody. They must have meant more to Teniers than merely performing the mechanical task of scale reduction.

At the same time that he was involved in the *Theatrum Pictorium*, Teniers produced a series of ten spectacular 'Picture Gallery ensembles' of highlights of the collection (again all Italian pictures) brought together into an ideal interior (see fig. 65). These are the supreme examples of that Flemish speciality, the gallery interior (see nos. 25 and 50). It may have been in part for these works that Teniers executed his individual pastiches – for they do require that the style of the paintings-within-a-painting is convincingly suggested, even if in postage-stamp format.

Both the *Theatrum Pictorium* and the gallery scenes demonstrate the extraordinary reverence with which the Italian old masters were regarded. It is perhaps significant that in 1660, the year of publication of the *Theatrum*, the States of Holland and Friesland presented to the newly restored Charles II a collection of paintings which they had bought from a Dutch merchant, Jan Reynst. The collection was made up of Italian and not Dutch painting, as one might have expected. A collection of prints after every one of them – in effect another *Theatrum Pictorium* – was executed to mark the occasion.

JACOB DE FORMENTROU (*fl*.1640–59)
A Cabinet of Pictures
Oil on canvas
75.3 x 112.1 cm
Signed and dated 1659 on one of the subsidiary images
RCIN 404084
Acquired by George III
White, no. 31

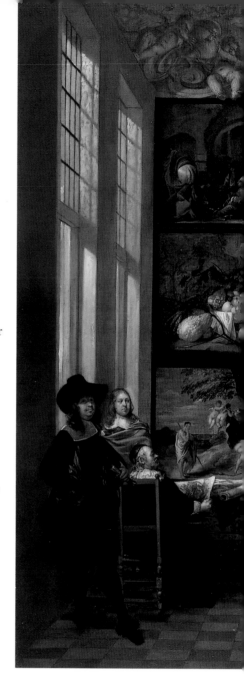

This classic example of the picture gallery interior shows clearly how the genre depends upon a series of tiny thumbnail parodies of the styles of different artists. So convincing are the separate paintings here that the work as a whole has been thought to be a collaboration, each painter 'being himself', as occurred with the lost painting executed by a group of artists under the supervision of Jan Brueghel for the Archdukes Albert and Isabella (see p. 25 and fig. 10). A detailed technical analysis of the pictures has not been able to resolve this question either way.

No interior would have been hung this densely at this date, except that of an art dealer. This is probably not intended as an illustration of a particular dealer's stock but more as a 'variety pack' produced by (or with the approval of) a group of artists in order to promote themselves. Painting had become a significant export at this time and it was also an important expression of the prestige of the city of Antwerp to show that it could still produce the variety of superlative craftsmanship in painting for which it had been famous over a period of 150 years.

About half the works have initials, which can be matched (sometimes conjecturally) against known painters. Arranging the paintings in columns (reading from top to bottom) and reading the columns from left to right we can list the subjects and, in most cases, the artists: *Gypsies in a Crypt* by Antoine Goubeau (1616–98); *Fruit in a Landscape* by Jan Davidsz. de Heem (1606–84); *Cymon and Iphigenia*;

Judgement of Solomon (the composition based on a lost painting executed for Amsterdam Town Hall) by Erasmus Quellinus (1607–78); *Moonlit Seascape*; *Garland of Fruit and Flowers* by Joris van Son (1623–67); *Church Interior*, dated 1654, by Peeter Neeffs I (1605–56) or II (1620–75); *Mountainous Landscape* by Jan Peeters (1624–77); *David with the Head of Goliath*, possibly by Theodore

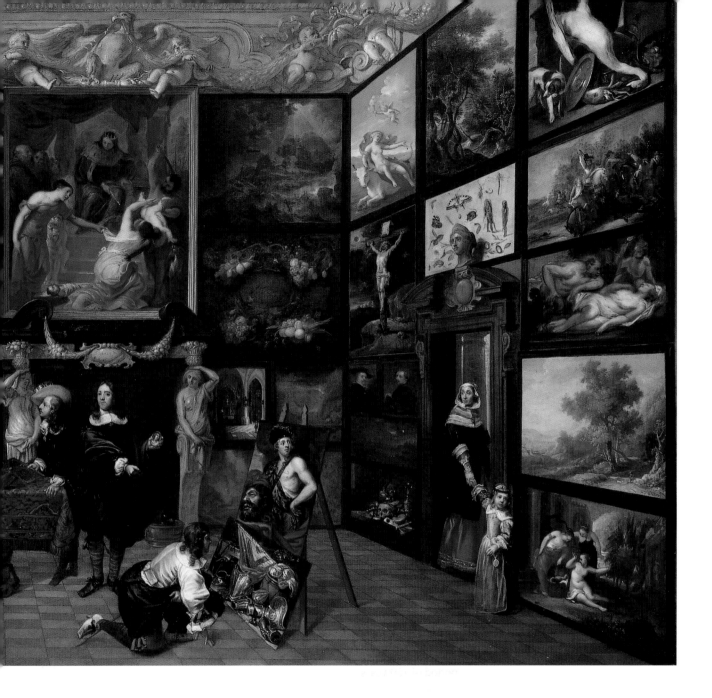

Boeyermans (1620–78); *Still Life of Arms and Armour; Rape of Europa; Christ on the Cross*; portraits of Rubens and Van Dyck (compare nos. 30 and 32); *Moonlit Landscape; Still Life with a Skull*, possibly by Harman Steenwyck (1612–56); *Wooded Landscape* by Pieter de Witte II (1617–67); *Insects, Flowers etc.* by Jan van Kessel (1626–79); *Still Life with a Dead Swan* by Pieter Boel (1622–74); *Cavalry Skirmish* by Nicolaes van Eyck (1617–79); *Jupiter and Antiope; Landscape with a Tree* by Gaspard de Witte (1624–81) and *The Finding of the Infant Erichthonius*.

It is possible to see a pattern in this grouping: the majority of identified artists were from Antwerp and in their thirties or early forties at the time, which suggests that such works involved like-minded colleagues clubbing together. Presumably the elusive author of the work, Jacob de Formentrou, belonged to this generation. The arrangement includes two slightly older artists of distinction (Erasmus Quellinus and Jan Davidsz. de Heem) and images of two dead artists (Van Dyck and Rubens) of such supreme importance that no celebration of Flemish art could leave them out.

GONZALES COQUES (1614–84)
The Family of Jan-Baptista Anthoine
Oil on copper
56.5 x 73.8 cm
Signed and dated 1664
RCIN 405339
Acquired by George IV in 1826
White, no. 21

The career of Gonzales Coques demonstrates the degree to which eighty years of war failed to destroy the cultural links between the northern and southern Netherlands. Born in Antwerp, where he studied with Pieter Brueghel the Younger, by the late 1640s Coques was in Holland, working for the stadtholders Frederick Henry and Amalia van Solms. Thirty years later, in 1671, he became court painter to the Count of Monterrey, the governor of the southern Netherlands. His style is similarly an integration of the two traditions. The principal influences on his work come from Flanders; his elegant figures appear to be miniature versions of those of Van Dyck, while the (obviously imaginary) architecture derives from Rubens's family portraits and 'conversation pieces' (*conversatie*), like the *Garden of Love* (Prado) of 1636. Coques seeks to emulate the informality with which Rubens depicts his own family, an effect which can also be seen in Philip Fruytiers's watercolour of 1638–9 (no. 33). However, it was Dutch artists who specialised in the depiction on a small scale of middle-class families, some grave, some boisterous, set in a lucid architectural space. There are excellent examples by Frans Hals, *Family Group* of *c.*1635 (Cincinnati Museum), and Pieter de Hooch, *Family in a Courtyard in Delft* of 1658–60 (Vienna Academy). When he acquired this picture, George IV already owned a *Family Group* of the same type by the less well-known Dutch artist Barent Graat (1628–1709), dated 1658 (fig. 66).

The sitters in no. 51 can be identified by the coat of arms on the huge curtain: Jan-Baptista Anthoine, knight and postmaster of Antwerp, is shown with his wife Susanna de Lannoy, two sons, Louis and Jan-Baptista, and two daughters, Maria-Alexandrina (1659–1723) and Barbara Catharina. Anthoine's inventory mentions a family portrait by 'Gonsael' (Gonzales). It is perhaps significant, in view of the elegant quality of this image, that he also owned Van Dyck's grisaille of *Rinaldo and Armida* (National Gallery, London).

Though wishing to convey a mood of indulgent informality, Coques is perhaps more anxious than Frans Hals might be to suggest that each member of the family plays an appropriate role. The eldest son, who will inherit the title, plays at being a knight (that is a 'cavalier' or 'horseman') with a hobbyhorse and plumed hat. The eldest daughter tends her younger sister or brother in a group which seems to have been derived from Van Dyck's *Five Eldest Children of Charles I* (Royal Collection). The father stands against the view of the garden; the mother sits with her children within the space of the room. This effect is made more pronounced by the remarkable perspective of the painting, which requires the eye of the viewer to be situated very close to the painting at its right-hand edge. Jan-Baptista Anthoine is seen against a long avenue of trees, which evokes the link between the formal garden and the surrounding land of an aristocrat's country estate (compare no. 29). The rest of the family are seen in strikingly oblique perspective (as can be deduced from the deformation of the square floor tiles), as if out of the corner of the eye.

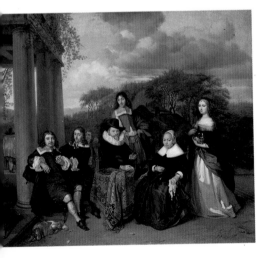

FIG. 66
Barent Graat, *A Family Group*, 1658; oil on canvas
(Royal Collection, RCIN 405341)

TIMELINE *People and events with particular significance in the text are given in bold type.*

	HISTORICAL EVENTS	KINGS OF FRANCE	HOUSE OF HABSBURG HOLY ROMAN EMPERORS
*c.*1470–1540	Mary of Burgundy signs the 'Great Privilege' (1477) Luther's 95 Theses – the start of the Protestant Reformation (1517) The Diet of Worms – Luther declared a heretic (1521) The Sack of Rome (1527)	Louis XII (r.1498–1515) Francis I (r.1515–47)	**Maximilian I** (1459–1519; r.1493–1519) **Charles V** (1500–1558; r.1519–55/6)
1540–1560	The Diet of Augsburg (1547–8) The Franco-Habsburg War (1551–9) The Abdication of Charles V (1555/6) The Treaty of Câteau-Cambrésis (1559)	Henry II (r.1547–59) Francis II (r.1559–60)	Ferdinand I (1503–64; r.1555/6–64)
1560–1570	*Beeldenstorm* (19–23 August 1566) The 'Council of Blood' (9 September 1567) The Battle of Heiligerlee (23 May 1568) Execution of the Counts of Egmont and Horn (5 June 1568) **The Eighty Years War** (1568–1648)	Charles IX (r.1560–74)	Maximilian II (1527–76; r.1564–76)
1570–1600	**The 'Spanish Fury'** (8 November 1576) The Union of Arras (6 January 1579) The Union of Utrecht (23 January 1579) The Act of Abjuration (26 July 1581) The Capture of Antwerp (17 August 1585) The Spanish Armada (1588)	Henry III (r.1574–89) Henry IV (r.1589–1610)	Rudolph II (1552–1612; r.1576–1612)
1600–1620	**The Twelve Year Truce** (1609–21) The Thirty Years War (1618–48)	Louis XIII (r.1610–43)	Matthias (1557–1619; r.1612–19) Ferdinand II (1578–1637; r.1619–37)
1620–1650	The Surrender of Breda (5 June 1625) The Battle of Nördlingen (6 September 1634) **The Peace of Westphalia:** The Treaty of Osnabrück (15 May 1648) The Treaty of Münster (24 October 1648)	Louis XIV (r.1643–1715)	Ferdinand III (1608–57; r.1637–57)
1650–1713	The War of Devolution (1667–8) The Dutch War (1672–8) The Chambres de Réunion (1679–84) The War of the Grand Alliance (1688–97) The War of the Spanish Succession (1702–8) **The Treaty of Utrecht** (1713)		Leopold I (1640–1705; r.1658–1705) Joseph I (1678–1711; r.1705–11) Charles VI (1685–1740; r.1711–40)

KINGS AND QUEENS OF SPAIN	THE NETHERLANDS	HOUSE OF ORANGE STADTHOLDERS OF THE DUTCH REPUBLIC	KINGS AND QUEENS OF ENGLAND
Ferdinand II (1452–1516) and Isabella I (1451–1504), King of Aragon (r.1479–1516) and Queen of Castile (r.1479–1504)	Mary, Duchess of Burgundy (1457–82; r.1477–82) **Maximilian I** (1459–1519), regent (r.1482–93) Philip the Handsome (1478–1506; r.1493–1506) Margaret of Austria (1480–1530), regent (r.1506–15)		Henry VII (r.1485–1509)
Joanna 'the Mad' (1479–1555) and Philip the Handsome (1478–1506), Queen of Castile (r.1504–16) and Philip I of Castile (r.1504–6)	**Charles V** (1500–1558; r.1515–55) **Governors reporting to the King of Spain:** Margaret of Austria (r.1519–30)		
Charles V (1500–1558), Charles I of Spain (r.1516–55)	Maria of Hungary (r.1531–55)		Henry VIII (r.1509–47)
			Edward VI (r.1547–53)
Philip II (1527–98; r.1555–98)	Emmanuel Philibert of Savoy (r.1555–9) Margaret of Parma (r.1559–67)		Mary I (r.1553–8) Elizabeth I (r.1558–1603)
	Fernando Alvarez de Toledo, 3rd Duke of Alva (r.1567–73)		
	Luis de Requesens (r.1573–6) Juan of Austria (r.1576–8) Alexander Farnese, Duke of Parma (r.1578–92) Duke of Mansfeld (r.1592) Count of Fuentes (r.1592–4) Archduke Ernest (r.1594–5) Count of Fuentes (r.1595–6) Archduke Albert (r.1596–8)	**William 'the Silent'**, Prince of Orange, Count of Nassau (1533–84; r.1572–84) Maurice, Prince of Orange, Count of Nassau (1567–1625; r.1585–1625)	
Philip III (1578–1621; r.1598–1621)	**'The Archdukes' Albert and Isabella Clara Eugenia** (r.1598–1621)		
			James I (r.1603–25)
Philip IV (1605–1665; r.1621–65)	**Isabella Clara Eugenia** (r.1621–33) Marquis of Aytona (r.1633–4) Cardinal-Infante Ferdinand (r.1634–41) Francisco de Melo (r.1641–4) Manuel de Moura, Marquis of Castel Rodrigo (r.1644–7)	Frederick Henry, Prince of Orange (1584–1647; r.1625–47)	Charles I (r.1625–49)
	Archduke Leopold William (r.1647–56)	William II (1626–50; r.1647–50)	Commonwealth (1649–60)
Charles II (1661–1700; r.1665–1700)	Don Juan José of Austria (r.1656–9) Marquis of Caracena (r.1659–64) Don Francisco de Moura, Marquis of Castel Rodrigo (r.1664–8) Duke of Feria (r.1668–70) Count of Monterrey (r.1670–75)		Charles II (r.1660–85)
Philip V (1683–1746; r.1700–1746)	Duke of Villa Hermosa (r.1675–8) Alexander Farnese II (r.1678–82) Marquis of Grana (r.1682–5) Marquis of Gastañaga (r.1685–92) Maximilian Emmanuel of Bavaria (r.1692–1702)	**William III** (1650–1702; r.1672–1702)	James II (r.1685–9) **William III and Mary II** (r.1689–1702)

FURTHER READING *All the publications listed have additional bibliographies.*

ROYAL COLLECTION CATALOGUES

L. Campbell, *The Early Flemish Pictures in the Collection of Her Majesty The Queen*, Cambridge, 1985

O. Millar, *The Tudor, Stuart and Early Georgian Pictures in the Collection of Her Majesty The Queen*, London, 1963

C. White, *The Dutch Pictures in the Collection of Her Majesty The Queen*, Cambridge, 1982

C. White, *The Later Flemish Pictures in the Collection of Her Majesty The Queen*, London, forthcoming

C. White and C. Crawley, *The Dutch and Flemish Drawings of the Fifteenth to the Early Nineteenth Centuries in the Collection of Her Majesty The Queen at Windsor Castle*, Cambridge, 1994

SOURCE MATERIAL

L. Guicciardini, *Descrittione di tutti i Paesi Bassi*, Antwerp, 1567

R.S. Magurn, *The Letters of Peter Paul Rubens*, Cambridge MA, 1955

K. van Mander, *The Lives of the Illustrious Netherlandish and German Painters from the first edition of the Schilder-boeck (1603–4)*, trans. H. Miedema, Doornspijk, 1994

E. Norgate, *Miniatura or the Art of Limning*, ed. J. Muller et al., New Haven and London, 1997

J. Reynolds, *A Journey to Flanders and Holland (1771)*, ed. H. Mount, Cambridge, 1996

STUDIES, EXHIBITIONS AND HISTORICAL BACKGROUND

W. Adler, *Corpus Rubenianum Ludwig Burchard Part XVIII, Landscapes and Hunting Scenes, 1. Landscapes*, trans. P. S. Falla, London, 1982

S. J. Barnes et al., *Van Dyck: A Complete Catalogue of His Paintings*, New Haven and London, 2004

C. Brown, *Making and Meaning: Rubens's Landscapes*, exh. cat., National Gallery, London, 1996

K. Bussmann and H. Schilling (eds.), *1648: War and Peace in Europe*, essay vol. 2: *Art and Culture*, exh. cat., Westfälisches Landesmuseum für Kunst und Kulturgeschichte, Münster, 1998

L. Campbell, *Renaissance Portraits, European Portrait-Painting in the 14th, 15th and 16th Centuries*, New Haven and London, 1990

L. Campbell, *National Gallery Catalogues: The Fifteenth Century Netherlandish Paintings*, London, 1998

L. Duerloo and W. Thomas (eds.), *Albert et Isabelle 1598–1621*, exh. cat., Musées Royaux d'Art et d'Histoire, Brussels, and Katholieke Universiteit, Leuven, 1998

Flanders in the Fifteenth Century: Art and Civilization, catalogue of the exhibition 'Masterpieces of Flemish Art: Van Eyck to Bosch', Detroit Institute of Arts, 1960

M.J. Friedländer, *Early Netherlandish Painting from Van Eyck to Bruegel*, London, 1956

C. Harbison, *The Art of the Northern Renaissance*, London, 1995

J. Israel, *The Dutch Republic: Its Rise, Greatness and Fall, 1477–1806*, Oxford, 1995, (rev. edn 1998)

D. Jaffé et al., *Rubens: A Master in the Making*, exh. cat., National Gallery, London, 2005

P. Nuttall, *From Flanders to Florence: The Impact of Netherlandish Painting 1400–1500*, New Haven and London, 2004

G. Parker, *The Dutch Revolt*, London, 1977

P.C. Sutton et al., *The Age of Rubens*, exh. cat., Museum of Fine Arts, Boston, 1993–4, Toledo Museum of Art, 1994

H. Vlieghe, *Flemish Art and Architecture 1585–1700*, New Haven and London, 1998

C. White, *Peter Paul Rubens: Man and Artist*, New Haven and London, 1987

J. Woodall et al., *A Touch of Brilliance. Oil Sketches and Related Works from the State Hermitage Museum and the Courtauld Institute of Art*, exh. cat., Courtauld Institute of Art, London, 2003

PICTURE CREDITS

All works reproduced in this book are in the Royal Collection unless indicated otherwise. Royal Collection Enterprises are grateful for permission to reproduce the following:

© Biblioteca Ambrosiana, fig. 57

Bibliothèque nationale de France, fig. 25

© Bibliothèque royale de Belgique, Brussels, figs. 6, 46

Museum Boijmans Van Beuningen, Rotterdam, fig. 21

© bpk: Photo: Jörg P.Anders, fig. 23

© The British Library Board. All rights reserved Maps C.29.e.l, volume 1, number 17; 564.e.20. (2.), figs. 4, 31

© Bury Art Gallery, Museum & Archives, Lancashire, fig. 63

© Photo: Collections management Antwerp, Belgium, fig. 3

Reproduced with the permission of the Department of Conservation and Technology, Courtauld Institute of Art, London, fig. 38

Dordrecht, Simon van Gijn – museum aan huis, fig. 1

© Fitzwilliam Museum, Cambridge, fig. 20

© The State Hermitage Museum, St. Petersburg, figs. 50, 61

© Historic Royal Palaces, fig. 22

Courtesy of Johnny van Haeften, London, p. 72 (detail), figs. 39, 40a–c

Kimbell Art Museum, Fort Worth, Texas, fig. 62

Kunsthistorisches Museum, Vienna, figs. 11, 32, 47, 51, 54, 58, 65

mhk, Gemäldegalerie Alte Meister, Kassel, fig. 7

© The National Gallery, London, figs. 30, 55

National Gallery of Scotland, fig. 12

Museum Plantin-Moretus/Pretenkabinet, Antwerpen: collection prentenkabinet, © Photo Peter Maes, fig. 2

© Museo Nacional Del Prado, Madrid, figs. 10, 49

Private Collection, fig. 29

Image courtesy of Reproductiefonds Vlaamse Musea, fig. 53

Rijksmuseum, Amsterdam, figs. 26, 43

Rijksprentenkabinet, Rijksmuseum, Amsterdam, figs. 35, 37, 42

Royal Museum of Fine Arts of Belgium, Brussels, fig. 27

V&A Images, fig. 44

Every effort has been made to contact copyright holders of material reproduced in this publication. Any omissions are inadvertent, and will be corrected in future editions if notification of the amended credit is given to the publisher in writing.

Numbers in **bold** refer to catalogue entries; numbers in *italics* refer to figures

Albani, Francesco 106
Albert, Archduke *12*, 25, 102–4, *104*, 113, 114, 129, 130, 132, 146, 162, 190
Alva, Duke of 9, 10, *10*, *76*, 76–7, 88, 90, 94
Anthoine, Jan-Baptista 192
Antwerp 10, 12, 15, 18, 19, 20–21, 23, 34, 76, 95, 104, 165, 190
 Academy 26, 41, 174
 Guild of St Luke 25–6, 70, 146
 Rubenshuis 14–15, *15*
 'The Spanish Fury' 94, *97*, 129
'Archdukes', the *see* Albert, Archduke; Isabella, Archduchess
Auden, W.H.: *Musée des Beaux Arts* 9

Bacon, Francis 126, 129
Badens, Francesco 39–40
Baglione, Giovanni 38, 40
Balen, Hendrick van 146
Bassano, Jacopo 98
Beeldenstorm (1566) 75–6, *76*, 129
Bellori, Giiovanni Pietro 36, 40–41, 132
Bentvueghels, the *38*, 38–9
Biset, Charles Emmanuel 25
Bloemaert, Abraham 106
Boel, Pieter: *Still Life with a Dead Swan* 191
Boerdous, Michel de 168
Boeyermans, Theodore: *David with the Head of Goliath* 190–91
Borcht, Pieter van der: *Triumphal Entry of Archdukes Albert and Isabella into Antwerp in 1599 12, 12*
Borromeo, Cardinal Federigo 29, 30, 32, 38, 111
Bosch, Hieronymus 36
Boy at a Window (anon.) (no. 9) 34, 35, **68–9**
Braun, Georg, and Hogenberg, Franz: *Anverpia* 16–17
Brederode, Hendrick van 75, 76
Breenbergh, Bartholomeus 39
Bril, Mattheus, the Elder 108
Bril, Paulus 30, 38, 39, 108, 168
 Fantastic Landscape 30, *30*
 Landscape with Goatherds (no. 17) 30, 39, **108–9**
Broeck, Crispin van 98

Christ Healing the Sick (no. 15) 36, 41, **98–9**
Brouwer, Adriaen 28, 178
Bruegel, Pieter, the Elder 26, 27, 28, 36, 38, 42–3
 Battle between Carnival and Lent 27
 Children's Games 27
 Fall of Icarus 9
 Flight into Egypt 28
 Massacre of the Innocents (no. 14) 9, 9–10, 11, 15, 20, 27, 31–2, 40, **88–91**, 111
 Peasant Dance 28, *28*, 111
 Peasant Wedding 28
 The Return of the Herd 29, 32, 113, *138*, 140
 Temperance 19, *20*
Brueghel, Pieter, the Younger 9, 26–7, 192
 The Massacre of the Innocents 27, 88, *88*, *91*, 113
Brueghel, Jan, the Elder 25, 26, 27, 29, 30, 32, 36, 38, 108, 111, 114, 118, 166, 174, 180, 190
 Adam and Eve in the Garden of Eden (no. 19) 21, 30–31, **114–17**, 140
 Allegory of Sight 20–21, *24*, 25, 166
 Peasant Dance in Honour of the Archdukes 113, *113*
 A Village Festival (no. 18) 11, 20, 28, 30–31, 108, **110–13**, 134
Brueghel, Jan, the Younger 27
Brueghel, Pieter, III 27
Brussels 12, 15, 29, 37
Buckingham, Duke of 136, 138, 172

Calcker, Jan van 39
Callot, Jacques: *The Siege of Breda* 162
Calvaert, Dionys 38, 40, 106
 The Assumption of the Virgin (no. 16) 41, **106–7**
Caravaggio, Michelangelo Merisi da 150, *150*
 The Calling of Sts Peter and Andrew 150
Carracci, Agostino 40
Carracci, Annibale 30, 40, 106
Carracci, Ludovico 40, 106
Charles I 23, *23*, 41, 43, 122, 146, 156, 172, 187
Charles II 43, 123, 167, 168, 172, 189
Charles V, Emperor 11, 14, 34, 35, 49, *49*, *54*, 55, 62, 74
Charles the Bold 46
Christian II, of Denmark 62

Christina of Denmark 62, *62*
Claude Lorrain 108
Cleve, Joos van 64, *65*
 Katlijne van Mispelteeren, the Artist's Wife (no. 8) 34, 35, **64–5**, *67*
 Self Portrait (no. 7) 34, *34*, 35, 36, **64–6**
Coeck, Pieter 26
Coninxloo, Pieter van (attrib.): *Margaret of Austria* 55
Coques, Gonzales 21, 27, 41, 192
 The Family of Jan-Baptista Anthoine (no. 51) 14, 18, **192–3**
 Portrait of a Young Scholar and his Sister 22, *22*, 23
Correggio (Antonio Allegri): *Assumption of the Virgin* 132
Coxis, Michael 43

Danvers, Lord 143
Delacroix, Eugène 42
Domenichino (Domenico Zampieri) 25, 106, 167
Dou, Gerrit 178
Duquesnoy, François 38, 41, 168
Dyck, Sir Anthony van 21, 26, 38, 39, 41, 146, *147*, 152, 156
 Charles I with M. de St Antoine 23, *23*
 Christ Healing the Paralytic (no. 34) 22, 40, 41, **150–51**, 152
 Five Eldest Children of Charles I 192
 'Images of Foremost Men of Learning' 21
 The Infant Christ and St John the Baptist (no. 38) 41, **158–9**
 Margaret Lemon (no. 37) 35, **156–7**
 Mystic Marriage of St Catherine (no. 35) 22, 41, **152–3**
 Rinaldo and Armida 192
 Virgin and Child with Two Donors 152
 Zeger van Hontsum (no. 36) 35, **154–5**

Egmont, Count of 74, 75, 76, 77, *77*
Ehrenberg, Wilhelm Schubert von 25
Eighty Years War 77, 94, *94*, 180
Elsheimer, Adam 108, 123, 172
 Aurora 138
 Jupiter and Mercury in the House of Philemon and Baucis 124
 St Anne and the Virgin 172
Erasmus, Desiderius 13, 19, 35, 58, *59*, 60
Eyck, Nicolaes van: *Cavalry Skirmish* 191

Ferdinand, Cardinal-Infante 162–3, 164
Ferdinand II, Emperor 172
Floris, Frans 39, 43, 98
Fontana, Prospero 106
Formentrou, Jacob de 191
 A Cabinet of Pictures (no. 50) 14, 18,
 19, 21, 22, 23, *23*, 25, 32, **190–91**
Fourment, Helena (Rubens) 27, 144,
 148, 156
Francken, Frans, the Elder 126
Francken, Frans, the Younger 21, 25, 36,
 126
Allegory on the Abdication of Charles V
 48–9, *49*
Cabinet of a Collector (no. 25) 19, 21, 25,
 34, **126–9**
Frederick, Prince of Wales 43
Frederick Henry, Stadtholder 21, 192
Fruytiers, Philip 148
Four Children of Peter Paul Rubens and
 Helena Fourment with Two Maids
 (no. 33) **148–9**, 192

Gaspars, Jan Baptist 156
Geest, Cornelis van der 25, 146
George III 32, 43
George IV 43, 144, 174, 178, 192
Gijn, Simon van: *Alva as Chronos* 10
Gillis, Pieter 19, 35, *60*, 58, *61*
Giovanni Bologna (Jean de Boulogne) 40
Goes, Hugo van der: *The Trinity Panels:*
 Edward Bonkil with Two Angels 34–5, *34*
Goltzius, Hendrick 106
Gossaert, Jan (Mabuse) 38
 The Three Children of Christian II of
 Denmark (no. 6) 18, 34, *34*, 35, **62–3**
Goubeau, Antoine: *Gypsies in a Crypt*
 190
Goudt, Hendrick 124, 138
Graat, Barent: *A Family Group* 192, *192*
Guicciardini, Lodovico: *Descrittione di*
 tutti I Paesi Bassi 12–13, 15, 18, 19,
 22, 98, 174
Guise, Charles de, Cardinal of Lorraine
 10
Guise, Henri of Lorraine, 3rd Duke of
 10

Haarlem, Cornelis van 106
Haecht, Willem van: *Gallery of Cornelis*
 van der Geest 146
Hals, Frans 154
 Family Group 192
Heem, Jan Davidsz. de: *Fruit in a*
 Landscape 190, 191
Heemskerck, Marten van 36, 38, 39,
 43, 79
 The Four Last Things... (no. 12) 29, 40,
 41, **82–3**

Jonah under his Gourd (no. 11) 10, 34,
 78–81
Portrait of the Painter with the
 Colosseum in the Background 34, *37*, 38,
 79, 81
Heiligerlee, battle of (1568) 77, 94, *95*
Hendricx, Gillis van 21
Henry VIII 18, 58, 62
Hoecke, Jan van der
 The Battle of Nördlingen 163, *163*
Hoefnagel, Joris 97
Hogenberg, Frans
 Anverpia (with Braun) *16–17*
 The Battle of Heiligerlee 95
 Beeldenstorm 76, *76*
 The Execution of Egmont and Horn... 77
Holbein, Hans, the Younger
 Christina of Denmark, Duchess of Milan
 62, *62*
 Sir Richard Southwell 32
Hollanda, Francisco de: *Dialogues* 29
Hollar, Wenceslaus 156
Hooch, Pieter de: *Family in a Courtyard*
 in Delft 192
Hoogstraten, Samuel van: *Man at a*
 Window 34, *68*
Horn, Count of 74, 75, 76, 77, *77*
Houckgeest, Gerrit 124

Isabella Clara Eugenia, Archduchess *12*,
 25, 102, *105*, 113, 114, 129, 130, 146,
 162, 190

James I 103, 122, 146
Joanna the Mad 47, 49, 53, *53*
Jonghelinck, Jacques (attrib.):
 The Spanish Fury 97

Kessel, Jan van 21, 191
Key, Adriaen Thomasz.: *William I,*
 Prince of Orange 96

Lampsonius, Dominicus: *Pictorum*
 Aliquot Celebrium Germaniae Inferioris
 Effigies 40, 64, *65*
Lanfranco, Giovanni: *Assùmption of the*
 Virgin 132
Le Franc, Martin: *Champion des Dames*
 47
Leoni, Leone: *The Duke of Alva 76*
Leopold William, Archduke 32, 37, 174,
 180, 187, *188*
Lomazzo, Giovanni Paolo 36, 106
Louis of Nassau 77
Lunden, Susanna 144, *144*

Mabuse *see* Gossaert, Jan
Mancini, Giulio 30
Mander, Karel van 10, 18, 23–4, 26, 27,

29, 31, 32, 33, 34, 35, 38, 39, 40, 64,
 79, 82, 88, 96, 97, 106, 122
Mantua, Vincenzo Gonzaga, Duke of
 32–3
maps 46, *74*, *94*, *102*, *103*, 105, *162*
Margaret of Austria 49, 55, *55*, 62
Margaret of Parma 14, 74, 75, 76, 95
Marnix, John 75, 76
Mary of Burgundy 46–7, 53
Massys, Cornelis 70
 (follower of) *Landscape* (no. 10) 31,
 34, **70–71**
Massys, Quinten 14, 70
 Desiderius Erasmus (no. 5) 19, 34,
 58–60
 Pieter Gillis 19, 34, *60*
Maximilian I, Emperor 47, 49, 53
Memling, Hans 56: *Portrait of a Man*
 (no. 4) 35, 39, **56–8**
Michelangelo Buonarroti 29, 30, 39, 40,
 129
Momper, Joos de 129
Monterrey, Count of 21, 192
More, Sir Thomas 19, 58
Moretus, Jan 20
Münster, Treaty of 11, *162*, 165

Neeffs, Peeter: *Church Interior* 190
Noort, Adam van 130
Nördlingen, battle of (1635) 163, *163*
Norgate, Edward 30, 32, 108, 113, 138

Order of the Golden Fleece 46, 47, *51*,
 53, 55, 75, 76–7
Ostade, Adriaen van 28, 178
Overbury, Sir Thomas 104

Parma, Alexander Farnese, Duke of 95
Peeters, Jan: *Mountainous Landscape* 190
Philip II, of Spain 13, 14, 49, 64, 74, 75,
 75, 77, 89, 94, 102
Philip III, of Spain 102
Philip IV, of Spain 162, 163
Philip the Bold 46
Philip the Good 46, *47*, *50*, 51, 62
Philip the Handsome 35, 47, 49, *52*, 53,
 53
Piles, Roger de 34, 37, 42
Plantin, Christopher 20
Poelenburgh, Cornelis van 39
 Shepherds with their Flocks in a
 Landscape with
 Roman Ruins 30, *31*
Pourbus, Frans, the Younger: *The Infanta*
 Isabella Clara Eugenia, Archduchess of
 Austria 105
Poussin, Nicolas 25, 38, 41, 42, 108, 167,
 168
 Venus and Adonis 168, *168*

Quellinus, Erasmus II 167
 Judgement of Solomon 190, 191
Quevedo, Francisco de 77

Raphael 39, 41, 42
 Madonna della Perla 129
 Portrait of Leo X 32
Rembrandt van Rijn 34, 154, 178
 The Three Trees 120
Reni, Guido 106
Requesens, Don Luis de 14
Reynolds, Sir Joshua 40, 43, 88, 178
Rubens, Sir Peter Paul 14, 21, 23, 25, 26,
 27, 28, 31, 32–3, 36, 37, 38, 39, 40,
 41, 42, 102, 108, 130, 146, 148, 150,
 165, 167, 172, 174
 Adoration of the Shepherds 134
 The African Fisherman, 'Dying Seneca'
 150, *150*
 Anthony Van Dyck (no. 32) 35, 36, 37,
 146–7
 Assumption of the Virgin (no. 26) 37,
 41, **130–32**
 The Assumption of the Virgin 132, *132*
 Banqueting House ceiling, Whitehall
 41, *41*
 Boar Hunt 135
 'Le Chapeau de Paille' 144, *144*
 Château de Steen 31
 Christ giving the Keys to St Peter 28–9
 The Coronation of the Virgin 130, 132
 Daniel in the Lions' Den 120
 The Effects of War 37
 Garden of Love 192
 Landscape with Moon and Stars 172
 Lion Hunt 143
 Little Fur 156
 Milkmaid with Cattle in a Landscape,
 'The Farm at Laken' (no. 27) 11,
 14–15, 30–31, **134–5**, 140, 144
 Portrait of Archduke Albert 104
 Portrait of a Woman (no. 31) 18, *34*, 35,
 36, 37, **144–5**
 The Prodigal Son 11, 135, *136*
 Pupils of Justus Lipsius 32, 37
 Pythagoras Advocating Vegetarianism
 (with Snyders) *134*, 135
 Self Portrait (no. 30) 35, 37, 132,
 142–3
 The Stage of Mercury: Mercury Moving
 Away 164, *164–5*
 'Stages' for Cardinal-Infante
 Ferdinand 163–5
 Summer: Peasants Going to Market
 (no. 29) 11, 14–15, 29, 30–31, 32, 35,
 117, **138–41**
 Three Studies for Occasio 36, 144, *144*
 Winter: The Interior of a Barn (no. 28)
 11, 14–15, 30–31, 36, **136–7**, 138

(studio of) *Philip II, King of Spain* 74, *75*
Rudolph II, Emperor 15, 88, 90, 114,
 118, 120
Ruthven, Mary 156
Ryckaert, David, III
 Peasants' Joy 182
 Peasants' Sorrow 182

Sacrifice of Isaac, The (tapestry) 18, *18*
Sandrart, Joachim von 152
Savery, Jacob 118
Savery, Roelandt 11, 97, 118
 Landscape with Birds (no. 20) 21, 31,
 118–19
 Lions in a Landscape (no. 21) 21, 31,
 120–21
Scorel, Jan van 39, 79
Seghers, Daniel 27, 38, 166–7
 A Cartouche Embellished with a Garland
 of Roses (no. 40) 25, **166–7**
 A Relief Embellished with a Garland of
 Roses (no. 39) 25, **166–7**
Snyders, Frans 27
 (with Rubens) *Pythagoras Advocating*
 Vegetarianism 134, 135
Solms, Amalia van 21, 192
Son, Joris van: *Garland of Fruit and*
 Flowers 190
Spierincks, Karl 38, 41, 168
 Venus with Satyrs and Cupids (no. 41)
 36, *36*, 41, **168–71**
Spinola, General Ambrogio 162
Spranger, Bartholomeus 106
Stadanus, Jacopo 40
Steenwyck, Harman (?): *Still Life with a*
 Skull 191
Steenwyck, Hendrick van, the Elder 122
Steenwyck, Hendrick van, the Younger
 21, 27, 122
 Figures on a Terrace (no. 22) 18, 25,
 122–3
 Liberation of St Peter (no. 23) 10, 25,
 122–3
 Liberation of St Peter (no. 24) 10, 25,
 124–5
Sustermans, Justus: *Portrait of Galileo* 32

Teniers, David, the Elder 27, 174
Teniers, David, the Younger 23, 26, 27,
 36, 41, 174, 187, 189
 Archduke Leopold William in his Gallery
 in Brussels 32, 37, *188*
 The Drummer (no. 46) 21, **180–81**
 Fishermen on the Sea-shore (no. 43) 15,
 21, 28, 31, **174–5**
 Interior of a Farmhouse with Figures,
 'The Stolen Kiss' (no. 45) 15, 21, 28,
 176–9
 Interior of a Kitchen with an Old Woman

Peeling Turnips (no. 44) 15, 21, 28,
 176–9, 180
 A Kermis on St George's Day (no. 47)
 15, 21, 28, **182–5**
 The Virgin and Child (no. 48) **186–9**
 The Virgin and Child with Sts Stephen,
 Jerome and Maurice (no. 49) **186–9**
Theatrum Pictorium (pub. Teniers) 187,
 189
Titian (Tiziano Vecellio) 36, 152, 154,
 189
 Bacchanales 168
 Portrait of a Woman in a Fur Wrap 156,
 156
Turner, J. M. W.
 Calais Sands at Low Water: Poissards
 Collecting Bait 174, *174*
 A Country Blacksmith... 178
 Lyme Regis, Dorsetshire: A Squall 174
Twelve Year Truce *102*, 104, 129, 140, 162

Vasari, Giorgio 24, 32
Veen, Otto van 130
Velázquez, Diego Rodriguez de Silva y
 154
 The Surrender of Breda 162
Verhaecht, Tobias 130
Vermeer, Johannes 124
Visscher, Claes Jansz.: *'The Belgian Lion'*
 103, 104
Vries, Hans Vredeman de 36, 122, 123,
 124
 Christ in the House of Mary and Martha
 (no. 13) 10, 14, 19, 25, 34, **84–7**, 124

Watteau, Jean-Antoine
 L'Embarquement de Cythère 43
 L'Enseigne de Gersaint 42, 43
Weyden, Rogier van der 56
 (after) *Philip the Good, Duke of*
 Burgundy (no. 1) 18, **50–51**
Wiericx, Jerome: *Joos van Cleve* 54, *65*
Wilkie, Sir David
 Blind Fiddler 178
 Blind Man's Buff 178
 The Penny Wedding 178, *178*
William I, Prince of Orange
 (William the Silent) 74–5, *76*, 94, *96*
William II, Prince of Orange 182, 184
Witte, Gaspard de: *Landscape with a Tree*
 191
Witte, Pieter de, II: *Wooded Landscape* 191
Wouters, Frans 172
 Landscape with a Rainbow (no. 42) 31,
 172–3
Wtewael, Joachim 106

Zoffany, Johann 32
 The Tribuna of the Uffizi 32, *33*, 35, 37, 43